Wake Up,
This Is Joburg

A Theory in Forms Book

SERIES EDITORS Nancy Rose Hunt and Achille Mbembe

Wake Up,

Words by Tanya Zack
Photographs by Mark Lewis

This Is

WITH A FOREWORD BY ACHAL PRABHALA

Duke University Press
Durham and London 2022

Joburg

© 2022 DUKE UNIVERSITY PRESS
Printed in the United States of America on acid-free paper ∞
Designed by A. Mattson Gallagher
Typeset in Degular

Library of Congress Cataloging-in-Publication Data
Names: Zack, Tanya, author. | Lewis, Mark (Photographer),
photographer. | Prabhala, Achal, writer of foreword.
Title: Wake up, this is Joburg / words by Tanya Zack ; photographs
by Mark Lewis ; with a foreword by Achal Prabhala.
Other titles: Theory in forms.
Description: Durham : Duke University Press, 2022. | Series:
Theory in forms | Includes bibliographical references and index.
Identifiers: LCCN 2022007472 (print) | LCCN 2022007473 (ebook)
ISBN 9781478016069 (hardcover)
ISBN 9781478018704 (paperback)
ISBN 9781478023326 (ebook)
Subjects: LCSH: Informal sector (Economics)—South Africa—
Johannesburg—Pictorial works. | Entrepreneurship—South Africa—
Johannesburg—Pictorial works. | Informal sector (Economics)—
South Africa—Johannesburg. | Entrepreneurship—South Africa—
Johannesburg. | Photography, Artistic. | Johannesburg (South
Africa)—Social conditions—Pictorial works. | Johannesburg (South
Africa)—Social conditions. | BISAC: PHOTOGRAPHY / Photoessays &
Documentaries | HISTORY / Africa / South / Republic of South Africa
Classification: LCC HD2346.S62 J643 2022 (print) | LCC HD2346.S62
(ebook) | DDC 338/.0402220968221—dc23/eng/20220625
LC record available at https://lccn.loc.gov/2022007472
LC ebook record available at https://lccn.loc.gov/2022007473

Cover art: Jeppe Street, Joburg, 2017. Photograph
by Mark Lewis.

Contents

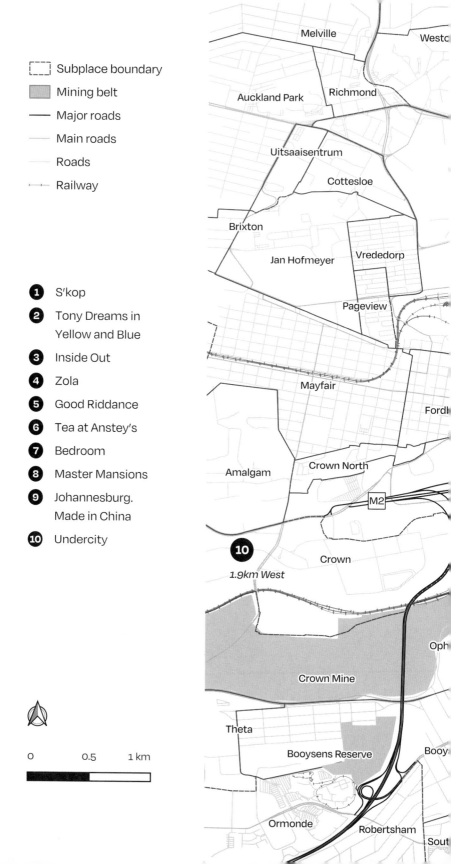

Subplace boundary
Mining belt
Major roads
Main roads
Roads
Railway

1. S'kop
2. Tony Dreams in Yellow and Blue
3. Inside Out
4. Zola
5. Good Riddance
6. Tea at Anstey's
7. Bedroom
8. Master Mansions
9. Johannesburg. Made in China
10. Undercity

0 0.5 1 km

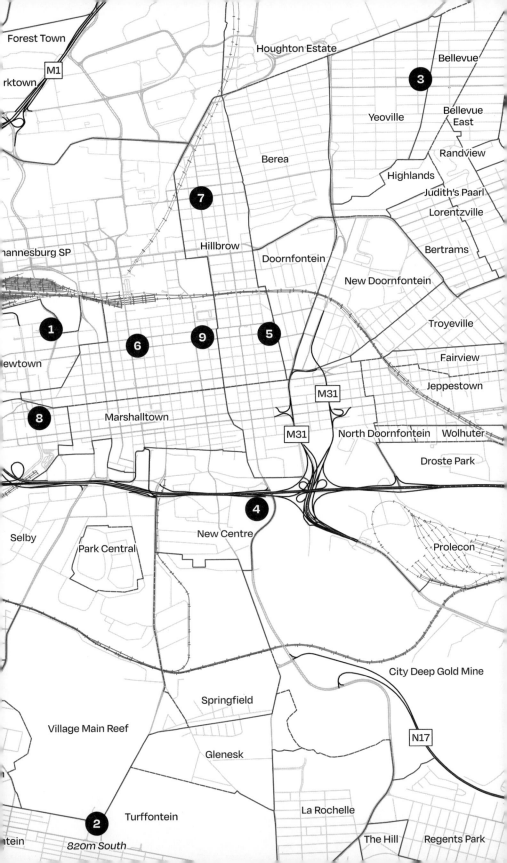

Foreword True Places

ACHAL PRABHALA

It is not down in any map; true places never are.
Herman Melville, *Moby-Dick; or, The Whale*

One evening, a few years ago, I wrapped up my last hour of teaching at Wits University in Johannesburg and drove home. I was in a good mood: the weather was perfect, the semester had gone exceptionally well, and I had two days of nothing ahead of me, after which I was going to take a flight back to my other home—Bangalore, in India—which is where I mostly live. To get home, in Yeoville, I took a route I had taken a thousand times, down Empire Road, up a road that no one ever calls Clarendon Place but is, and on to Louis Botha Avenue, a long, narrow strip with only two lanes on each side, which makes driving along it a bit like playing a late 1980s video game: choose the left lane and get stuck behind minibus taxis as they arbitrarily lurch to a halt; stay in the right lane and get stuck behind someone who wants to turn right into Berea, Hillbrow, or Yeoville.

As I pulled up to the Clarendon Place junction, I stopped at a red light by Clarendon Court, an exquisitely distressed midcentury island of flats marooned in a sea of midcentury roads. I had my window rolled down. I had the radio on. It was my fourteenth year of living in South Africa, so when I saw a young, casually dressed man sizing me up as he leaned against the outer wall of Clarendon Court, I should have known what was coming. But I did not. Instead, I stayed frozen as he sauntered over, my window still open, my hand still resting on the door, the radio still on. He asked me

to hand over my phone, putting one hand in his pocket, saying he had a gun. I remember remaining frozen, but I must have refused, because he got mildly worked up and said he would shoot me. Right then, the lights changed, traffic moved, and so did I, rolling up my window as I accelerated. My would-be assailant tried to hold on until it became clear that his arm was no match for my electric window, so he simply cursed and ran away into Clarendon Court, or the road behind it, or the teeming inner city that lay beyond the road, or somewhere even further.

The whole thing was quite funny. I can still remember every pivot on that young man's emotional register, from the initial swagger to consternation to eventual defeat. At that point, I had lived in Johannesburg's baddest zone for so long, the program—the small, oddly specific things you're told to do when you live in an area like Yeoville—had become part of my body at a cellular level. Perhaps my cells momentarily collapsed; perhaps I thought I could will my mood onto the city. Maybe I was sick of following not just one program but several at the same time—maybe all those conflicting lines of code colliding against each other in a single day or even in a single journey had finally shut my system down. Walk anywhere in the day in the inner city, but don't walk alone after dark; don't walk anywhere at any time in the rich suburbs; seek out people; fear crowds; drive a Toyota, everyone does; never drive a Toyota, everyone wants one; drive a rubbish car that no one will steal; never drive a rubbish car because the police will haunt you; talk to people; don't talk to anyone; enjoy your freedom; fear everything.

I should confess that I spend most of the year in a city where the worst thing that ever happens is the weather. In Bangalore, people discuss the single-digit variations in temperature that mark what passes for seasonal change in the hushed tones of Northcliff neighbors discussing the latest triple homicide in Johannesburg. Don't get me wrong; it's not the boondocks. Bangalore is a sprawling, snarling metropolis of eight million people, and I love it, but sometimes I just want to push it off a cliff. A decade ago, after the unhappy conclusion of a brief relationship with a resident of Karachi, Pakistan—one of the most unstable cities in the world—I received what remains the most withering insult ever hurled at my hometown: "And Bangalore! I mean, does it even *have* a crime rate?"

To be sure, I don't think crime is exciting, and I don't miss the feeling of having to watch my back in public one bit when I'm away from Johannesburg. It's nerve-racking, and the reality of crime in the city—a disproportionate

reality for poor people—is heartrending and tragic. And still, through two decades of living and working in Johannesburg, crime is also not something that has actually happened to me. Perhaps it's because I have dark skin and don't look rich. Perhaps it's because I'm male and built fairly big. Perhaps it's because I have only ever lived in working-class Johannesburg, secure inside that secret fold between poverty and wealth. And mainly, perhaps, it's because I've been lucky. But I offer you this anecdote of a doubtful crime to place this one little narrative against what is undoubtedly the ur-narrative of Johannesburg. I've loved this crucible of civilization for almost two decades now, as do millions of residents and visitors, and occasionally it can feel as if my conception of the city, the prevailing conception of the city, and even the city's *own* conception of itself are like different motorways, all with the same signs, except leading to different places.

I felt similarly dislocated when I read *S'kop*, the first in a set of slim volumes published by Fourthwall Books in Johannesburg—each story had a limited individual run before being brought together in the book you now hold—which is to say, the story felt both wrong and revelatory. You could say that *Wake Up, This Is Joburg* has its finger on the pulse of this pulsating city. You could say that it explores, with breathtaking sincerity, the extraordinary details lurking behind the ordinary lives of people who make this city function. You could say that it chronicles a remarkable catalogue of work, from mining cow skulls to mining gold, from sorting rubbish to making bowler hats, from selling fantasy weddings in a vegetable market to building baroque fantasies in Turffontein.

As for me, I would rather think of it as the equivalent of barreling down a hundred different motorways all at once, without a care for where you might end up, because wherever you do end up, you know one thing for sure: it will be a true place.

I took some time to acknowledge my own true feelings for Johannesburg. Like every other child growing up in Soviet-aligned India, I dreamed of going west and living in a fabulous Western city surrounded by fabulous Western things. What I didn't know then was that the Western city I yearned for was in South Africa, which, to be fair, is to the west of India. Try as I might—and I have—I cannot see Johannesburg as a festering sore in need of medical attention. I know the poverty, inequality, and crime statistics; in fact, I work with them on a daily basis in my life as an activist. In some factual manner, I get that Johannesburg is a wretched city, divided by a growing income gulf, plagued by persistent racism, rife with class

tension, teeming with crime, blistered by xenophobia, crowned with corruption, and inflicted with bad governance. But I did not grow up in Amsterdam or London or Boston, and I don't think cities can be defined by their worst problems. I cannot recognize the specter of imminent apocalypse that's invoked every time a new pothole appears on a road, and I am not traumatically shocked when a member of the police force asks for a bribe.

I'm sure I have low standards—spend an hour in Bangalore and you'll agree. I know I have some, but hopefully not too much, of the heartless immunity to poverty that other African immigrants to Johannesburg will recognize. Endless power cuts and the abject failure of the state are not bugs; they've been features of my daily life since I was born. Let me put this bluntly. Some people see Johannesburg as hell. I see it as a modern Western city, full of unimaginable freedoms, and run by black people: paradise. I'm not ashamed of what I feel—I think I live a responsible and engaged life, and I know it's possible to deeply love a deeply flawed city without having it imply a lack of concern for those trapped in its flaws.

This is my true Johannesburg: the glittering Western cosmopolis filled with desire and possibility and mobility, where everyone from every class and every race collides; where everything is questioned; where nothing is what it is or will be; and which is something that transforms itself, and me, every second of every day.

When I was about ten years old, I watched cycles and scooters overtake us as our car stalled in dense traffic, and I asked my father why we couldn't simply blow our horn and push them off the road—I assumed it was our right, being in a car that could go faster than two-wheelers, to go faster than two-wheelers. My father, a radar engineer who isn't normally given to moments of empathy with the class struggle, saw through my question. I was asking why we, as upper-class, upper-caste residents of Bangalore, did not have more of a right to the road than people who were not. "The reason we're not being murdered in our beds by all these people," he said, in a matter-of-fact voice, "is because they can overtake us on the roads."

I thought of my father's words in Rio de Janeiro, some years ago, at a dinner hosted by a French investment banker. I was just getting to know Brazil. His magnificent house in São Conrado had sweeping views of the South Atlantic; the pâté was perfect; the wine, wonderful; and except for my partner and me, everyone else in the room was white. As we looked out onto the ocean, I asked him the one question that was eating me up:

We had been in Rio for weeks and hadn't met a single middle-class black person. What was the deal with that? He shrugged. Were there any at his bank? I asked. None that he could think of, he replied, at least none in positions that mattered. "You know what the strangest thing about it is," he continued, expanding on the fact that 50 percent of the population had zero representation at his bank, "They don't seem to mind. They just don't seem to mind." As we left his house that night, one of the four armed security guards on the night shift clicked open an enormous metal gate. A flotilla of lights connected to an electronic security system blinked into submission, and another guard escorted us to our car. As we drove off, his military-grade security apparatus swung back into place, the guards retreating into their bunkers as the thick, opaque gate sealed shut, turning the whole place into an impenetrable fortress once again.

No, I thought: they *do* mind.

I could go on endlessly about the remarkable similarities and differences between the daily churn in Bangalore, Rio, and Johannesburg, the three cities I have lived and worked in for the better part of my adult life, but that's a subject for another time. I will say, though, that after having spent some time in the usual outposts of civilization, and having chosen to spend far more time in the tropical destinations I call home, stable societies get on my nerves. I'm convinced they're just better at hiding their flaws. Sure, I'd choose Sweden over Syria if those were the only choices, but give me the rampantly unequal, multi-ethnic, multiracial, multilingual democracies I've lived in over Scandinavia every single time. Even my bovinely placid Bangalore is churning; stubbornly and passive-aggressively, but churning it is—with conflicts over class, caste, language, and skin color flaring up at every turn. We may have no gun crime, but this city has been fiercely negotiating power and belonging from the moment it was formed, and the churn shows no signs of slowing.

When it comes down to it, there's no contest, really: as the youngest, loudest, and brashest of all third-world megalopolises, Johannesburg churns like it's being struck repeatedly by lightning bolts. The ferociousness of change can be disorienting; the direction and velocity of the change, whiplash-inducing. The change can be thrilling and liberating; it can be painful and debilitating. And I'd like to believe that the exciting, unsettling mess it leaves in its wake is something that will, one day, look a lot like progress.

Acknowledgments

It has been a pleasure to develop this edition under the careful eye of Elizabeth Ault, and we are grateful for her rigor and guidance.

This full-color edition is made possible with the generous support of William Kentridge, Anne Stanwix, Wendy Fisher, and the School of Architecture and Planning at the University of Witwatersrand.

The first edition of this book was a set of ten full-color photo books. We are indebted to Fourthwall Books, who were inspired to turn the collaboration into photo books. In particular we thank Bronwyn Law-Viljoen, Terry Kurgan, Carla Saunders, and Oliver Barstow.

The School of Architecture and Planning at the University of Witwatersrand—where Tanya is a senior researcher—has provided a supportive and generous intellectual base for our learning. We are privileged to have had many enthusiastic dialogues about the Johannesburg-specific and not-so-specific elements within this work with the leading urban experts in the school.

One of the photo books (*Johannesburg. Made in China*) took shape while Tanya was a resident at the spectacular Rockefeller Foundation Bellagio Center in 2014, and for that experience she owes the foundation immense gratitude.

The introduction was developed in 2019 in the collegial and stimulating environment of the Johannesburg Institute of Advanced Study.

Each photo book was launched by Fourthwall Books and with the generous input of guest speakers. We thank Sarah Charlton, Yasmeen Dinath, Hugh Fraser, Philip Harrison, Caroline Kihato, Christa Kuljan, Brian McKech-

nie, and Dilip Menon. We also thank the readers who gave valuable insight and direction, including Kirsten Harrison, Isabel Hofmeyr, Achal Prabhala, Bonnie Rosen, and Melinda Silverman.

It was a great pleasure to have Alli Applebaum and Denise Lim reflect with us on our work style and relationship to the city. They helped us articulate our process.

And to work with Adam Potterton, who was undaunted by the task of indexing and tackled it with a calm rigor.

Thank you to Reitumetse Selepe for mapping the location of the stories.

We have been encouraged and supported throughout the making of this work by our loved ones—Grace, Brian, Simon, and Ava. They have listened to multiple iterations of these stories and pored over many photos with us; their love is quite simply the reason it's all worthwhile.

—T.Z. and M.L.

Acknowledgments

Introduction

The truth sometimes reminds me of a city buried in sand.... As time passes, the sand piles up even thicker, and occasionally it's blown away and what's below is revealed.

Haruki Murakami, *Colorless Tsukuru Tazaki and His Years of Pilgrimage*

|

Inner-City Johannesburg

ON NOVEMBER 12, 2018, the mayor of Johannesburg, Herman Mashaba, made a citizen's arrest. The news clipping recording this event cautions: "WARNING: This story contains graphic images." The article reproduces the mayor's tweet of the day before, which is illustrated by said graphic image (of a man pulling a trolley of slaughtered bovine heads in the Central Business District [CBD]): "I have just personally stopped this illegally [*sic*] act in our city. How do we allow meat trading like this? I am waiting for [the chief of the Johannesburg Metropolitan Police Department (JMPD)] to come and attend before we experience a breakdown of unknown diseases in our [City of Johannesburg]" (Mjo 2018). Further messaging from the City noted the person who was arrested was "undocumented"[1] and

1 Foreign migrants to South Africa are required to have work, residence, refugee, or political asylum–seeking permits for their presence in the country to be deemed "legal."

would be charged accordingly. The congratulatory responses the mayor received for this act were drowned out by the negative publicity his conduct aroused. On social media and in the press, he was criticized for his anti-poor and anti-foreigner sentiments. Several commentators emphasized the ordinariness of the practice being denounced by the mayor. The removal of flesh from bovine heads is an informal but regular activity that supplies meat to the equally informal meat preparation on braziers set up at many transport interchanges in the city. But the mayor responded defiantly. This time his Twitter retort was "We are not going to sit back and allow people like you to bring us Ebolas in the name of small business. Health of our people first. Our health facilities are already stretched to the limit." That tweet landed him in front of the South African Human Rights Commission. In the days thereafter, he was compelled to apologize for the offense he may have caused street traders and foreign nationals. Within days of his expressed revulsion at the everyday sight of bloodied cow heads, the mayor announced the imminent release of a long-awaited policy for street trading in the inner city. And while this moderated impulse to direct informality through applying the law or penning a strategy still occupies bureaucrats, the economic activity attached to these cow heads—which our first story in this book probes—continues.

The executive mayor hailed from the Democratic Alliance (DA), the country's official opposition party. His leadership of the City was the product of a coalition between that libertarian party and the far-left Economic Freedom Fighters (EFF). He was known for his uncompromising "back to basics" rhetoric and his support of the "free market," by which he meant formal business. He determinedly twinned his straight-talking mission for order and cleanliness in the inner city with vehement animosity toward foreign nationals and informal enterprise. His arguments spun on the "irrational jargon of criminality, backwardness and alarming health risks" (Mabasa 2018).

Mayor Mashaba had considerable support for his law-and-order approach to dealing with the problems of the inner city. The criminalizing of informal workers was not new in the City. Nor was it the position of only one political party. Rather it had currency across the political spectrum, especially when those workers were also foreign migrants. Mashaba's predecessor, the African National Congress (ANC) mayor Parks Tau, had presided over massive removals of street traders. Mashaba was simply the contemporary spokesperson for much that is feared in inner-city Johannesburg. His public statements on the inner city frequently linked high

rates of crime, building decay, congested living conditions in deteriorated buildings, and grime with the presence of informality and of foreign migrants. It is the sort of crude messaging that easily stokes a paranoia in a city built on segregation and on suspicion of the outsider. And it is the kind of messaging that fuels alarm that the inner city is tilting toward ungovernability.

This is Johannesburg. It's a place of reeling. A city where the public good is contested. Where making a living can be messy. Where the poor may be criminalized by the authorities mandated to protect them. Where violence simmers. But where people will stand up for their rights. So that there is an immediate outrage and a counter to a mayor's xenophobic messaging or acts of social injustice. In this way Johannesburg's moral measures are continually shifted and shunted across the balance board. And as the city lurches between crisis and celebration and back again, it surprises with its core strength, its agility, and its posture.

The contradictory forces that support and slacken the tension around being informal in the inner city implicate political ideologies, unemployment, segregationist histories, and hatreds as much as they invoke innovation, tolerance, and opportunity. The multiple influences beaming on the scene of a man pushing bloodied cow heads along an inner-city street are confounding. They are not explained by the mayor's assessment. Indeed the stressed environment of the inner city is enormously productive, yielding social and monetary value and globalized connections that easily outstrip those of affluent suburban commerce. As a planner and a photographer, we are curious about the complexity that lies behind the activities and scenes that are in many ways peculiar to Johannesburg's streets and buildings. The stories we tell in this volume are the product of our looking, listening, and reflecting on the ordinary and the extraordinary in ten slices of the city.

The city is generous in its manifestation of a contemporary postcolonial African urbanity. If you have the eyes to see, it offers a concentration of the plurality and the energy of an Afropolitan metropolis (Mbembé and Nuttall 2004) that would fill a library of texts. It parades modernism and its surplus with the expectant vigor of newly arrived migrants; local practices with globalized trade; exquisitely urban experiences with deep linkages to rural homesteads; and affection and hostility for the other—because in some way or another most inhabitants here are outsiders.

It interweaves the past and present in inextricable ways. There is no escaping the dramatic superimposition of eras in the few city blocks that

compose the historical core. A single frame shot from a high-rise building in Johannesburg can reveal the city's earliest history in its mining infrastructure to its modernist architectures to its chaotic informality and its yet-to-be-determined future. These views are windows to perplexity. They inspire a rabid curiosity in Johannesburg's downtown.

The transformations of Johannesburg's inner city are sometimes described in sweeping ways told as a series of dramatic changes, as if the waves of people moving in or out of the city happened overnight. But actually change happens in small adjustments and intrusions at many sites in far more incremental ways. In these stories we are interested in the *Individual*. It is the individual person in the single building or room, the particular edge of a mine dump, or the shadow of a highway underpass that tugged us into the city. The questions of how one recycler conducts his daily routine, where he lives, where his dreams locate compelled us. Call these individuals survivalists or entrepreneurs who are making their way, we are interested in their intentions or dreams or the outcomes of their actions. By looking at the minutiae of activities and people who are in the edginess of the city—whose activities are not coded and regulated and who are forging improvised livelihoods, and making decisions that are driving and altering the city—we invite readers to think about urban transformation from a different angle.

The readers of this work are people who are inquisitive about urban living in ways and worlds they do not encounter on a daily basis. This is a city that attracts debate and writing. It is a site of academic and popular writings, of works of fiction and nonfiction, of songs of praise and of resistance. It is a palimpsest for reflecting the best and worst of urbanity. We are writing for curious readers who may know some or much of that rich body of work, and who have a sense of the complexity of urbanity. Like us, they are thirsty for sense-making about Johannesburg.

History

4 From the description rolling off the tongue about Johannesburg's genesis on "the richest gold-bearing seam in the world" to its current status as a postcolonial Afropolitan metropolis, everything about the city is hyperbolic. And contrary. Exaggerated claims ring around this city fashioned from and generating extreme prosperity, conflict, oppression, and pluck. With its stubborn geography of segregation, it is the go-to case study

for urban inequality, but it is also a model of transformation. And it is the trademark arrival city on the African continent.

As Harrison and I have observed elsewhere (2012), when the world's richest gold fields were first opened up in 1886, the metal was highly sought after, as the major European economies were tied to a gold standard. The discovery attracted prospectors from as far as the news of gold could be heard, as men threw themselves toward hope on the unknown Witwatersrand. But from its onset this cunning gold field favored capital. The gold-bearing reefs breaking the surface in enticing outcrops dip steeply into the earth, requiring deep-level mining, with expensive technologies, for extraction (Beavon 2004; Innes 1984). The opportunity for small-scale artisanal miners was short-lived, and the new gold field was soon dominated by a handful of "Randlords" who had made their fortunes on the Kimberley diamond fields and who were backed by international investment capital (Harrison and Zack 2012).

There was a delicate balance between cost and revenue, with gold being mined at increasing depths and costs but earning a fixed price. The state was complicit in supporting the reproduction of low labor costs to bolster the gold mining economy (Innes in Harrison and Zack 2012). As early as 1896, the Chamber of Mines was recruiting labor not only from what would later become Bantustans in a Union of South Africa but also from neighboring countries. And the "City of Gold" was built on the paradoxical reliance on African and foreign (including Chinese) labor and the dislike for having Africans as urban occupants in increasing numbers. Regulations and working conditions were instrumental in keeping the labor force at bay. Male migrants were housed in single-sex compounds for limited periods and returned to families in rural areas when their contracts expired.

The spatial evolution of early Johannesburg was profoundly shaped by the physical presence of mining and by the hierarchies and intersections of a society emerging around the mines. The crudely laid-out, grid-patterned settlement of Johannesburg was proclaimed on a triangular piece of leftover state-owned land—*uitvalgrond*—immediately north of the mining belt (Beavon 2004). Within ten years, it was the largest urban center in Africa south of the equator (Chipkin 1993). And it was already segregated when, in 1928, it was proclaimed a city. When black Africans entered employment in other sectors, migrants found accommodation in municipal compounds and in slums in and around the center of town and in domestic accommodation in white residential areas. The state re-

5

fused to accept this interracial proximity and embarked on a long history of attempts to segregate out the race groups (Parnell and Mabin 1995). The whole of the municipality of Johannesburg was proclaimed white by 1933, and by the late 1930s the local authority had used the provision of the Slums Act 1934 to clear mixed-race inner-city neighborhoods and move black African residents to newly built townships such as Orlando (the first township established in Soweto). Indian and colored (mixed-race) communities maintained their foothold near the inner city, in places like Fietas, until the apartheid era, when they too were forced into peripheral townships.

Melinda Silverman and I (2007) have elsewhere described the development and decline of the property market in an inner-city neighborhood. Apartheid was formalized in a post–World War II South Africa. For Johannesburg's property investors, the 1950s was a heady time of robust economic growth. The municipality offered land-use rights to encourage high-rise development on the northeastern fringe of the CBD. The developer community responded with modernist towers in Hillbrow. The apartments accommodated a large population of predominantly single, skilled, white workers from various European countries in need of rental accommodation. These white artisans contributed a cosmopolitan flair to Hillbrow, which spawned a café society of clubs, coffee bars, and bookstores (Silverman and Zack 2007). It became an entertainment magnet for white suburbia, and later for black residents, in search of spaces of liberation from the authoritarian gaze of the government, its associated institutions, and a repressive and repressed society.

The late 1970s heralded a radical change for the inner city in the form of a massive exodus of whites from inner-city residential space as well as from commercial space. Some of this flight was emigration, and much of it was to suburbia. This flight was inspired by uncertainty following the student uprisings of 1976 as well as by a trend toward suburbanization. The city continued to expand and modernize. The state built an ambitious American-style freeway system, easing movement and decentralization of business from the CBD. Decentralized retail and office nodes developed immediately north of the CBD in Braamfontein and Parktown, and then further north to the new shopping centers around Rosebank and Sandton. A polycentric city was born. And as Sandton in particular grew as the new financial heart of Johannesburg, the inner city rapidly lost its economic dominance.

The suburbanization of residential stock was facilitated by new loans

for first-time homeowners in the suburbs. These moves led to high vacancy levels. This was coupled with a severe housing shortage in colored, Indian, and African areas. Push factors for white tenants and pull factors for blacks led to a rapid change in the demographics of the neighborhood, with increasing numbers of black tenants moving into the area in defiance of the prohibitions of the Group Areas Act. By the end of the 1970s, it was apparent the system of influx control (including the notorious passbooks) was unable to control the movement of black Africans into the city. Landlords, increasingly desperate for tenants in the face of white flight, were happy to facilitate what was then known as the "greying" of the inner city. This process was accompanied by capital flight, hikes in rentals, subletting, and overcrowding (Morris 1999). The deterioration of many buildings set in, and the inner city would over the next two decades be notorious for its "bad" or "hijacked" buildings (Silverman and Zack 2007).

The 1990s brought a new turn. The key registers of the period were in-migration, informalization, and gentrification. The dawn of democracy in South Africa, coupled with political changes, conflicts, and economic decline in several other African states, witnessed a steady influx of foreign migrants to South Africa. Johannesburg deepened its role as an "arrival city" in Saunders's (2011) framing of the term, a place where migrants, many of them rural, with ambitions fixed on the symbolic city and its opportunity, engage in monumental struggles for survival or to establish a financial or spatial foothold for their dependents. In this process, they create urban spaces with distinct networks of relationships and functions that are the imagined and, in many instances, actualized loci of transitions from poverty.

Meanwhile the conversion of office buildings and the rehabilitation of old residential blocks were set in motion by developers who rode the optimistic wave of a New South Africa and catered to a seemingly insatiable demand for well-located lower-middle-income housing. That gap was filled often at the expense of poor households who had lived in overcrowded cheaper accommodation. Years of gentrification were coupled with years of evictions from inner-city buildings.

7

The Inner City within Johannesburg

The drama of contestation plays out most vociferously in inner-city Johannesburg. Nowhere else in this divided city do the forces of a modernity built on big capital rub up against a present-day urbanity etched by

the poor as directly as they do in the original downtown. There are other Johannesburgs beyond the border of this business district, which was the site of the first mining settlement and is located on the eastern portion of the modern city's administrative area. The callous geographies of the city designed to service white supremacy still structure the palimpsest. Neighborhoods are divided into those pockets whose environments and residents were intended to succeed and those premeditated to fail. These mono-racial and mono-class geographies were stitched together in a pattern based on ensuring good location for white residents and white commerce and marginal, distant spaces for black residents—who were denied any proximate commercial space other than the odd industrial zones that black townships were attached to as labor pools.

In a post-apartheid city, much of the racial and class patterning prevails. Roughly speaking, the wealthy northern suburbs of the city have retained the markers of elite living—high walls, manicured lawns, securitized estates, and allied shopping malls. Sandton, the city's financial center, fifteen kilometers north of the old city center, boasts skyscrapers and all the trappings for elite living. Suburban shopping and commercial districts are similarly modeled as internalized exclusive lifestyle centers. Townships have retained their high-density, compact government-issue housing, many with backyard developments. These are spaces where microbusiness occupies residential space and where high-density living spills into street space. New formal developments in suburban Johannesburg have taken the form of townhouse developments and gated estates. But by far the most significant expansion of the city has been informal and has occurred in informal settlements at the fringes of the urban space, often attached to existing black townships. And in the more compact working-class neighborhoods hugging the inner city, dramatic shifts have occurred in demographic changes, densification, and a mix of uses and housing solutions.

These are the headline changes. But across the city there have been multiple changes in density, in demographics, and in infrastructure challenging the apartheid city form. Some of these are driven by state investment in transportation or plans deliberately forging greater inclusionary development. Others are driven by private developers' responses to the pent-up demand for lower-income residents to live in better-located parts of the city. And many more are driven by the incremental imperative of poor people to find a foothold and build a livelihood in better-located places. These actions have wrought changes across Johannesburg. The

8

privately militarized suburbs barricaded against the poor are finely contrasted with the working-class neighborhoods and townships, informal settlements, and the inner city where Johannesburg's lowest-income residents live. Working-class districts have been more malleable to the forces of change than others. But the urban poor live in many parts of the city—in seemingly purely middle-class or affluent neighborhoods, poor people live un-housed, in parks or riverbeds or under bridges; elsewhere poor residents occupy empty factory buildings or houses that have been abandoned or seized from owners.

No neighborhoods have changed as utterly as the inner city has since the dying days of apartheid. And none presents the mix of users—of residents, workers, commuters, and visitors—that the old Central Business Districts do. Nor does any other neighborhood boast the scale of infrastructure and the hardiness of place that attends life in the inner city. And no other neighborhood offers the opportunity for individuals to make a living in the shadow economy.

Nearly three decades into democracy, the inner city compresses multiple Johannesburgs in one space. In spite of a massive decline in the demand for office space, the City's original commercial center still retains several large banking and mining headquarters and a range of small-scale office suites. It is a local, regional, and cross-continental retail center. It remains Johannesburg's premier transport hub with many public transit routes traversing the downtown. It is a key cultural hub hosting theaters and public art and music venues. And it is a site of many low-fee, under-resourced private schools and colleges. The major investment in the area in recent decades comprises the conversion of defunct office space into residential apartments. There are pockets of city investment where public environment upgrades in the form of new paving, public parks, and lighting seek to respond to or encourage private investment. Overall the platform to support these uses strains under the load of poor management, increased densities, overwhelming and competing demands, and constrained budgets. Service levels, maintenance, and facilities have not kept pace with investment or with the enormity of change, nor have they reached many of the urban poor, who for their part have found loopholes and footholds to live and work in precarious ways alongside the more formalized changing inner city. They have led a different transformation of space.

Shadow City

The ways in which people are improvising to make a living and a home among the spaces and enormously robust infrastructure of the original city center lie at the heart of the inquiry setting up the *Wake Up, This Is Joburg* project.

All over Johannesburg—but especially in the inner city—seemingly unusable land and redundant buildings are appropriated temporarily or irregularly for living space, places of religious worship, gambling, or survivalist income generation. The spaces threatened or criminalized or ignored by the authorities are often the only remaining places of opportunity for new entrants to make a living in the saturated informal economy of the inner city. Boundaries are more powerfully signaled by micro-exclusions than by coded rules. A signboard warning people not to enter an abandoned mineshaft is flagrantly ignored in "Undercity" (chapter 10). Shielding oneself from the law demarcating where one may or may not conduct a livelihood occupies much of the energy of petty entrepreneurs in the City. Making a living involves penetrating Johannesburg's leftover spaces and freshly choreographing the places of neglect and decomposition. And these spaces define new socially constructed territories and microboundaries around who is welcome or not.

Such welcome may be signaled by the state in one way while it is withheld in another. Street trading in the inner city is trapped in an ambiguity between these poles. The municipality's restrictive approaches were interrupted by periods of tolerance and even highly permissive allowances for street trade, and the activity proliferated in the inner city. However, the overarching policy and regulatory framework remained ambiguous and kept traders vulnerable to unpredictable law enforcement and harassment. The most unexpected of these was the massive removal of traders from the streets of the inner city in 2013. Operation Clean Sweep was later declared unlawful by the Constitutional Court, and traders returned to the streets. They remain there, and the policy and governance regulating their activity remains unresolved. Operation Clean Sweep lies at the extreme of a logic about street trading focused on control and on the conjoining of informality with crime, filth, and disorder. In these ways fortunes in Johannesburg can turn in an instant. And the state is unpre-

dictable. One cannot know if a new activity or new way of living in the city might be supported or resisted.

We resist the term "underbelly." These stories reveal not some underside of the city but rather an urbanity and a making of "cityness" that is inescapably with us. The stories we encountered have allowed us to pay attention, for a time, to lives lived alongside our own, but in the shadows—possibly even shadows we ourselves cast. The stories are an exploration. They are an attempt to sharpen our perspective, to focus our senses.

The stories in *Wake Up, This Is Joburg* search for the ideas about Johannesburg that cling to expectations of the protagonists we encounter. They probe the dreams and intentions of people who live and work in the inner city and ways in which their ideas of the city are giving form and structure to certain buildings and spaces, and remaking those buildings in the contemporary city.

This compilation of stories of the shadow city into one volume offers us an opportunity to reflect on some of the themes that emerged across the books. In the following section, we trace those themes that punctuate the shadows.

Value and Effort

The statistics occupying the daily accounting of the poor pepper a number of the stories. How many platefuls of food can one cow head deliver? How many kilograms of waste can one man's sixty-one-kilogram mass drag up a hill? How many additional kilometers will a waste reclaimer drag that load to secure a few cents' additional profit from their sale? How many kilograms of gold-bearing rock can a man carry on his back as he crawls for several kilometers to surface from an underground rock face? How many buckets of water does each person in an apartment housing thirty-four people need per day, and how many containers can be stored in the corners not required for the rituals of sleeping, cooking, and daily ablutions? How many people can share a double bed in the same apartment? How much salt will keep food fresh for longer in spaces with limited refrigeration? There are also shadow worlds in which a food vendor's day begins at 2 a.m., an informal trader in a market works every day of the year, and a waste reclaimer wakes at 3 a.m. to begin his thirty-four-kilometer round trip by foot—until the day his feet will not carry him anymore.

A number of stories in this book track the labor of protagonists. There are stories of people making hats, chopping cow heads, painstakingly repairing discarded objects, pulling enormous loads of waste, digging for gold, cooking food, washing taxis, and working inordinately long hours in informal markets. In these ways survivalist entrepreneurs and workers toil the modern city. Their work is not un-modern but is locked into contemporary global processes of distribution and dealing with the debris of a late capitalist consumptive economy.

These are pathways and logistics not factored into city road signage or into the infrastructure plans for public toilets. The formal coding of the city bypasses its inhabitants. It fails to provide them with a platform of dignity. And it misses the power of their collective energy.

The City as Carcass: Transformations from Below

Informal and extralegal economic endeavor in the city is often aligned with decay and with the unmaking of a previous life and a built form in the city. It is necessarily simultaneously innovative and destructive. Metaphorically it gouges out the carcass of the city even while it inserts and fills its cavities. While it may operate at the fringes of capital and the edges of our consciousness of how the city is changing, it cannot be discounted as peripheral to the reprogramming of the city. In Johannesburg's inner city, informal endeavors undertaken by migrant entrepreneurs are proving to be more than registers of marginality and precarity. They are front and center of urban transformation and investment.

The description in "Undercity" (chapter 10) of MaLetsatsi digging for gold under her shack evokes so much about unearthing, stability, precarity, and a city eating itself. It is a city inked onto the world map by a metal incidentally deemed valuable, a metal still surfacing at ground level along roadsides and streams and even under dwellings located along the top of the reef. It is a city whose insatiable appetite for that metal transformed highveld into skyscrapers and highways and introduced toxins into its air, its groundwater, and its soil. But this robust city outlasted the gold. And there's no reason to believe it will not prevail even after the earth on which it stands is gouged out and its water sources are contaminated. This image also speaks to the tug between the vertical and the horizontal in the city. Between those energies and people inhabiting the surface world and those literally and figuratively "below"—figures, images, and rumblings stirring our fears.

12

The ceaseless extraction characterizing this city poses threats of material decay. Possibly, most alarmingly, threats turn again to the underworld of the city. They are the reports that informal miners might blast the remaining pillars propping up a city built atop the cavities, recklessly gouged out of the earth by a hungry gold mining industry.

A visible excavation is taking place in its inner-city buildings. Armed security guards are hired by building owners to secure their high-rise inner-city apartment blocks from "hijacking." This is a ubiquitous Johannesburg term that can signal the takeover of a building by criminal gangs or vandalism or overcrowding of apartments. These security guards also shield the remains of buildings progressively destroyed through arson and pilfering of their resalable infrastructures. "Because, you know, they eat buildings," one guard told us.

And the glimpse of a livelihood opportunity is not delinked from the fissures of scarcity disrupting this well-appointed modernist city's metropolitan ambitions. At transport interchanges, hawkers peddle plastic water boilers—so necessary where access to hot water for cooking or washing can be tight. It is a city in which the bare bones of discarded and decayed infrastructures can be repurposed, reinvented, and reinhabited in new ways. And where informalized infrastructure provision might take place in the very shadows of modernist skyscrapers.

"Everything Here Is Money"

Against these messages stand the voices of interminable hope in a city that will keep on giving. A migrant declares his host city's buildings to be extremely strong and its corruption laughably negligible by comparison with his home city of Lagos (chapter 3). For many, the City of Gold's excess infrastructure offers an intersection between exclusion and opportunity. "Everything here is money," an informal butcher in "S'kop" (chapter 1) says of his workplace in the abandoned parking garage where everything is commoditized, where different value chains are attached to the flesh, bones, and skin of a single cow head. His words could well be a tagline for the whole city.

Johannesburg is a vessel for the collective financial muscle and fervor of tens of thousands of goal-directed fortune seekers. Microtraders cluster in repurposed office towers. Their retail trade is birthing a radical new architecture in its revaluing of the city carcass. Here informal enterprise attached to a hive of cupboard-sized shops is servicing all of sub-Saharan

13

Africa and accounting for an annual turnover of over R10 billion (US$639 million) in an otherwise depressed commercial center. This is the setting for "Johannesburg. Made in China" (chapter 9), and it is the transnational African urban. These secret shopping centers epitomize the mass consumption of twenty-first-century global capitalism as they funnel Chinese fast fashion moving to the far reaches of sub-Saharan Africa. With its eye always on the frontiers of consumption, Johannesburg imitates and blends the brashest of contemporary culture. It is shaped then by forces far beyond its borders.

The city swanks. Its conspicuous consumption has outlasted fads and eras. From its mid-twentieth-century extravagant department stores, with their displays of glamorous French fashions and delicacies, to its first hat factory and its current low-price fast fashion frenzy, it's a "show-off" kind of place.

Darkness and Fear

Once we enter the spaces, our own anxiety about the location shifts significantly. But if we carry our own unease and fear in the inner city, we also carry the privilege of choice about where, when, and how to move through its streets. Our work has allowed us to get closer to the lives lived in spaces that felt alien and intimidating to us. The threats that have surfaced then have not been threats to us. They have been the multiple dangers many of the protagonists of our stories confront day-to-day. It is not primarily about how safe we feel but about how unsafe the city is for many people whose options are restricted.

To navigate Johannesburg is to navigate fear. The literal shadows a highway bridge casts over a taxi stand or that shroud buildings whose electrical wiring has been stripped conceal much of the inner city. Darkness and its urban companion, violence, converge in nights of terror in notorious spaces police officers refuse to enter because they are too dark. Danger and fear truncate the day's labor as nighttime flight saps the life out of energetic trading in the early evening. And danger reverberates in people's accounts of institutionalized violence and of the city's commonplace thuggery and petty crime. Everyone has been or knows someone who has been attacked and robbed in these streets. Everyone has a story about a police officer taking money. Everyone has a strategy of locking doors, hiding money on the body, adopting a confident gait, and moving in

a group. And there are micro-exclusions (De Boeck 1998) in which tribalism or associational barriers may be erected against waste pickers hoping to work at a municipal dump, or informal miners who organize themselves in ethnically defined work teams.

Violence is both alien and cruelly familiar in this city in which many residents carry memories of perils survived and escaped. It is familiar to those who fled conflicts of the Democratic Republic of the Congo or Zimbabwe or townships east of Johannesburg. And to those whose personal lives have been rocked by the violent killing of parents, siblings, or children.

Home

The obligations and hopes of migrants bind them to this arrival city as much as to elsewhere. The connections are urban and rural, and they are intergenerational. A tailor lives in Johannesburg while supporting his wife and children in Lagos; an informal miner builds a house in Bulawayo; a waste reclaimer is acquiring a herd of goats in Lesotho. The entrepreneurial endeavors of these migrants introduce unfamiliar foods, customs, and practices to the city. Native Joburgers learn to eat cassava, *kwassa kwassa,* and *injera*, while local informal miners adapt the Zimbabwean practices of the *amakhorokhoza*. The dreams of migrants carry longing. A man's experience of feeding pigeons on a Johannesburg street connects him with his memories of Bombay; Amharic music streams through Ethiopian coffee shops in Jeppe; an outsider artist decorates his house with friezes of Madeira.

And if "elsewhere" is imprinted, then there is simultaneously a determined connection with localized place. This is starkly obvious in those parts of the city that have changed fundamentally in demographic terms and in density since the end of apartheid. These are the near-inner-city suburbs of Johannesburg that defy the "geography of fortifications and enclosures" (Mbembé and Nuttall 2004, 364) so prevalent in most of suburban Johannesburg. Places where it is still possible to see the front of a house from the street, to surmise who lives there and how, rather than to 15 be walled off from the private domain. They are centers of demographic mixing, where diversity is not exceptional.

This arrival city offers sanctuary even as it alienates. It blurs and blends identity. In "Inside Out" (chapter 3) a man asks himself, "Am I more Congolese or more South African?" The city's refuge is not to be taken for

granted. Its hospitality can turn into a dark feast of taunting, stick-wielding, petrol bombing, and looting. It is a place of which a Congolese migrant in "Inside Out" (chapter 3) says, "People will hate you without knowing your intentions."

Forced removals render the inner city a fickle host. Yet it is not absolute in its hostility. The ten stories reveal varied and at times shifting senses of belonging as they find that the personal investments people make to the buildings and streets of this part of town are surprisingly unpredictable. The intimate moments of homemaking in temporary homes or in homes that have witnessed generations of children playing along their corridors reflect enduring connections to a city all too often associated only with transience. But transience has its own domestic ordinariness. The home life remembered in family photos and stories of long dinner tables sits alongside the rituals of feeding and dressing grandchildren on the edge of a raft of beds in a flat housing thirty-four people. The need to make daily ritual and to situate oneself in the city is not exclusively the reserve of those characters or material objects staying for years.

It is in the privacy of people's lounges and bedrooms where we were privy to ordinary domesticity and to personal stories, whether of life lessons passed down from a late parent or of deep tragedy and loss. It is here too that we witnessed an act of kindness central to someone's survival. These are the textures and contours delineating individuals and households whose life in the city is so readily diluted in our generalized descriptions of community or of the poor or migrants.

|||

The City Within

Our own identities and positionalities in the city shaped our views as well as the access we were given to stories and images.

TANYA My own sense-making comes from looking at space through the immediate, the direct, and the intimate. I have always lived in Johannesburg. I grew up close to the inner city, in Judith's Paarl, a small working-class suburb established east of the Central Business District in 1896. The neighborhood of my childhood was small and intricate. My worldview was concentrated in the knottiness of the two city blocks where we lived,

went to school, shopped, and caught the bus outward (generally to the city center). We lived on the upper level of a two-storied apartment building. When I reflected later on the different homes I visited and played in on our short street block, they read as a study in low-rise housing forms. They included small houses set in concreted yards; semidetached, face-bricked walk-ups; large bungalow houses; and apartments. And they included the house I loved. My friend's blue-and-white tiled house—mosaicked inside and out with the remains of her father's projects as a tiling contractor. The spaces also included the small rooftop servants' quarters, located above my bedroom, and accessible via the fire escape at the back of the building. The two blocks would easily inform a map of neighborhood morphology. I walked to the school at the corner of the street. I remember the high street. I remember the lavender curtains of the hairdresser, the chime of the bell as you entered the pharmacy, the stepped display of fruit baskets at the greengrocer, the dusty smell of the wooden post office counter, the comic book stand at the corner café, and the red wooden bus-stop bench marked "EUROPEANS ONLY."

This is the neighborhood in which I was an insider. It was a localized, parochial, formative experience. Perhaps it informed my struggle with seeing the big picture, and my need to start small. I have always been attracted to the local scale, more comfortable in a compact urban setting.

My work life has often intersected with the inner city. But from around 2008, I had the opportunity—through research and policy work—to examine some of the municipality's urban planning challenges in the inner city. I became convinced I needed to spend more time in understanding and in diagnosing what I saw before I could hope to respond to it as an urban planning practitioner. At a more personal level, my urge was sensory. I needed to see, touch, smell. I walked the streets of the inner city, and I was overwhelmed with the excitement of it. I felt humbled by how little I knew and understood.

Photography became a natural extension for me in the act of watching, and I spent many months taking photos. This was also a vehicle of access because each photo required conversation and permission, and so I got talking to people. It was still a personal project—looking, taking pictures, turning these into collages for the pleasure of absorbing and playing with the extraordinary images of the inner city.

In a way, the collages were an act of taking images and remaking them into new stories by placing them in different configurations. On reflection, it was experimental story making. I tentatively started writing what I was

seeing, first in a diary fashion—reflecting on my own experience and my responses to the inner city I was rediscovering. Later I began to craft profiles of people or places I encountered. In some cases, the stories popped up because I encountered them in my wanderings. In other cases, I set out specifically to understand an activity or person and their livelihood in the city. I followed a group of waste reclaimers over a number of months by meeting with them on the road or at their home.

Relooking at an inner city I had frequented as a child, a teenager, a student, and a professional over forty years, and one that I had walked in, shopped in, and invested in, required leading with my ignorance rather than my analytical scrutiny. This was an attempt to look at my own city and the city I had worked in for over two decades in a fresh way. In this project, I was often aware of my tendency to lean into a didactic and normative stance, to think always about "what needs to be done." But these stories were collected from a different position. It was a project of entering parts of the city in a permeable way, with a focus on how places and stories looked and sounded and felt rather than what they meant against my urban planning toolset.

Listening required telling. In order to ask people to share their stories, I often first had to tell my own. These encounters highlighted my identities as a middle-aged white woman who now lives in a leafy affluent suburb, as a property owner in suburbia and in the inner city, as an urbanist, as someone who was born and raised in working-class near-inner-city neighborhoods, as a mother, and as a writer. And my identity as voyeur. I stumbled through many variations of the question "Why do you want to know these things?"

Certainly, if I am to write about the city inside of me, it is the inner city and the neighborhoods that cling to it. These are spaces of my childhood. The familiarity and unfamiliarity of places in these neighborhoods swirl around the journeys these stories took me to.

MARK I grew up in Klerksdorp, a town 160 kilometers west of Johannesburg. It was a small mining community. As teenagers, we found it parochial and dull, and all our conversations were about leaving. You knew you had to get out. As a teenager I would occasionally come to Johannesburg with friends. These were memorable days. The journey took three hours by bus. It was a big thing for us to come to Johannesburg, just to spend the day walking around, looking at shops and vinyl record bars, and being in the general buzz of the city. This city was where we wanted to be!

As a young adult I moved to Johannesburg and shared an apartment in Hillbrow. It was fabulous. I lived there and in the inner city at various times over the next decades, steeped in the edgy counterculture of the city. I lived on Jeppe Street in the 1970s, when many whites had fled. There were so many vacant apartments that we had the city to ourselves at night. It was dead quiet. But we had our own alternative communities; we went to clubs that aired an alternative rock culture and emerging crossovers between white and black South African music.

The inner city was a safe haven for subversive cultures in an otherwise repressive city. It was a punk rock scene, it was a gay scene, it was a drugging scene, it was experimental, and it was a place for many who felt outside of mainstream culture to find a sense of belonging. One could at last feel you were "from Johannesburg"—although that is something that is always a state of becoming. In some ways I am still in search of making this city my own.

I was assisting photographers and growing my own practice. I made a living shooting for commercials in an office at the top floor of the Carlton Centre—which was at that stage the tallest building in Africa (sometimes when we came to work in the early mornings, we were above the clouds). But I honed my skills shooting the places I lived and hung out in. I was always attracted to photographing street space or buildings and, more specifically, people in those spaces, making images of what was there in that moment. When I moved to London in the 1980s and started working as a fashion photographer, it was for alternative magazines. I was shooting for hip cultural magazines like *The Face* and *Blitz*—which were responses to austere Thatcherism. They were an exciting breakaway from formal magazines and the formal fashion scene, and they became social commentaries and social documentaries of the time. We were photographing people in the street, we were making clothes, we were not interested in the fashion only but in the people who wore these clothes and who listened to this music.

I returned to South Africa in the mid-1990s, and my practice moved toward documentary photography in various parts of Africa. I was thrust into cultures and places I knew nothing about. The work opened my eyes to the particularity of places. And to informality. I had never seen the scale and everydayness of informality that I encountered in the urban settings of Kinshasa, Lagos, Addis, and Mogadishu. Unbeknown to me, a new informality was rising in my home city in the 1990s. By the time I worked more intensely there in the late 2000s, much of what had seemed particular to

19

"other African cities" was on my doorstep. During the 2010 FIFA World Cup, I photographed stories all over South Africa. It was a welcoming moment when it was possible to cross the boundaries of South Africa's racialized living spaces in an easygoing way. That changed in the years thereafter. Violence and crime have made many parts of Johannesburg complicated to work in. And the surfacing of major identity politics has made us rethink how to work in documenting space and people. *Wake Up, This Is Joburg* has provided access to ways of working in the moment with what is possible.

Across the ten stories, our locating of ourselves and reflecting on our own experience within space and in realties to what we see and hear shifted as we grew more aware that our fascination of worlds we do not belong to is our own, and all that we can own in that are our experiences. Our inclination toward individual stories has challenged us to think about what is generalizable in the experiences of people who share a site, a working experience, a relationship to the state; and what is exquisitely specific to one person. We have considered the ways in which collective energies impact urban space, and each story focuses on one endeavor that a number of people are involved in. But we have tried to avoid assumptions about what drives each person we meet. We have learned that there are as many reasons and motivations that compel and propel people as there are protagonists in these stories.

The Collaboration

The ten stories were developed over a four-year period. Our process has involved walking and paying attention. We have looked, felt, gone back to areas or buildings or people again and again to get closer to what stories they might reveal. We have been attentive to the individual stories behind the policy, research, and creative work we were involved with together or separately. We have a personal connection with some of the places. I own apartments in the Anstey's building, for instance. Other stories are all around us—such as the stories of waste reclaimers.

20

A Politics of Approachability

Our field process involves several visits over many weeks and often months. The work on-site is often instinctive rather than conscious. It is a creative process in which we are not working to a predefined conclusion, but rather giving the work the freedom to be open-ended and to allow the

stories to be revealed in the process. Certainly, the camera and the notebook and our coded bodies allow us to look more closely, to make connections in the city, and to broaden our own access to places that might otherwise seem to be hostile to outsiders.

We access spaces together but differently. The combination of writer and photographer sets up a dynamic for each of us and a dynamic that presents us as a partnership in the site. At the most practical level, we look out for each other, we provide two sets of eyes on any subject, and our dynamic plays out in the chosen social space or setting. In most cases our approach as two white people entering hyper-black space has been met with reciprocal curiosity. People have wanted to talk. They have wanted to know who we are. This has often meant asking where we live and where we were born—people have been fascinated that we are South African, and not foreign tourists "looking" at the city. And they have wanted to know why we are there.

We may begin our work together and may conduct some interviews together, but much of our work is conducted independently at the same site on the same day. Mark will take photographs and connect that way, and I will talk to different people. We have had to discern when to conceal the camera and the notebook so as not to alarm people, and when to lead with the camera and notebook so as not to alarm people. Sometimes our intuition has failed us, and our miscalculation has shut down a potential story.

There's an element of spontaneity in Mark's approach. He usually enters a space with his camera clearly visible. He may even begin photographing as soon as he arrives. "You can't premeditate every image," he says. "There's something about the quickness of time, about instinct, that creates a strong image." These are generally cursory shots taken on wide-angle in public settings. Whether or not he takes photographs immediately, he arrives as the photographer, his camera already communicating what he's there for. This may attract, intrigue, or daunt someone in the space. There is still a negotiation to be set up, but the camera alerts people to what that negotiation is about. At times we are tentative and wait for invitations to enter or talk.

21

Most of the people we have met on this project have been open to photography and to our interest in them and what they do. It is unusual for someone to enter those spaces to simply ask what goes on there, and to be interested in who is there. That acknowledgment alone can provide access and break down suspicion.

Mark offers to give people their photo, and he is reliable about returning

within a few days with the photo. This sets up a ripple effect. If you return as promised, you start to build a relationship of trust with those who were photographed. The next time around you are likely to draw more people in, and more people are engaged and interested in participating in the project. Some people just like having their photograph taken. At the same time the camera creates a certain distance. There isn't as much talking and listening when you're taking the photograph. There is a "hiding behind" and a "looking at" that keep photographer and subject in their roles. And so the intentional talking and listening that I do necessarily elicits different contact with the people we encounter.

I am more tentative about revealing my notebook, and at times I do not take it out at all. I have found that walking into a space with the notebook has at times shut down a story completely. My taking of notes or making observations for a story often requires a lot of talking and listening long before any notes are taken. I have a very clear line in introducing my aim and myself. I always say, "If you want to talk with me, we can talk; and if not, that is fine." I also tell people we can stop the conversation at any time, and anything told to me in confidence will not be revealed in the story. I resist recording conversations because I myself feel awkward and find myself being overly careful about my words if I am being recorded. Instead, I allow the conversation to flow, and I discern when to make short notes and when to pause to get people's exact phrasing. I may ask them to repeat phrases where necessary. When people are willing to talk to me but do not want me to take notes, or when I have not yet secured permission to take notes but have made initial observations, I will take notes in the car as we leave the space.

Several stories are set in places people have appropriated. They may be more or less proprietary about that site. Different people in one site respond differently to our presence. Some may flatly refuse our entry, while others in the same space welcome us, and a discussion excluding us may be conducted about our presence before we can proceed. At times we have been given a message of "I can't stop you from being here, but I don't want you to take my photo or talk to me."

In many cases it is necessary to assess the politics of respectability—to be alert to the site community's social codes of conduct and etiquette. There have been sites in which our primary roles—with one of us looking for visual interest and the other listening for stories—have switched. And for me, there have been times of discomfort of being in hyper-masculine space, where I have felt my presence was not welcome. The edge of the

22

mineshaft where we interviewed several informal miners was the most complicated space for me. My instinct there was to wait for someone to approach me, rather than to deepen the awkwardness of having intruded by trying to talk with someone. Mark, who had previously photographed informal miners and had a greater knowledge of shafts and of their work, was comfortable among these miners and easily struck up conversations.

We have found it is easier to work in a place that is bounded and de-fined, even if it is an outdoor space like a taxi stand. These are places with local social structures, where an explanation of our intention to one or two key persons often opens access and permission for our work.

Knitting Text and Image

The images are both connected to and independent of the text. The two mediums both merge and operate in parallel.

The process of knitting text and image is interactive and takes place throughout the process. We debrief after every site visit; we discuss what we each saw and reflect together on the encounters. This is something we do both after our field visit and a day later, when we look at Mark's pho-tos together. These are opportunities to look closely, to look at things that each of us has noticed on-site, and to think about what the story offers. We spend time going through Mark's photographs; we talk about them; we talk about the possibilities for stories, about characters, about what we think this says that is unique to Johannesburg or not. We are in constant dialogue about the story and the subtext of the story over the months that we are involved in it. And we gather much more material and more photographs than we use.

It is important to us that text and image talk to each other consciously; when readers look through the work, they should be able to tell from the images alone what the story is about. If they read the essay, they should be able to imagine the images without the pictures.

The photographs allow readers to satisfy their own curiosity, to look for more than the text can tell, and to exercise their own interpretation of a space or person. The images reveal that these spaces are not flat. They may be grim spaces, but they are human. The photography highlights the emotional content of mundane spaces. The narratives reflect on harsh realities we access in constrained ways. Within this the photography re-veals the extent to which we are in fact not excluded but are welcomed and allowed to photograph and to talk.

23

The task of paring down stories and photographs is iterative. We are thinking about whether the text and the visual images will work together. In the main, the editing involves the images following the text. Although Mark selects the photographs for the books as he works, the decisions in his final cut revolve around the best relationship between image and text. Because there is limited space for images, and they are embedded in the text and don't sit as a photo essay on their own, there are always some images Mark would have liked to have in there but had to drop. The design of the page similarly follows the text, and Mark participates closely in the design to ensure that the relationships between text and image are maintained in the layout of the stories.

Because the text talks closely to the images, there is little need for captions. This is why we have elected only to caption portraits of people.

In the first edition of this series, each story was translated into the first language of a key protagonist. These translations appear in the original photo books. The translations in the text, which are the innovation of Bronwyn Law-Viljoen, editor at Fourthwall Books, recognize the fact that hardly any of the protagonists in the stories are Native English speakers. And that English is a limited medium on these streets. In many of our interactions we strained to hear the meaning within people's broken English, or were aided by interpreters. The translation of the texts into the mother tongue of a key protagonist in the story recognizes the multiplicity of spoken language on the streets of Johannesburg and that English is only one vehicle for communication.

IV

Urban Johannesburg confronts peculiar contestations between formality and informality, regulation and lawlessness, social exclusion and inclusion, marginalization and access. In expanding the intricate lattice of social relations and transactions, the multiple users of this space introduce and embody a deeply enriched urbanism.

It is in these cracks that Johannesburg's marginalized inhabitants— excluded through lack of income or documentation—are responding to their crises of poverty, unemployment, and lack of shelter through individual and collective actions of appropriating, adapting, and generating infrastructure for living and working. These adaptations of infrastructure occur in the shadows of formal regulation and planning. They might be

survivalist or aesthetic or entrepreneurial. They are creative innovations through which people are sculpting into a city carcass to reproduce and represent themselves, and at times they forge an entirely new cityness.

If you can weave stately embroidery patterns that signify royalty onto a dress made of brash colorful fabric your sister will wear to church in Yeoville, if you can build a castle out of waste, if you can travel forty hours to touch and feel a pink handbag for your customer in a small town in Zambia or Zimbabwe or Malawi, maybe you can make a whole new urbanity.

This is a city of extreme generosity. It is a glorious space for a writer and photographer to work in. There are so many stories. You just have to look. And listen. Despite efforts to be open to learning and to surprise, we did not attempt to be neutral in the telling of these stories. Ultimately these are our compilations, views, and choices of story. The stories use the voices of protagonists, are drawn from close looking, but they are our viewing of some characters in Johannesburg over a short period. And we led with an awareness we were not telling people's whole stories, but only small fragments of their stories as heard by us. These are ten stories we found. There are others. And it would take many more to constitute a batch of stories that might offer a social history of this changeable city in the early twenty-first century.

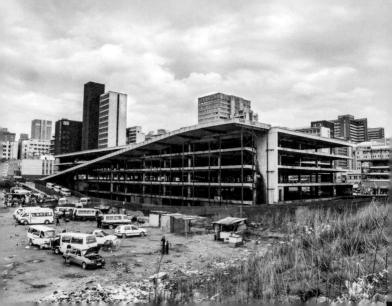

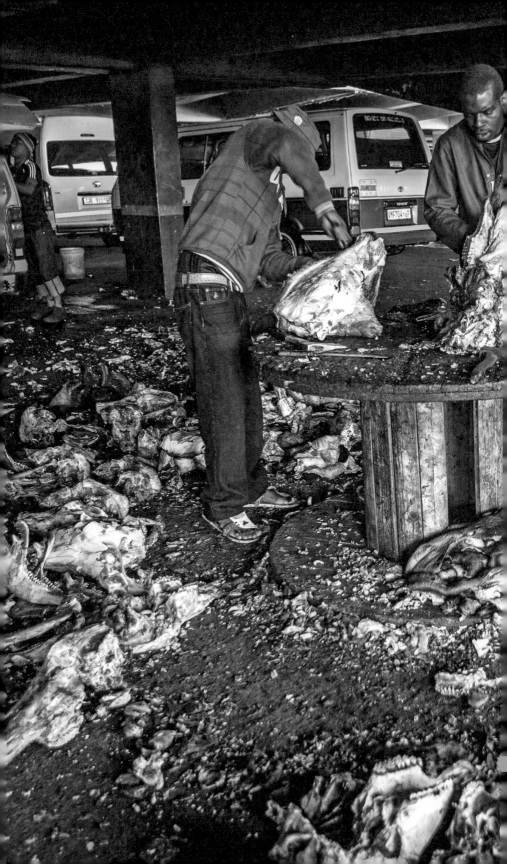

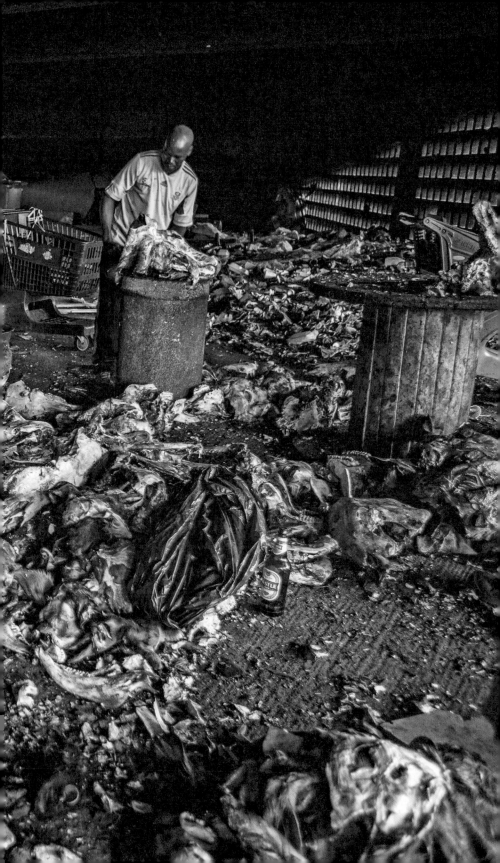

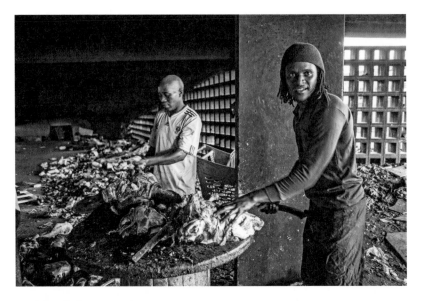

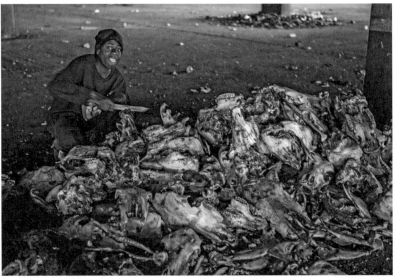

(*Top*) Andile Nkomo (*right*), Kazerne, 2013

Heads

IT'S A QUIET DAY IN THE BASEMENT of the abandoned Kazerne taxi stand. There are no fresh cow heads today, Elizabeth Okahi[1] groans, because on Mondays the abattoir slaughters. This means the deliveries to nearby butchers don't happen, and shopping carts full of heads are not pushed across Harrison Street all morning. So for today her business relies on retrieving the skins from the few frozen heads that are sharing the heat of a smoky fire with a catering-sized aluminum pot. The four fires that heat pots of water and pap[2] both lighten and dim the space. The choking smoke they emit is sucked toward the cavities in the wall facing the street, blurring the thin veil of morning light that doesn't even attempt to enter from this western flank of the building. A man crouched next to the water pot leans over and cuts a few thawed pieces of red flesh to grill over a mound of hot coals.

The ground between the blackened subterranean pillars is uneven. If there was ever a concrete floor, it has long been subsumed under, and reshaped by, the city's dust and runoff and a midden of bone fragments, hair, and skin. These are the traces of the many people who have worked or lived here for fleeting or extended periods since this unremarkable building was designed to accommodate the cars of shoppers and workers in Johannesburg's postwar heyday. The Kazerne building, completed in 1951, occupies most of a city block bordering the station through which scores of commuters enter town each day. The railway divides the city center from

31

1 At the request of interviewees, some names have been changed.
2 Pap is a porridge made from ground maize meal and is a staple food of many South Africans. It is often made in a thick consistency to accompany meat dishes.

the world north of it. The parking garage retains in its name the memory of the first use of this site—the police barracks (*politie kazerne* in Dutch) that housed the officers who oversaw the misdemeanors in a mining town that was never supposed to last.

Now this footprint of temporary abodes and undocumented livelihoods in Johannesburg is a dark concrete cavern with a carpet of debris that crunches, shell-like, underfoot. Here the inner city's best-fed rat colony thrives among the organic leftovers that have not been commoditized in the tight supply chain of cow heads and other animal parts.

Andile Nkomo (whose surname means "cow") says everything here is money. He is the most muscular of the six butchers working on the day we first visit Kazerne, and we soon discover that he is also the most active. But he admits that his output is variable. On those mornings after he has worked as a bouncer at a Hillbrow nightclub, he is not on peak form. "On a good day, I chop sixty heads," he says as he slams his axe repeatedly into one of three flesh-covered skulls being stripped at the wooden industrial cable spool that is the butchers' block. The surface is barely large enough to accommodate these heads, but three other butchers join Andile, and now four bare arms and four axes pummel flesh, fat, and skin in a stampede of blows. As the meat is loosened, it is tossed into gaping bags at the butchers' feet. Elizabeth, who has been heaping abuse on a young man she believes has addressed her disrespectfully, turns her attention to the butchers, watching closely as the skulls and cracked jawbones are flung away from the table, and the skins—necessary for her work—are piled next to the bags of meat. Only the softest skins are good enough for her, and she is as intolerant of tough skins or inflated prices as she is of insolence. Now that she has reminded everyone present of her seniority, she turns her nose up and warns us with a threatening forefinger not to photograph her. It will be many hours and take much deference from us before she drops her pose and volunteers some reflections on this underground world.

Occasionally a butcher pauses to talk to someone or to buy something from the vendor who wanders past with a tray of sweets and loose cigarettes. This mundane exchange reminds me that as remarkable as I find this scene, the cutting of animal flesh is, for many, an ordinary daily routine all over the city. At 10 a.m. some of the butchers are well into the fifth hour of their thirteen-hour working day. They pass beer around. The smell of coal fire, fresh meat, and *dagga*[3] hangs in the air.

3 Marijuana.

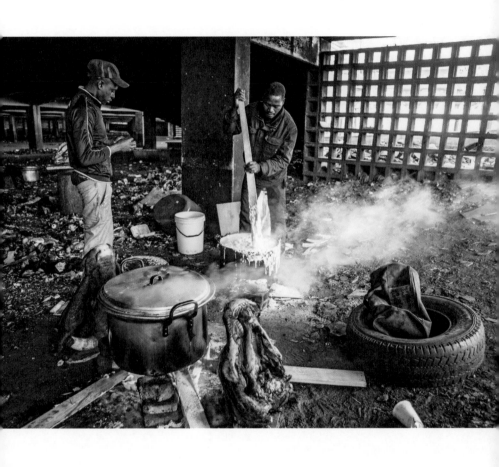

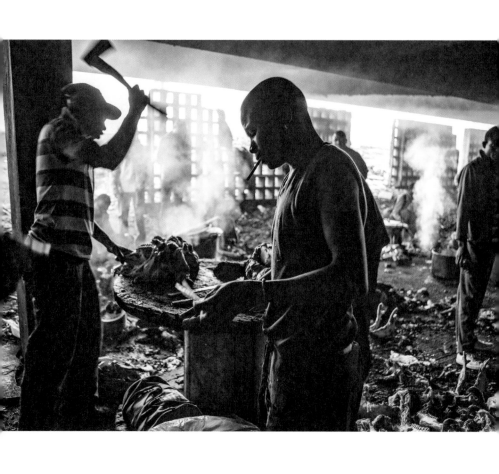

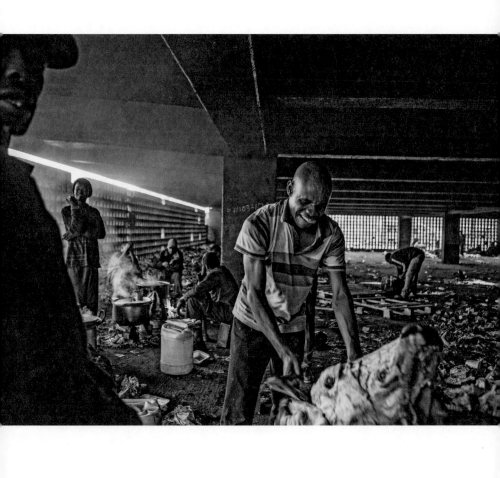

Malusi Ngwenya has fewer customers than Andile. "On a bad day, I do ten to twelve heads. On a good day, thirty," he says. He lives in a crowded room in the inner city, supporting his grandparents and sisters in Zimbabwe on a monthly income of R1,000 (US$70). He is a newcomer to this business and says that when he left his job at a fishery nearby (after the tip of his forefinger was sliced off in an accident and the company refused to help him), he came here, "to my homeboys." He speaks so quietly that I strain to hear him even in the relative quiet of the park opposite Kazerne. He wipes his blood-stained hands on his trousers before sitting down to describe the intricacies of his job. First you remove the skin by slicing the softest parts with a knife. It's easiest to start with the ears, lips, and cheeks. You pull the skin away and put it on a pile "for the Nigerians." Then you break open the jawbone with your hands and slice it away. You loosen the meat from difficult places with an axe and cut the rest of the meat off the head with a knife. The toughest part of the task is to get to the meat that is right up against the skull.

Heads arrive in shopping trolleys. They are bought at a nearby butchery and are sent by customers who will pay R10 (US$0.70) per head for the cutting service. Some butchers cut heads for themselves. They *braai* the meat at a makeshift stall opposite the Metro Mall taxi stand, across the park from Kazerne. A plate of *s'kop*[4] and pap sells for R25 (US$1.70), and each cow head delivers about twelve platefuls.

The various by-products of the butchers' labor make their way all over Johannesburg and beyond. Cow heads are sent or carried in by customers who leave with plastic bags of meat to be cooked at taxi stands on the East Rand, in Alexandra, or in Soweto. In the late afternoon, the bones are collected on a truck destined for Krugersdorp, where they are processed into bone meal and an additive for the making of ceramics.

Elizabeth's runners take the softest of the skins to a hidden location at the edge of the inner city, where they are transformed, with great effort, into an edible form. Elizabeth says, "You know the saying—One man's meat is another man's poison." She says there are cultural differences around food. "South Africans don't eat all the parts and sometimes get angry about what parts we eat. We Nigerians eat everything except the shit of the cow, and even that we use for fire or manure. Go to Hillbrow, go to Times Square in Yeoville, any Nigerian restaurant, they must add skin to the food. We mix it, with fish head, chicken pieces, meat, spices, and rice. Everyone likes it, even Zimbabweans and South Africans. Buy it! It is nice!"

4 Short for isiKop—"the head"—in a hybrid Zulu/Afrikaans slang.

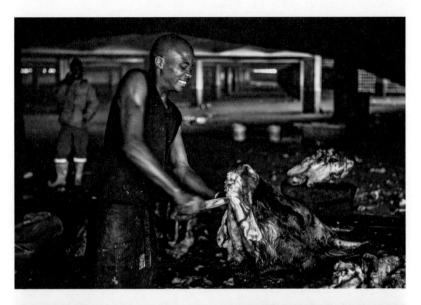

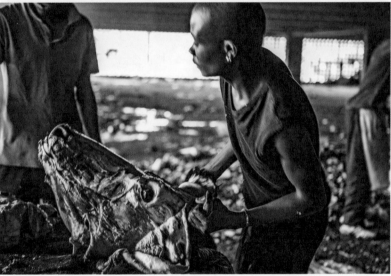

(*Top and bottom*) Malusi Ngwenya, Kazerne, 2013

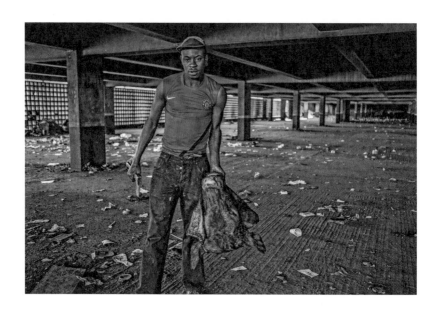

Jabulani Ndlovu, Kazerne, 2013

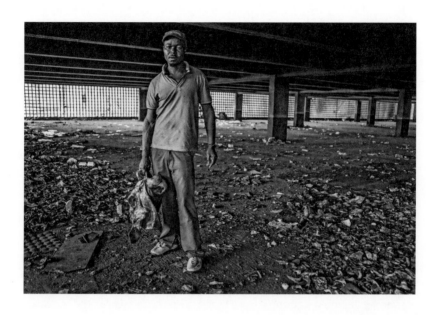

Ntando Ndlovu, Kazerne, 2013

Kazerne became obsolete as a public parking garage in the late 1980s, when "big business" headed out of the city center. Private cars were replaced by long-distance taxis that ranked here. When the gold and the corporates left, the city continued to draw travelers and traders from retail-starved small towns and the countryside, and from elsewhere in sub-Saharan Africa. They filled bags and suitcases with things to sell—clothing, blankets, homeware, cosmetics, and small items such as lighters, nail clippers, razors, and socks—and were ferried from Kazerne to locations along their trade route. But with no signage or infrastructure, and no proper storage for the baggage of commuters and retailers, Kazerne was an uncomfortable and inadequate taxi stand. The building's formal commuter activities ceased, and it became one of the leftover places in the city—a space that soon attracted homeless people and the butchers.

The city's violence spills in and out of Kazerne. There is talk that many who commit crimes—hijackings, muggings, theft—on the adjacent streets escape here. Elizabeth says people run inside to hide stolen things. "The police are moffies," she exclaims, surprising me with her use of the pejorative South African slang word for gay men. "They are too scared to lose their heads, they won't come in here." Indeed they won't, agrees Lisa Seftel, the city's head of transportation. She says city officials won't enter Kazerne because it is too dark and dangerous. There is no lighting in the building. All the wiring and infrastructure has been gouged out of walls and ceilings, and the circuit box stripped. The five-story modernist structure has sweeping ramps encircling a central core that creates a light well in the building.

In daylight hours it is possible to make out groups of men standing around fires, or people hanging washing on the few remaining louvers that are a reminder of the fins once adorning the perimeter walls.

The violence follows those who seek shelter here too. "Last month a boy was killed here," Elizabeth explains. "A man came in and shot him in the head. He said the boy had stolen his cell phone. It couldn't have been him. He was just a boy who hung around here and sometimes helped us carry things."

Lisa says the building has been so damaged by fire and by the pilfering of concrete, metal, and wiring that the structure is unsound. The city has given instructions for Kazerne to be demolished within a few weeks.[5]

5 Late in November 2013, weeks after these stories were captured, the Kazerne parking garage was demolished. A few butchers set up a table close to an informal taxi stand next to the remains of Kazerne and tried to continue their trade outdoors.

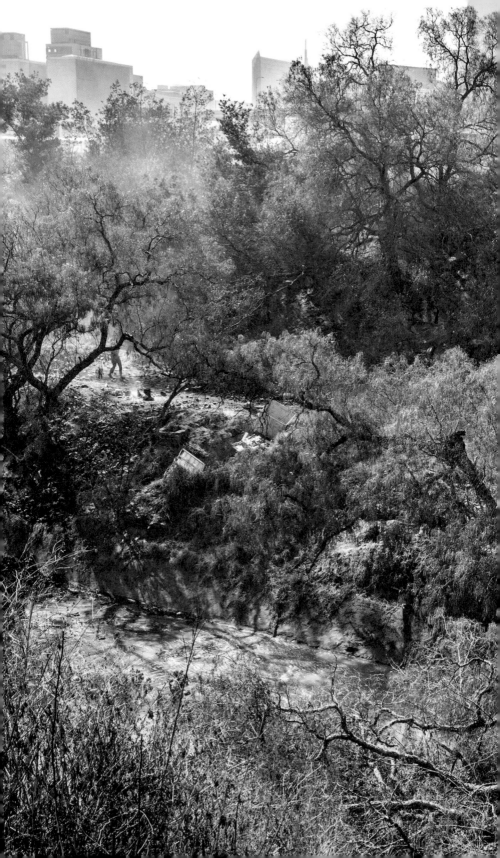

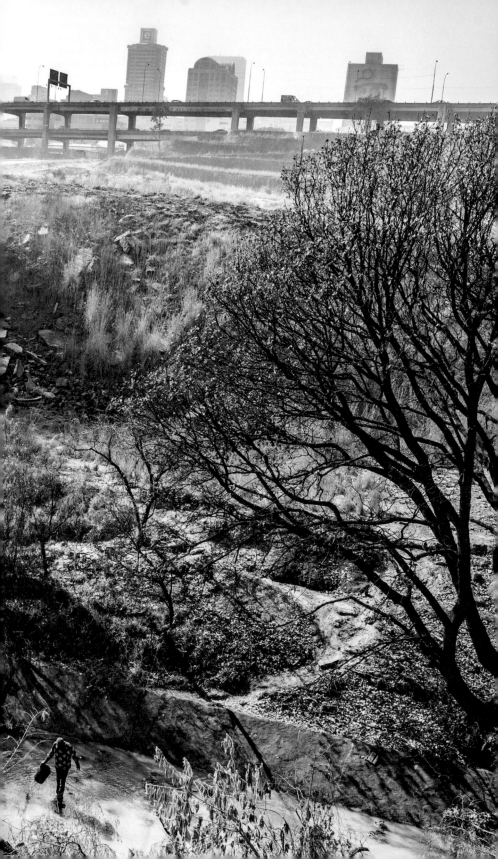

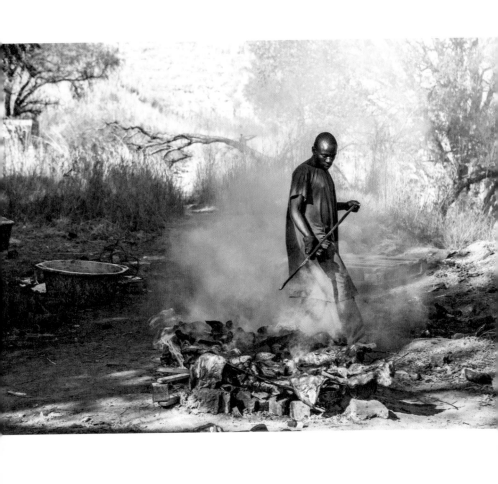

Elizabeth, however, doesn't think the building is dangerous. "In South Africa they used to dig deep when they built buildings," she remarks, as if the age of construction is past. "This one will stand, it is not like the buildings we build in Nigeria."

Skins

The Crown Interchange is the most dramatic decision point in the city's freeway system. Here the M1 north-south meets the M2 west-east, and each of the multilane ramps that plait across one another directs you to a different and unique portion of one of the world's most segregated cities. From here you can access the most prosperous or the most economically deprived areas in Johannesburg.

The interchange squats on a mine dump and meets the high-rise buildings of the inner city at waist height. A small mining headgear south of the interchange holds out against the passage of progress and decay. It has not yet been recycled in a city where all the metal can be hacked out of the carcass of an entire building in a single night.

The western arc of the highway forms an amphitheater of concrete reinforcements that sweep downward toward the leftover land—*uitvalgrond* in Afrikaans. Whether through contamination, undermining, or half-finished developments, this is a desolate moor of bushes, trees, and yellow dune sand.

The natural sounds in this low-lying plot are not the familiar pigeon cooing of the inner city, but the shrill singing and urgent calls of wilder birds in the grove of 120-year-old pepper trees. These hardy trees are known to repel flies—an important consideration in a desolate mining town where horses were the main form of transport. They now flank a body of water that to the ear is a gurgling river but to the nose and eye a murky canal flushing out of stormwater drains and heading under the next dump, perhaps to reach the Klipspruit reeds in an effort to be cleansed, perhaps to join the seeping acid mine waters that are threatening the city's groundwater.

In this forgotten landscape, a plume of smoke rising between the trees is not something anyone would pay much attention to. A passing motorist might attribute it to the smoke from a homeless man's early morning fire. But at sunrise, in the shadow of the pepper trees, men stoke fires; boil water; and scorch, soak, and scrub cow-head skins.

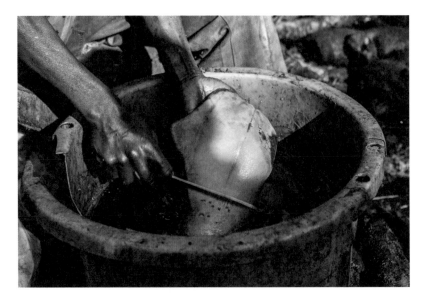

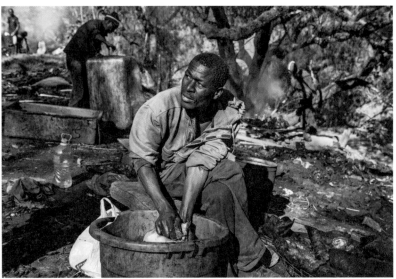

(*Bottom*) William Nathe, 2013

The clearing smoke reveals a man standing over a raging coal fire that rises through a metal spring bed base. This grill accommodates about thirty skins. Another man, in ankle-length red tunic and clay-colored pants, uses a six-foot pole to turn the blackening skins. After half an hour, they are ready to be handed to his companion, who has been boiling water in a tin drum. The skin washerman uses a sharp knife to scrape the cauterized hair from each skin before placing it in the boiling water. He then takes a wire brush and laboriously scrubs the skins in a basin of water that quickly turns grimy and gray, to remove the hair and dirt and reveal the yellow fatty-colored rubbery texture beneath.

William Nathe, who sits some distance away, works alone—sourcing, cleaning, and selling skins. He sells less working solo but prefers his independence. He says these men are working for the "Nigerian boss lady." They are paid about R70 (US$4.80) per day. His customers are butchers and others who sell on to people cooking in Hillbrow, where you can buy a plate of Nigerian food for R10 (US$0.70). "I sell to wholesalers," William explains. "They want to give me R100 [US$7.00] for sixteen head skins, but I try to sell each skin for R20 [US$1.40]." He is comfortable working alongside the men who were his coworkers and describes himself as fitting in anywhere and nowhere. He thinks of himself as Zimbabwean even though he has lived in South Africa most of his life and his mother was South African.

William says people from West Africa eat skins: "Those from Nigeria, Ghana, and Cameroon all know this food—this *kwassa kwassa*. There are too many people in those countries. One cow won't stay there! It's like this: in Nigeria if I could do this work, I could have a double-story house and five wives. Like Jacob Zuma!"

Money

Back in Kazerne, Elizabeth maintains that although the eating of skins may originate in West Africa, this hidden skin-cleaning business is an innovation born in Johannesburg. In Nigeria the cutting, cleaning, and selling of skins is a normal part of the butchery chain, and so skins are sold, formally or informally, alongside other meat. "It is normal for the butcher to cut skins in Nigeria," Elizabeth explains. In Johannesburg, five Nigerian migrants saw the opportunity to create a skin-preparation business. Elizabeth says she and others learned from them. "Now we employ Zimbabweans to clean the skins for us."

Elizabeth underplays her entrepreneurship as a mere survival strategy: "We do this work because we are looking for a job to survive. The job you know is not like the job you don't know. If I try, I try what I know. We just try to see what we can do for a job." Her goal is simple. "We know why we are here and why we work so hard: to send money home. Even in Nigeria, people think we are getting easy money in Johannesburg. But it is hard work."

Nor has the route been easy. Elizabeth describes how she spent two months in Sun City[6] because her partner in the business arranged to have her arrested for trading in skins. But she also beams with the success of her achievements. "I feel like Mandela," she says. "I give people the freedom to work here."

William agrees. He says he watched Elizabeth. She started off cooking skins, then joined her boyfriend in the cleaning of skins, and later took over the business on her own. "That lady helped us. When we saw she could do it on her own, some of us also tried for ourselves. I was working for her boyfriend, but when she left him, I also saw that this was money."

The taxi stand, the bushes alongside the highway, and the park are not ideal places for preparing or serving food. The clandestine locations offer precarious protection from city health officials. Elizabeth wishes for a place where this business could be normalized. "People need a place where they can buy this food, a place that is clean. They should build a big market. If we had that, people would buy from clean stalls. But now we are being forced to do it in these places." She has moved around the city with her band of skin cleaners. She points in various directions. "We have been up there, they chased us away; down there, they chased us away."

William says he is always on the lookout for the metro police, who have in the past razed the entire operation to the ground. But these days the threat seems more benign than the wholesale burning of the business. "The metros stop us," he says, "but they just say they want R100 [US$7] for cooldrink. It seems they are always thirsty. But R100? I don't know what cooldrink they buy."

And what if Elizabeth's business is moved by the authorities again? "Ah, if they move us, we gonna find another place," she smiles.

6 A prison located on the outskirts of Soweto, colloquially named after South Africa's most famous luxury pleasure resort and gambling mecca.

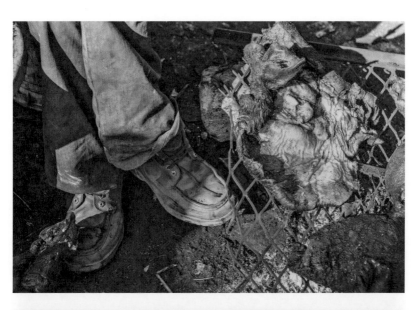

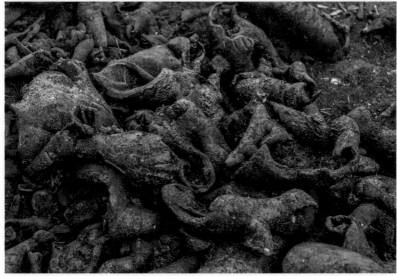

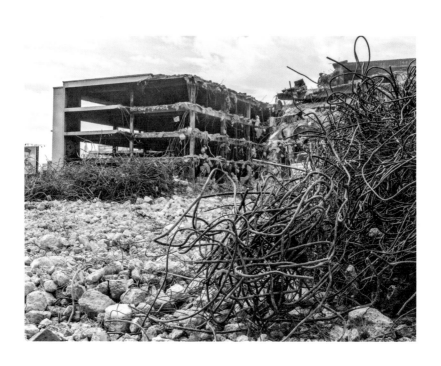

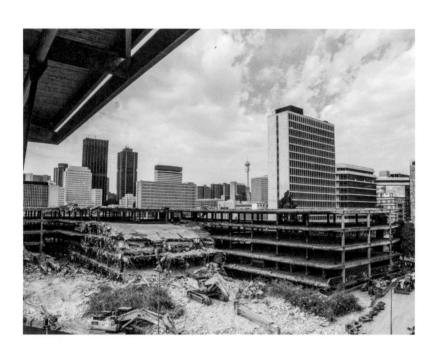

Tony Dreams
in Yellow and Blue

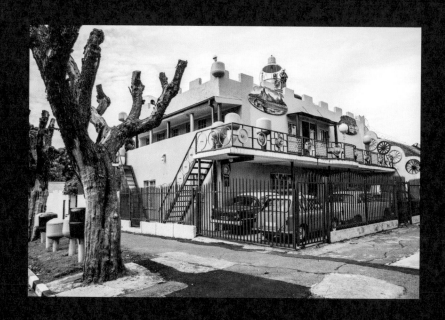

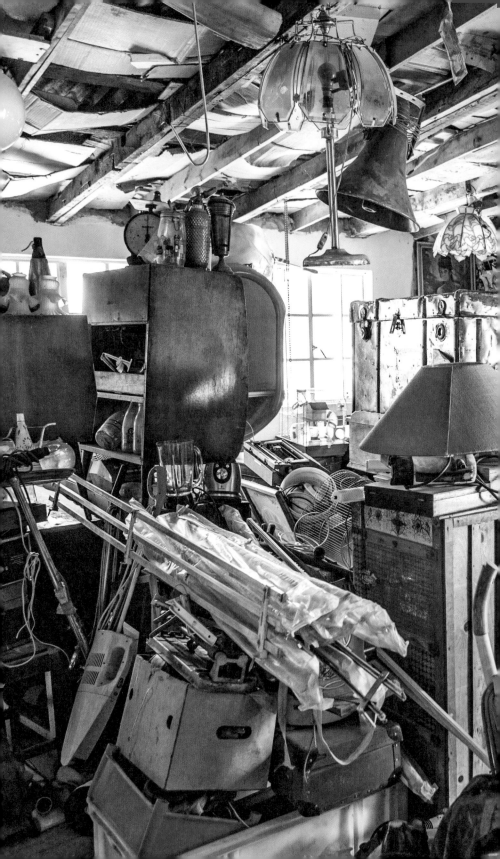

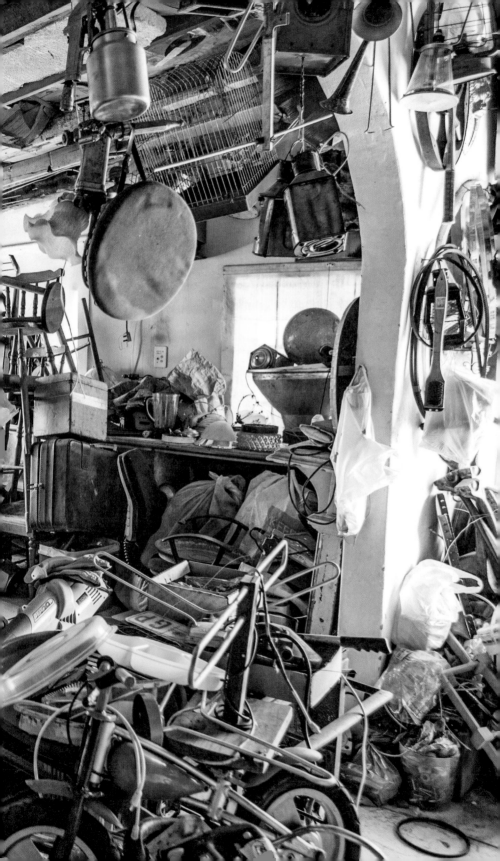

Tony Martins, Kenilworth, 2014

The Outside

HE HEAVES HIS BODY against the yellowing plastic disc that covers the hole at the top of the uppermost and ninth staircase in the house. The staples securing the disc pop under his weight, and I gasp, "Don't break it." But Tony says, "Ag, we break it, we fix it."

As we pull ourselves up to the small platform above this house of surprises, the feeling that we are ascending, childlike, to an enchanted land returns. It's a tight squeeze. We have emerged into a yellow birdcage, a gazebo-like turret that Tony says can seat six, but five of us—including a manikin dressed in mock spy gear—are craning around one another to see out. Miraculously, a small concrete table also fits into the space. Tony picks up a handmade wooden rifle from it and places the weapon under the manikin's arm to complete the outfit of jacket, black wig, dark glasses, and hat. "Sometimes he is my guard," Tony laughs, "but now he is off duty."

From here we can see the skyline of Johannesburg's Central Business District, still called "town" by many of its residents, even though the tower blocks further north are the real financial capital of the city now. Over the manikin's shoulder, we look eastward, to Rosettenville's mix of compact semidetached, single-storied housing; squat apartment blocks; and even more tightly packed narrow row houses. Their red roofs stand out against a patchwork of corrugated iron and plastic sheeting held in place by bricks and tires. These are the tops of backyard structures in the suburbs of arrival for new city entrants, suburbs that were first established for artisans in the employ of the earliest gold mines of the city and that continue to accommodate migrants with skills to sell. The view of housing and tree-

lined streets extends westward to the mine dump that disrupts the suburb of Turffontein. If the day were clear, we would see the edges of Soweto.

The turret sits above the third level of Tony's house, only two stories of which are visible from the street. He has lived here for over two decades and has gradually and tirelessly transformed the house from a nondescript cottage on the corner of Sheffield and Bishop into an improbable castle with a tooth-like parapet edging the top floor.

The evidence of the challenges of extending and decorating the house incrementally is everywhere. The second-floor balcony has a bright yellow balustrade made of carefully placed and not-so-carefully placed wheel spokes, tennis rackets, squash rackets, and patterned cast-iron screens. This elaborate filigree is one of many features fashioned from found objects that Tony has restored, remodeled, or repurposed.

Two human-sized plastic beverage bottles share the garage roof with a boat, a large windmill attached to a chemical drum, and a vintage moped driven by a Michael Jackson–lookalike manikin that Tony and his wife Orlinda have named after their son who lives in London. At sunset the front and rear lights of the moped and the line of large blue spheres edging the roof all light up. The yellow walls and the friezes around the property are illuminated too, and spotlights focus on a large mural of a Madeiran coastal village with a color scheme that might have been the inspiration for Tony's house. Wigged, bespectacled manikins on a dome on the roof and on the balcony look over into the courtyard.

The Lounge

"I paid R40 [US$3] for this Jesus," Tony says of the gold-sprayed statue that watches over the lounge from a marble plinth. "He is made of concrete, but he had copper-plated covering. He was stolen because people thought it was solid copper. But they saw it was just a thin layer and threw the statue away. I paid guys at the dump and sprayed it gold." Tony is incredulous that people throw away things that are still functional or easily repaired. He picks up a gold figurine that stands half a meter high; he places a clock and pendulum in her right hand. "See this? The hand had broken, but it was all there; it just needed to be glued. Someone threw it out, and I took it and fixed it." He points to one of several mirrors in the lounge: "I found this mirror frame at a dump. It was in nine pieces."

Tony says the house was "small and rotten" when he bought it in 1990. "It still had wooden floors and windows, and had probably not been reno-

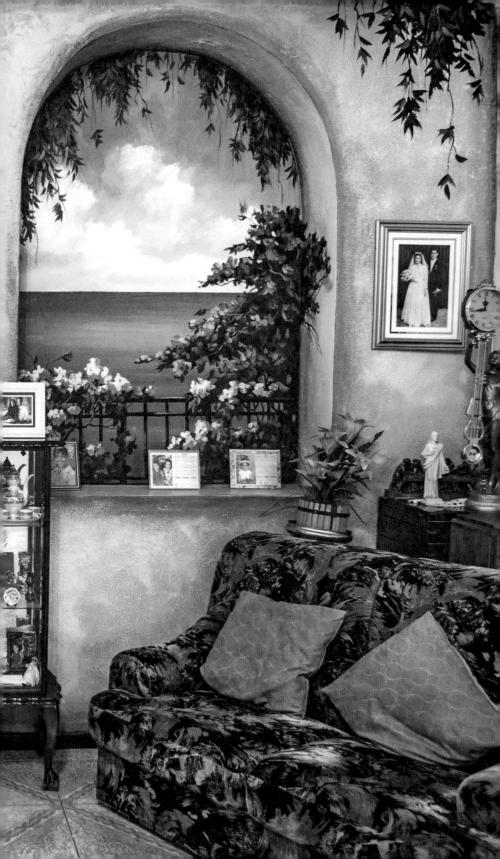

vated since it was built in 1924." He stripped and rebuilt the house almost singlehandedly. "My wife and I put the lounge ceiling in ourselves," he says. He puts his arm around Orlinda as he points out the many objects he has made from discarded items. The friezes in the symmetrical archways of the lounge wall frame the couple. Matching the outdoor mural, these scenes too are "from pictures we took in Madeira two years ago. I got a Russian guy to do them."

A carved elephant tusk hangs above an old radiogram. "I picked it up at a dump. It was broken in half; I glued it together." Of an object on the verandah, he says, "I got this pink buck from a nightclub that was throwing it out. It's a reindeer, but I put springbok horns on it. Wherever I go, I look for things. I stop at scrapyards or secondhand shops. I look at what they have. I look at things; I think about what can be done with them; I get ideas. I buy things and fix them." The pasted edges and rough finishes of the completed pieces reveal that the point here is not completion or resolution but to keep creating, and to compel things that don't fit together to meet. If the end result functions and it looks good, it's a success.

The South

Madeira may seep through in the colors, images, and traditions of the house, and Orlinda's language does not venture far from her native Portuguese, but Tony and Orlinda maintain that Johannesburg is home. They do not often venture far into the city. "I go to the dump every weekend. I take my wife. She is in the house all week, so on the weekend, I tell her, 'Let's go.' We go to the same dumps, on Saturday and Sunday, the ones around the south." He uses the generic term for the old suburbs that their residents define by their not being the affluent northern suburbs. Everyone knows that "the south" evokes a working-class, down-to-earth respectability, and a toughness born of not having things the easy way. Tony's journeys are to the old south, where the city's transformation from all-white suburbs to predominantly black neighborhoods is most pronounced. Here diversity is not an exotic option but a way of life as people get on with making their livelihoods alongside and among multiple cultures. Nigerian, Congolese, and Brazilian Pentecostal churches located in defunct department stores, small shop fronts, or repurposed synagogues compete with traditional Catholic and Anglican churches for souls. Francophone Africans converse in their mother tongue in bars and hair salons, and Nigerians can follow their soccer teams and familiar music in exclusive pubs. Newly

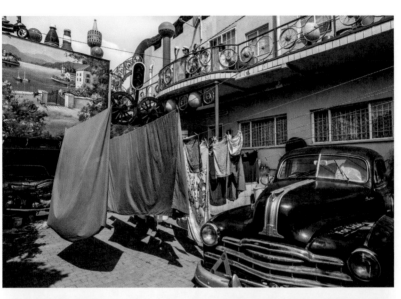

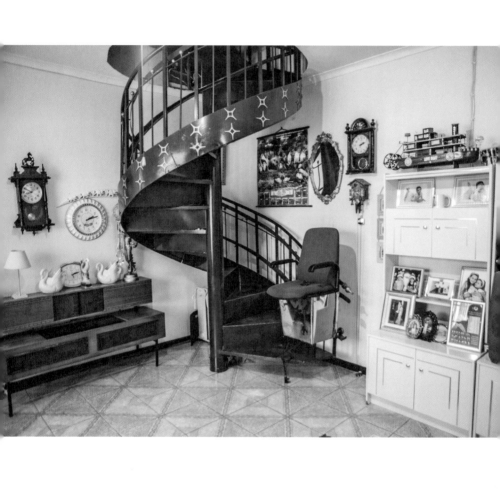

arrived Mozambicans can navigate the job market among Portuguese business owners, without having to learn English. Incrementally and without design or intervention, then, expressions of multiple ethnicities become part of the grid-patterned streets and the low-rise, compact housing and apartment blocks.

The Room

Tony turns to the strangest object in the lounge. "I got the steel pillar in a scrapyard, and I built these steps from scrap." He points two finger stumps (an accident on the railways, he later explains) toward a spiral staircase that rises from the lounge to the second floor and then to the roof. It is a staircase with promise and romance—a motorized chair is attached to its handrail.

But the chair isn't working, and it is a complex climb navigating the curves of the staircase and the piles of vinyl records and old toys that litter the ascent. These signal something different from the orderliness of the ground floor. On the second floor, we step off into Tony's storeroom. It is a room of accumulations more than collections, of uncountable piles of found things. Nothing has been tenderly placed. Rather, each object seems to have been tipped into the room, there to fend for itself. The exotic, the ordinary, the valuable, and the worthless are piled in no particular hierarchy. There is no standing room, and we stumble behind Tony through mounds of clutter. He shoves suitcases and trousseau chests aside and tries to extract a special car radio from a tangle of wire, or lift a dusty mattress to reveal a public telephone booth. Tony admits meekly that the mess of this room often overwhelms him. "Ai ai ai, this is too much," he says. "I would like to sort it out. Put this here and that there. But how?"

It proves impossible to list comprehensively the items heaped against one wall, whose purpose is to remind a prolific outsider artist that no creative ideas should ever be left stranded. There are paintings, tins, buckets, a baby pram, a plastic headboard mold, radios, birdcages, a gramophone, a combat helmet, a teacup, a beach umbrella, three kitchen chairs, suitcases, plugs, a press drill, a watering can, a door, a rake, an empty casing for a movie screen, three old projectors, two typewriters, a few circuit boards, odd shoes, and a Morse code radio that announces, "This will float." 65

Rooms for Rent

Above this story, and beneath a large blue canvas sheet, is a series of rooms constructed of drywall. One or two have been insulated with egg boxes. Tony says he found all the building materials used to create the labyrinth of rooms that he rents out to singles and couples. Behind his garage he has constructed another thirteen rooms, and this 550-square-meter site houses thirty-four people. "They are from all over," he says, "from Zim, Mozambique, Botswana, and Durban." These rooms represent Tony's entrepreneurial response to a housing need in the southern suburbs of the city, where migrants have generated a new rental economy in the backyards of established houses. The demand is overwhelming, and single rooms with communal bathrooms in Turffontein easily fetch between R1,000 (US$70) and R1,500 (US$104) per month.

The Unstoppable Projects

On the day we visit, there are multiple projects on the go at Tony's house—additional lighting wired to the moped, a car door repaired, a radiogram fitted with large speakers extracted from a vintage piano, and the body of an old motorcycle sprayed blue. Tony admits he cannot stop himself. "I don't sleep, I dream of things. I think of what I can do with things I have found. I sleep for two or three hours, and then I wake and think what else I can do. Then I have to do them in the day. I am always thinking. It's my imagination. Every day I get ideas. Yesterday I had the idea to get the painter back to paint another mural."

Tony's designs are not delicate, and many are characterized by appendages of grease and wire and metal. His obsession is not perfection but production. Whether it is a bolt that needs to be shaved and forced into a space it wasn't intended for, or a turntable attached with insulation tape to a set of speakers and inserted into a walnut cabinet that is patched and nailed together, Tony delights in the outcome. "It works!" he laughs as he forces the vinyl record onto the makeshift spindle and Peggy Lee croons from the back porch. "Don't worry, we'll put a piece of plastic on it," he says when I express concern that the rain may ruin the wood of the vintage cabinet.

67

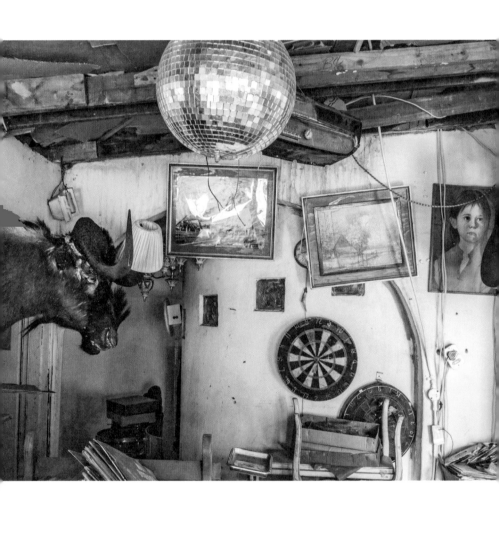

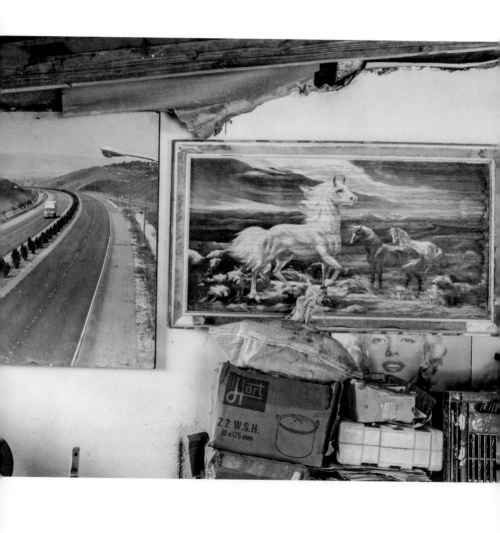

Orlinda's Domain

Orlinda doesn't mind Tony's preoccupation with making things. Nor does she mind the chaos of the second floor. She says she is pleased that Tony is always busy. Domesticity happens in and among the creations. Laundry is strung across the back courtyard and brushes over vintage cars as Tony and his auto-electrician friend John, or Fernando, his employee of five years, weave among the sheets and shirts carrying engine parts, welding metal pipes together, or washing greasy bolts and screws in their search for a good enough fit for a gear stick they are assembling.

But Orlinda has her domain. The ground floor of the house is the living area, and while the lounge sports many of Tony's creations, including seven clocks, multiple repaired statuettes, three radios, and several lamps, these are secondary to family photos, soft furnishings, and an orderly display of sentimental memorabilia.

A shiny white, tiled floor, spotless white surfaces, and neat lace curtains structure the cooking and eating space of the house. The kitchen's clinical absence of clutter is broken only by a colorful poster of *The Last Supper* on one wall. The main bedroom is just as neat. The soft blue of the walls is the same shade as the curtaining and linen and provides a sense of seamlessness in the room. A wooden rosary with a crucifix is centered over the bed and framed by matching pictures of the Christ figure above the identical bedside tables. The room is a calm, minimalist respite, in sharp contrast to the Tony-places of the home.

Tony's Photos

As we sit in the kitchen, Tony recounts the seminal moments of his life like a history lesson. "I was born in Madeira in 1940. I married in 1964. In 1966 we came to LM.[1] I worked there as a builder until 1970. In 1970 I moved to Rhodesia,[2] where I worked on the railways. After ten years, independence came, but we stayed there. In 1990 we came to South Africa."

He picks up a photo album. "I like to make things, to be creative, to show my knowledge a little bit here and there," he says casually as he shows

1 Under colonial rule, the capital of Mozambique was Lourenco Marques (now Maputo).

2 The unrecognized successor to colonial Southern Rhodesia, this state existed from 1965 until Zimbabwean independence in 1980.

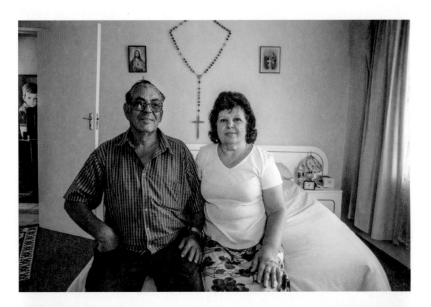

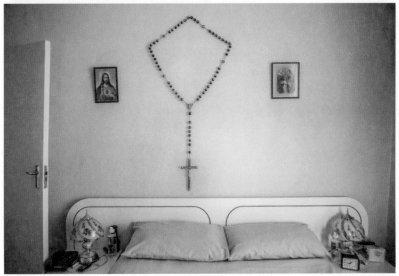

(*Top*) Tony and Orlinda Martins, Kenilworth, 2014

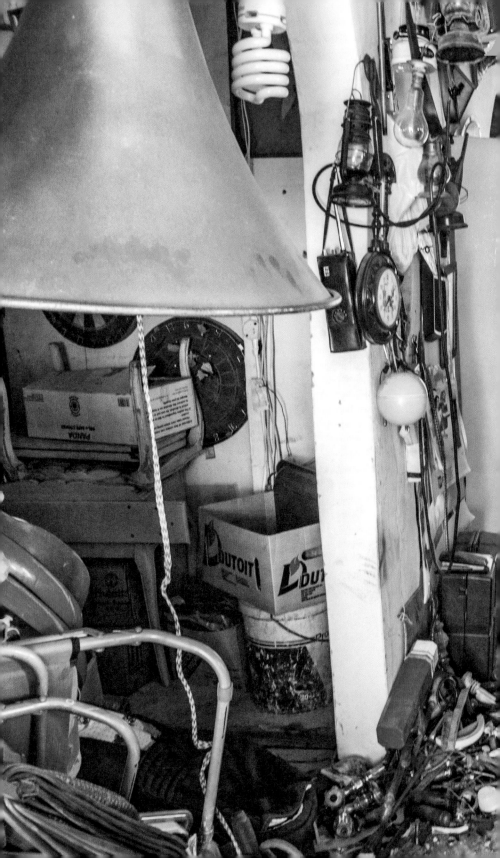

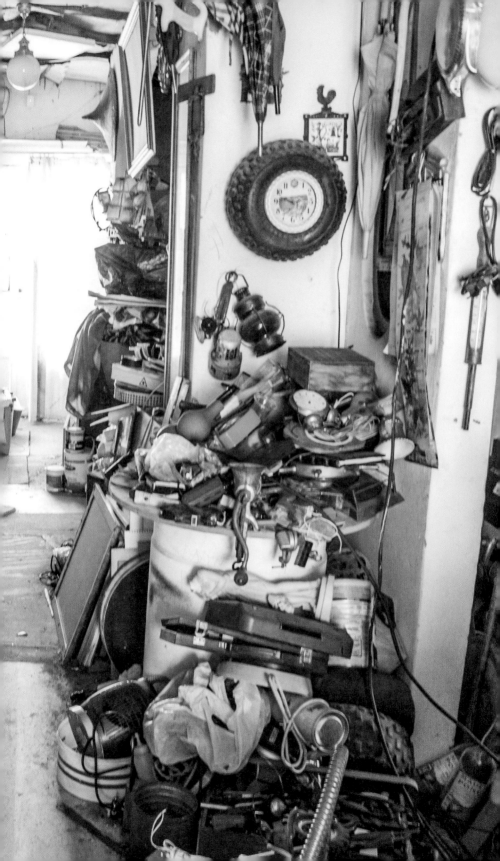

us pictures of retro couches made from the backs and fronts of cars. He holds up a photo of a small train he built for his children to ride on in the back garden of his home in Rhodesia. He used a piece of railroad track, wheelbarrow wheels, and a motorbike engine, and "it worked!"

Also in the collection is a photo of the first house that Tony built, a cottage in a village in Madeira. He says he built it when he was courting Orlinda in his twenties, because "her mother wouldn't let me take her until I had a house to live in." He puts his arm around Orlinda. "Forty-nine years we've been married. Look at her, she's sixty-eight, but she looks forty-eight!" Orlinda smiles coyly as he licks her forehead.

The Cars

Ten cars occupy the parts of the property not built on or being used as pop-up workshops for Tony's projects: A 1938 Chevrolet and a 1946 Pontiac. From the 1950s, a Plymouth Savoy, a Mercedes, an Austin-Healey, and an Opel Olympia. From the 1960s, a Wolseley, a Peugeot 404, and a Holden Special. The current family car is a more recent Nissan Sentra. And then there is the 1933 Austin 10 that Tony temporarily displayed in his lounge—by replacing a wall of the lounge with a sliding window—"just to surprise my son when he visits from London."

The seats of the Peugeot 404 have been removed and are lying in the front courtyard before being taken away to be upholstered. This car has special significance, and while its restoration, like many other projects around the house, is incomplete, this is Tony's premier project. When Tony and Orlinda got married in Madeira, they arrived at the church in a car just like this. It was a canary-yellow taxi with blue racing stripes. Tony has sprayed the Peugeot yellow and is remodeling it as a replica of the taxi. For their golden wedding anniversary in a few months' time, they will travel to a party venue in this car. For now, however, the boot is filled with old tools and things Tony couldn't find space for in his storeroom.

76

The Neighborhood

Beyond the sliding gates between this yard of cars and the public road, we look onto the sidewalk that wraps around the corner of Sheffield and Bishop. Tony has been active here too. The lollipop structures standing to attention along both lengths of the house are old swimming pool filters that he has attached to poles so that they resemble the clipped hedges of

(*Top*) Tony Martins, Kenilworth, 2014

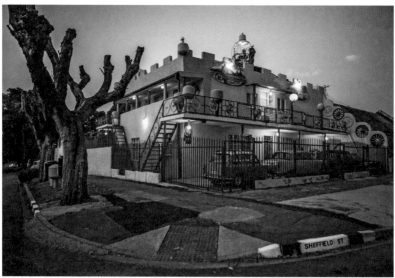

the northern suburbs. He feels that this is a "respected" portion of sidewalk. He leaves an old car out there and has had no threat of theft.

Across the road, a gray, warehouse-type building with small windows near the roofline defies the residential zoning of this working-class neighborhood. Tony explains it's the storage space for a pet shop, which illustrates a tolerance of land use and densities in a suburb where informal churches, *spaza* shops,[3] hairdressers, and *shebeens*[4] occupy front rooms and backyards. This is one way in which such neighborhoods adjust to changing social and demographic patterns in the post-apartheid city. Here there are no high walls to screen residents from their neighbors or from on-street or on-site activities, and living space is not distinct from spaces where livelihoods are made. Predictability is the only thing you can be sure is absent from this part of Johannesburg, and fortunes may go either way. One might even turn one's home into a castle.

As we leave the house, Tony and Orlinda climb into the family car and reverse out of the driveway to the tune of "Für Elise." Tony laughs, "It only works for the reverse!" he shouts above the loud music. "It's a gadget I bought. Made in China I suppose."

3 Small shops operating from private residential homes, typically selling food, drinks, and groceries.
4 Taverns selling alcoholic beverages and operating on private residential property.

Inside Out

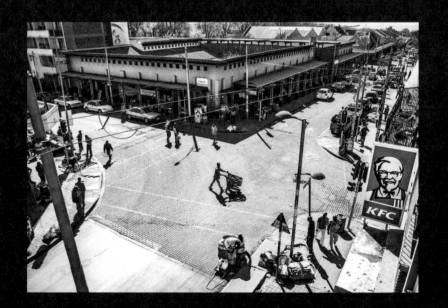

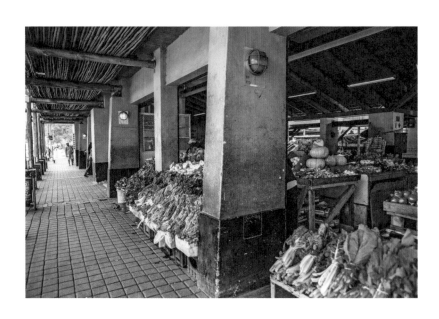

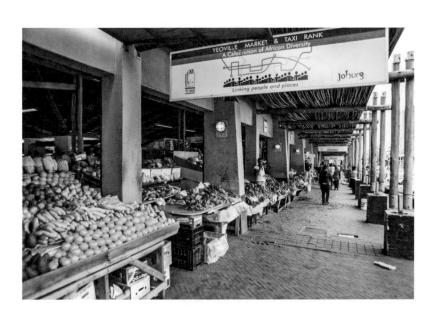

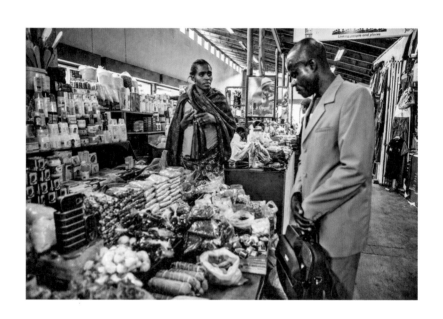

Senga Mutombo (*left*), Yeoville, 2014

Coming to Johannesburg

"I LED MY SEVEN BROTHERS TO SOUTH AFRICA." Senga Mutombo's impressive opening line is an understatement, for her mother (who never reveals her name but says, "Call me Mama Senga"), sister, and daughter were also among the ten relatives who followed the twenty-three-year-old to Johannesburg. The expedition happened some time before Senga joined the Congolese, Nigerian, Ghanaian, Angolan, Ugandan, Kenyan, Zambian, Cameroonian, and South African stallholders in the Rockey Street Market. The migration showed remarkable solidarity in a family characterized, above all, by the powerful individuality in its ranks. The outspoken relatives, who now range in age from sixteen to fifty-seven, but who, thirteen years ago, included toddlers and few kin of employable age, seem an unlikely group of people to pack up and readily follow the cue of one member. It would no doubt have been a hotly contested decision. Each would have been encouraged to express their feelings and opinions, to hold nothing back— "say exactly what you feel"—so that when the move was made, no one's misgivings or hopes would be unknown to the others.

Without their father and away from their homeland of the Democratic Republic of Congo (DRC), this family would leave the security of a Zambian church community and go with their eldest sibling to Johannesburg, where the only certainty was that nothing would come easily. Daily survival would be a struggle of physical labor, and the city streets would be dangerously poised against their dark skins[1] and strange tongue. For years

87

1 The end of institutionalized racial discrimination in 1994 has not brought about
 racial integration or stemmed racial inequality. Black South Africans' ongoing dis-

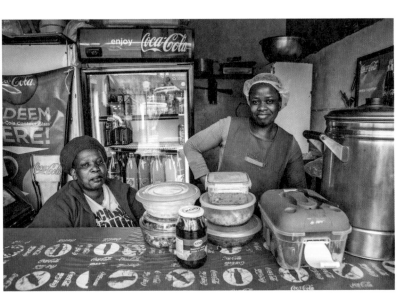

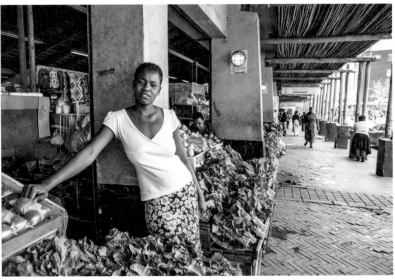

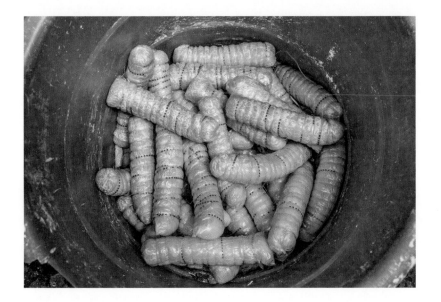

they would have to carry papers to remind themselves—and any bank clerk, police officer, or other petty bureaucrat—that they were not immigrants, but refugees. More accurately, they would be termed "asylum seekers," living without status for as long as the state machinery wished to keep them in that limbo.

In Johannesburg, there are many layers of legitimacy. You might find yourself caught between being legal and illegal, depending on where you were born, what languages you speak, what skills you have, what products you sell, or where you live. Like Senga, you may live here for over a decade, have children born in Johannesburg, but still be considered an asylum seeker who does not qualify for a bank account or a travel document.

Senga's Stall

Arranged on the two tiers of Senga's stall in the Rockey Street Market are foods and oils unfamiliar to native Joburgers but as familiar as their own

advantage and frustration over their lingering lack of access to opportunity is often directed at those who are not "citizens" of South Africa. Also, in a complicated politics of "othering," skin tone remains a key identifier and the basis of suspicion—and consequent prejudice and discrimination—of South Africans toward fellow Africans.

language to those who have crossed half a continent to be here. There are varieties of beans from Malawi and the DRC, palm oil from Ghana and Cameroon, spices from Nigeria, Mopani worms and dried fish from Zambia. Face creams and antiseptic lotions from the DRC, Côte d'Ivoire, and France confound the description of this and other kiosks as "vegetable stalls."

Each product carries a tale of a journey from a place that people have left behind but that lingers in the unknowable dreams in this market. When Senga talks of the DRC, she enunciates each word slowly and deliberately and simultaneously pokes my upper arm with her forefinger as if to inject her teaching into me. "It-is-the-richest-country-in-Africa," she says. "Everyone-wants-its-minerals. If-we-can-only-work-together-there-is-no-better-or-stronger-country." She withdraws her hand, and her tone drops. "I am so, so sad for my country."

Senga sits down on a bucket next to her stall. She negotiates in French for a long time with a customer. "She is a good customer. From Cameroon," Senga explains when the woman has left. When she is not dealing with customers or suppliers, Senga is talking spiritedly with other stallholders, who also manage their stalls single-handedly, armed with small notebooks, scraps of paper, and at least two cell phones. "We talk trader language," she says, "about where to source cheap things, about money, about prices, and about quality."

There is little variety here: many sell identical products, and traders complain of the tough competition. Senga says, "If someone has something different to me, I buy what I want when they get their stock. And if my stock arrives, they all come and look first and grab something."

The Rockey Street Market

Within a few paces of the food stalls are men repairing shoes or making shirts, women pounding cassava, braiding hair, or beading hats. Or selling fabrics. Vertical platoons of material parade on wire across many stalls. These wax prints are veritable experiments in color, designed in factories where nobody doubts that green and blue can be combined or that pink and red work well together. I pick out green and white hearts on an orange backdrop; rust and cream spirals; blue and burgundy berries and leaves; orange, black, and yellow checkerboards; gold and black fans; magenta and green fish; dancing stars, bolts, birds, and leaves; and pink and yellow zigzags.

The covered but not enclosed Rockey Street Market is porous, allowing views into and out of a building of green pillars and few walls that is

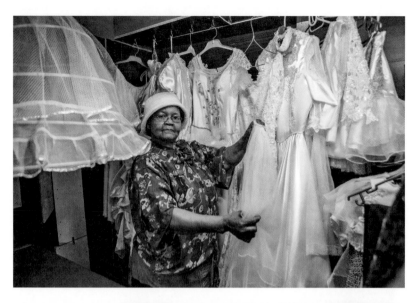

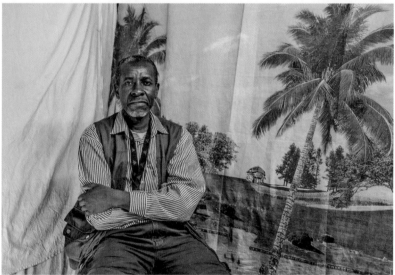

(*Top*) Pileng Mokoena, Yeoville, 2014
(*Bottom*) Philippe Kadilu, Yeoville, 2014

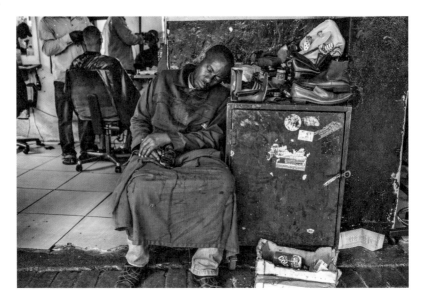

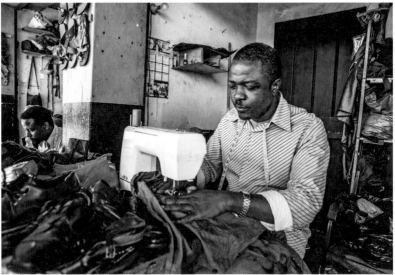

(*Bottom*) Samuel Chukuru, Yeoville, 2014

connected to the surrounding streets. The market was a response to the City's wish to mop traders off the main street of a suburb that was, as far as bureaucrats were concerned, losing its way. It was the late 1990s, and Yeoville was filling with migrants, many of whom had arrived as singles and shared rooms in overcrowded houses and flats in the already dense inner-city suburb. These new arrivals would provide a constant customer base for countless traders selling vegetables, donuts, hairpieces, and sweets on sidewalks that the City thought should be reserved for pedestrians. But the market was a vain attempt to establish order in a place where even the smallest parcels of land quickly become sites on which to cram multiple housing options and income-generating endeavors—Yeoville has, in the words of one Nigerian homeowner, "so much space that you can still use." But when the market was completed in 2000, many street traders resisted being moved away from the traffic of customers along the sidewalks. They were not enticed by the ablutions, water, and cooking facilities or the mix of street- and interior-facing stalls.

But some of the new arrivals—like Samuel Chukuru, a tailor and shoe-maker from Lagos—were. Samuel saw an opportunity to work in the market and live in this suburb. It was an expensive choice as rents are high—"What I pay for one room for one month here, I pay for two months' rent for a three-bedroomed flat at home." But it was a considered decision. For all its local woes, the rand remains stronger than the Nigerian naira, and so Samuel can afford to send money home each month. Although he has fifteen years' experience as a shoemaker and can create shoes from scratch, he now does only repairs.

But Samuel's mainstay is clothing alterations. His chair faces Hunter Street, and on one of the days I visit, he is watching the street life quizzi-cally over the top of his sewing machine while guiding a shirtsleeve under the humming needle. He is adapting the garment for the bearded young man swaggering around in another shirt that the tailor has just altered by at least two sizes. To the left of the stall, Ghanaian tailors call out to pass-ing customers from their row of street-facing cubicles that offer fabrics, design, and manufacture on-site, as well as clothing alterations. A man carries a large bag of cassava leaves on his back into the market. A huddle of young men debates loudly near the stall. The cobblers who sit outside adjacent stalls bend over the shoes they are gluing, trimming, and stitch-ing. A taxi driver presses down on his hooter incessantly. Samuel's work is interrupted when a woman hobbles over with one foot unshod and passes a sandal to him for an "immediate" repair. He accepts the job and throws

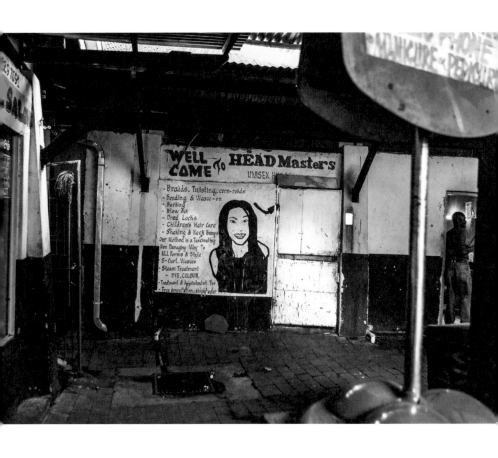

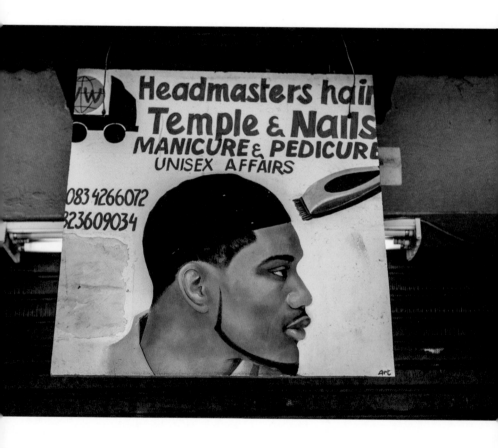

the sandal to one of the shoemakers attached to no particular stall—"John, stitch this for me!" In five minutes the sandal is repaired, and Samuel tells the surprised woman that there is no charge.

Samuel smiles and talks of the pleasure of living in Johannesburg, where you can do well as a migrant, "as long as you keep to yourself and do not engage in *unmeaningful* activities." He says he loves living in a country where there is democracy, where you can speak your mind, "even if you say the things that Julius Malema[2] says," and where there is "no corruption." When I raise my eyebrows at that comment, he scoffs. "This is not corruption; it's nothing! You don't know what corruption is like in my country! The only problem here is the government promises houses and more things than any government in the world can deliver. They must reduce the promises."

He stops sewing for a few minutes to talk of the home with wife and three children he returns to twice a year, a home he left thirteen years ago because "it was leave or starve. It has to be a collective decision to live like this. You don't want to leave; she doesn't want you to leave. But you are making a dream for the future."

This strip of tailors and cobblers is one of the micro-agglomerations along the perimeter of the market. Around the corner, Charles Imo owns the largest of the narrow hair salons that make up the eastern edge of the market. He boasts nineteen years in Yeoville and commands the street with a certain authority, shouting to people across the road, and joking with customers and stylists in the adjacent salons. Charles says the market is known to the diaspora community, "who even come from Sandton and Kyalami. People come here, and they can't believe that they can find every kind of their home food here." He is right. From the clutch of grocery stalls, the butcher, the long row of fruit and vegetable sellers, and the cassava corner ruled by fierce women chopping, blending, and packaging leaves and roots, the market offers familiar foods, low-cost dressmaking and hairstyling services, and, of course, the opportunity to speak Swahili, Portuguese, Yoruba, French, Bemba, or Ganda.

Geraldine

Someone is rushing over to Senga Mutombo's stall with a large canvas bag. The two women talk animatedly in the few seconds it takes the supplier to drop the bag at Senga's feet before she rushes off again. Senga pulls

2 Leader of the Economic Freedom Fighters (EFF), a left-wing opposition party.

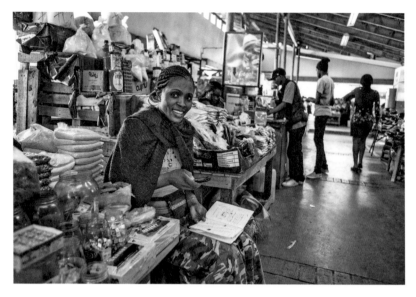

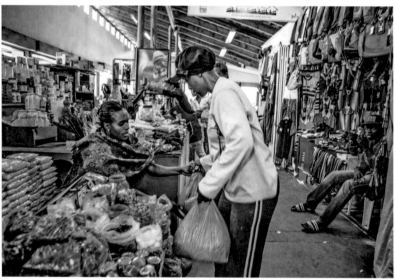

(*Top*) Senga Mutombo, Yeoville, 2014
(*Bottom*) Senga Mutombo and Geraldine Chipalo, Yeoville, 2014

flat dried fish out of the bag and arranges them in various size categories on the floor. Now other market traders are peering over, asking her what the prices are. She reaches into the bag for tiny scraps of cardboard on which the supplier, Geraldine Chipalo, has scribbled almost illegible numbers, and tries to match the prices to the piles of fish that hardly vary in size. This is a good product. Senga knows she can easily double the price on each fish and sell out in three days. The fish last for a long time. "You divide the fish into four, cook one portion at a time. It makes a delicious gravy with pap," Senga explains.

Geraldine is Zambian. Her imports of beans, peanuts, cassava, dried fish, eggplant, and okra are sought after in Johannesburg, Cape Town, Durban, and East London. She sources goods for regular customers and brings in what is in good supply. She is networked to the delivery trucks that serve traders like herself across South Africa. Sometimes the trucks carry only goods for cross-border traders. But if they are carrying furniture or other large items, the drivers might agree to add an extra bag or box to their load for the market traders. Geraldine also works with individual suppliers and customers who do not use trucks, but carry bags of spices, creams, or vegetables on their backs. "If someone is coming, I tell him to bring what I need," she says. The trading lattice is organized by word of mouth, and transactions are recorded on scraps of paper or in notebooks. It's low-end globalization: boxes of goods arrive from many countries and are funneled through backyards to be sorted and to join other goods bound for stalls, shops, and restaurants across South Africa.

Some customers collect from Geraldine at the house where she occupies a back room and stores her goods in a corner of the backyard. She is a solo entrepreneur and also lives alone. Like many properties in these inner-city blocks, the main house is occupied by several migrants. It is surrounded not by a blank-faced barrier so typical of suburban Johannesburg, but a wall that has a tuckshop and hairdresser inserted into it.

When she failed to find work after she graduated from a hotel management course, Geraldine started selling. She moved between Botswana, Zimbabwe, and Malawi, selling clothes, hardware, and electrical goods. "Then I started coming to Johannesburg. I was introduced to people from other countries. They couldn't find our food here, and I saw the opportunity to sell. They encouraged me. Now I stock from Nigeria, Cameroon, Malawi, Tanzania, Ghana, Mozambique, and Zambia." She has been in this business for ten years and has fashioned a rigorous daily routine. "I wake up at 4 a.m., dress, and do my exercise [a run around the neighborhood]

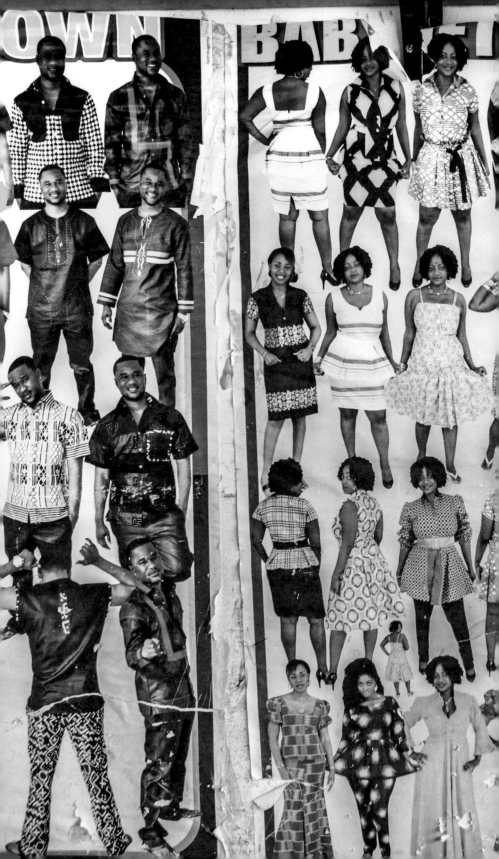

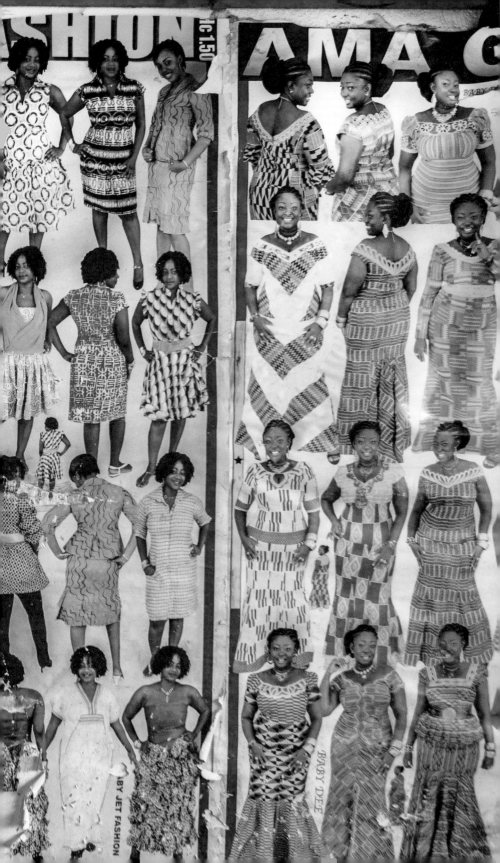

and prayers. Then I pack and price the goods. I go to Newtown to find the Somali truck drivers who go around the country."

Geraldine's customers, with their limited cash flow, need small quantities of stock every two or three days. "My customers pay in installments. Some give problems, but most pay. I am always collecting." She holds up a small exercise book. "I keep two books. I take one to the customers and keep a copy at home. It is my accounting system. It's my most important possession." The pages of her book are filled not so much with lists as with jumbles of names and numbers that are crossed out and replaced with higher or lower amounts.

The Book

Senga's book is similarly small and filled with names and amounts. "I sell and buy on credit," she says, standing amid the stock that crowds her stall. Many suppliers come every day to collect their money. "I give them R80 [US$5.10], R100 [US$6.39], and so on, and I keep a note in this book of people I owe and of people who owe me." The pages are headed with names that are peculiar to me: Papi, Pappas Paul, Pakali, Papa Njovu, Abndrew, Mama Pelazi, Kettie, Maman Beya, Mama Dalas. And of course Geraldine's name appears too. Senga stores the phone numbers of her suppliers in her cell phone. There are no other contact details. She has built long-standing relationships in this business. "I like my suppliers, and I deal with the same people. I like them because they are patient. If they come and I only have a small amount of money, I pay that or ask them to return the following day. On a good day I make R1,500 [US$95.96]. It is not my profit; it all goes to suppliers." Relying on credit is not ideal business practice: "You can't take a risk or grow the business because you can't spend other people's money."

A woman standing nearby has overheard our conversation, and she now interrupts us to introduce herself as Hilda. She is selling crocheted shoes to a stallholder near Senga. She says she is South African and, with a silent "but," adds, "I love these people—use that in your story. I love their food, I love the way they care for each other. They are interesting people."

Threat

"People say it. They say when Mandela dies they will attack foreigners." Senga's weary eyes flicker, and her movements are no longer graceful as she stretches across a pile of fabrics to place another jar of face cream

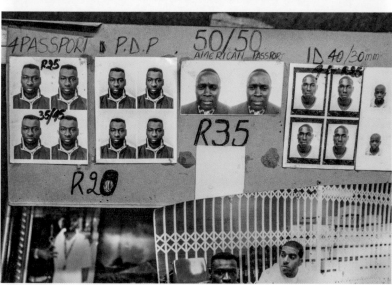

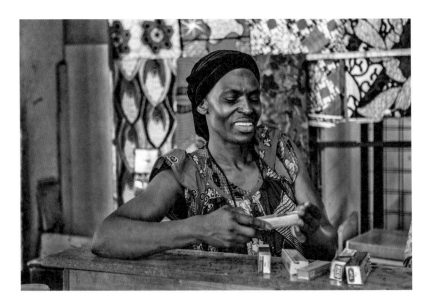
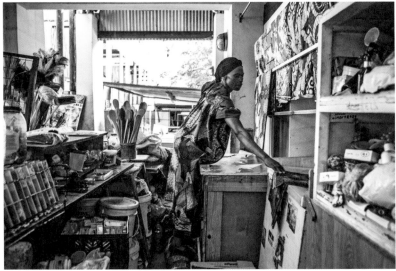

(*Top and bottom*) Mama Senga Mutombo, Yeoville, 2014

on her mother's stall. For now she has left her own stall at the other side of the market and is helping her mother unpack items from a large trunk. "We know trouble when we see it," she says. "I told my mother we have to leave this country. South Africa is not safe for us. All our family are boys. I am scared for them. It is not safe in this city." She returns as always to that great uncertainty that hovers over the lives of asylum seekers. "Every six months we must go and renew papers. On that day all our children must stay out of school, and we must all go to Pretoria to renew papers. It's been ten years living like that. Every day is hard and painful. I am really tired of it." The family members have recently renewed their papers, so this is not her chief concern today. Nor is her disquiet sparked by hostility from South Africans.

It is the City of Johannesburg's removal of traders across the inner city, an action the City has labeled "Operation Clean Sweep," that makes her anxious. "These weeks metro police arrive. They move street hawkers without warning." Senga's stock is low, and customer numbers are down. "We depend on each other," she says. She and others have tried to stock in anticipation of Christmas, but there are oversupplies of some goods and shortages of stock whose suppliers have heard about the police raids and are reluctant to deliver because there are not enough traders to sell to. Senga also sources goods from "people in town, people who have now been removed." When will this market be targeted, "more than it already is?" she asks. She feels there is some security from the police here and that she is not as exposed to police corruption as street traders are. Daily, street traders rush into the market, into shops or secret corners, to hide their bags of tomatoes, onions, or cassava from metro police who raid their illegal trading spots on the sidewalks. Even within the market Senga is not immune from harassment and the risk of goods being confiscated. Because the City's health regulations are open for interpretation, she can be deemed noncompliant on one day and aboveboard on another.

Mama Senga's Stall

At the other end of the dense market, a miniature agglomeration economy of tailors sporting the identical wax-print cloth crowds the passageway alongside Mama Senga's stall. Babafemi Lawai's sewing table, a storage crate, and the board he uses for cutting and ironing occupy less than two square meters of the corridor of tiny enterprises. Babafemi combines impatient perfectionism with the easy confidence of an experienced de-

signer and crafter. Many seek him out for his unique skills in the hand and machine embroidery associated with royalty in Nigeria. He designs and makes Western and African dresses, men's shirts, and full traditional West and Central African suits, often combining the brash spontaneity of multi-colored fabrics with the stately touch of his embroidery.

A few stalls down, in a less public compartment, many of the white wedding gowns on display are for hire. Sixty-eight-year-old Pileng Mokoena honed her skills as a seamstress with well-known South African textile and dress designer Helen de Leeuw, in the 1960s and 1970s. Now Pileng's shop in the market bears her own name, and from here she has been creating attire for wedding parties for almost ten years.

Next door is Philippe Kadilu, a Congolese photographer whose images of soldiers serving the Mobutu regime very nearly got him killed and led to his harrowing escape to South Africa. His small, caged-in stall offers everything from passport shots to wedding photography. Every shelf in this studio-cum-office is packed with framed and unframed photos, cameras and camera accessories, DVDs, and files. He has a small space for customers to pose in front of a backdrop featuring a palm island landscape.

Along the corridor that fronts Mama Senga's stall, brightly colored shoes race each other down a diagonal display board next to tables overflowing with disposable Chinese fashions and shelves of African wigs on startled white manikin heads.

The multiple entrances to the market create the possibility of drama and unexpected meetings. A tailor, a dressmaker, and a shoe seller from nearby stalls gather around Mama Senga's stall. The mood is restless, and everyone is talking at once. There are rumors of more of the everyday violence in Yeoville. Mama Senga translates for us: "Last night there was a fight in a pub. It was over soccer. One Nigerian took a panga and cut the other man's hand off."

As if it were a mascot for the whole market, Mama Senga's stall, at the confluence of two passages, has a variety of goods that makes it neither grocery outlet nor cosmetics booth, neither tailor nor food stand. The stall consists of three tables arranged snugly against one another, an overhead railing, and a set of shelves. Next to a trunk that bulges with fabrics and clothes awaiting repair or completion, a freezer contains clear plastic packets of finely chopped cassava leaves. Grass brooms, steel wool, umbrellas, earrings, rakes, locks, baby clothes, face creams, oils, and toilet paper are displayed on the rails and table. Between goods on the over-

flowing shelves are also the means to make a cup of tea and a sandwich during the day.

The original intention of the stall is advertised on a poster displaying bold wax-print dresses. The designs all feature a low-cut back, a tight fit around the curves of the body, and skirts flared at calf length. The similarity in the basic aspects of the dress designs is compensated for in the varieties of bright fabrics hanging at the back of Mama Senga's stall.

Of the clutter in the stall, she says, "I try new things. If you don't sell this, you can sell that. Even toilet paper. Everyone needs toilet paper. But it's as if we are not working. This is just a small, small job." In this market I often hear the same message: We are trying, we are struggling to survive, we do what we have to do. I follow Mama Senga around the stall while she rearranges her displays, unpacks creams, instructs the seamstress she employs, and deals with customers, one of whom buys a minute lock after a fifteen-minute negotiation. "I work every day of the year," she sighs, "even the 31st of December. Unless I have to take a half day to get stock. Since 2004 I have not had a break. If I am sick, I go to the doctor, and I come back to work. I also take half a day off if the family has to go to Home Affairs."

A trader arrives. Her parcel is modest: a bag with two bolts of fabric. But the small young woman is exhausted, and she slumps onto the chair next to the stall. I ask her about her business in Johannesburg. "I come every month from the DRC. My child lives here with my brother, so I come to see her at least once a month." These visits are combined with trading lightweight goods that she can carry in a small bag. She also buys supplies here to sell back home. "Mostly I buy phones from Pep Stores." But you cannot legally stock up on many phones at once—the limit is five. "I can buy five phones each day plus get a friend to buy five. So in five days I get fifty phones to take home each time. I buy them for R125 [US$9], I sell them for R250 [US$18]."

Armand

Armand Mutombo, the eldest of Senga's brothers, is tall and strikingly attractive. Even in the Yeoville market, where dark-skinned Congolese men are by no means an unusual sight, heads turn as this handsome man walks with an easy confidence along the lively corridors. He strides toward the row of African food houses along the sunnier, east-facing passage of the open-air courtyard. He joins us at a wooden table opposite his mother's

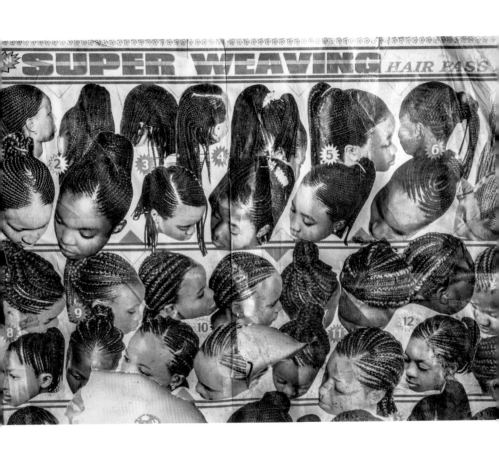

general dealer-type stall. We order spicy *jollof* rice and tea while he chats easily about his family and life in this city.

Armand is in awe of the two women who sustain the family. "My sister was the role model and the breadwinner in Johannesburg. We followed her. Nine of us, brought by my mother to where Senga was making a living by plaiting people's hair." He remembers that Senga had to take care of all of them with that job, and that there were days of hunger, days when Senga told them there would be food at ten o'clock because that was when her client was arriving, but then the client didn't come.

While varying fortunes have seen family members study or enter into business and entrepreneurial ventures over the almost decade and a half of life in Johannesburg, Senga and her mother, both of whom found a place in the Yeoville covered market in 2004, have continued to labor without respite. It is not unusual to work for twelve or thirteen hours, seven days a week in this market. Armand glances at his mother, her distant stare and her quiet voice belying her taut physique. She lifts boxes and shuffles packets to locate the shirt of a customer who has arrived for a fitting. Armand says, "I think she has not had joy since my father died."

Family visits happen in the market. Children might drop in after school, or a brother may come by during his lunch hour. Each is pulled in to pack something or deal with a customer or manage the stall for a few minutes. Senga's own children are too young to make the journey to the market.

Armand is unsure of whether he is more Congolese or South African. He feels that his family lives both inside and outside of the Johannesburg Congolese community. Certainly they attend the Congolese church in Yeoville and feel solidarity with Congolese and other migrants who face the hostility of a city where "people will hate you without knowing your intentions." But within a dislocated community, there can be deep suspicion of new arrivals. Everyone is nervous of being asked for something. And a discomforting vigilance accompanies the anxiety of refugees, each one wide-eyed to the world and to how others are surviving here. The spotlight on your life in this city as well as on your history in your home country is on full glare. Many times Mama Senga has heard Congolese women say, "Your children are leaving us to take South African people." They are referring to Armand's South African girlfriend. But Armand is upbeat about possibilities in Johannesburg: "There is much more opportunity here than in the USA. I do business with South Africans; they treat me with respect. I wouldn't want to go anywhere else. Here I can start a business myself. I couldn't do that in the USA."

Inside Out

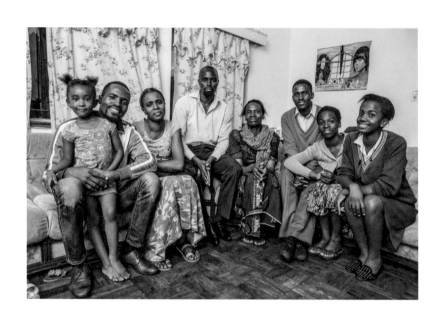

Mutombo family, Yeoville, 2014

A Family Photo

The "boys," as Senga calls them, have all gathered at their mother's apartment in Yeoville. We have asked them to get together so that we can make a family portrait. But not everyone is present. One brother is coaching soccer and is not available. Gathering seven men, each of whom is pursuing his own entrepreneurial venture or studies, or both, is not easy. Add to that the needs of the school-going younger children and the little family time that remains outside of market hours, and it is easy to see why this family has so few family photos. Today they will not get one either. One missing family member is not the issue. Senga's brothers, her sister, and her teenage daughter are deeply skeptical about the value of putting a family picture into the public domain. Two brothers think a photograph will be a false symbol for successful migrants, and that outsiders shouldn't be allowed to peer into family success or its struggles. Why should this home, which may be a sometime gathering place for this three-generational family, but is certainly not open to strangers, or even to close friends, be publicly exposed? Even if the home and those connected to it emit courage and passion, escape from the first stage of arrival, of trying to "make it" in a hostile city, is not guaranteed.

It is an unsurprising response to the camera lens. The guardedness has also been present in each of our encounters with Senga. We have heard few details of this intriguing large family, each member blessed with sculpted beauty and lofty stature. The private life of each person or of the family has determinedly not been on show. And despite the apparent division, now they are united in seeing their family as unique. "We are not like other Congolese families," they each stress. "We are independent; we speak our minds."

A fierce debate of strongly argued positions and the odd personal attack ensues. Armand, the eldest and tallest of the brothers, holds that since each will have the opportunity to view my text and comment on it, there is no danger in taking a photo today, and it is convenient because they are all here. "Later on we can decide if we let them use it," he suggests. But Christian points out that if this is the case, then a decision about taking the photo can also be delayed until they see the text. Everyone is now animated, voices are raised and bodies lean forward. Each is allowed to speak, and even if one sibling talks over another, they all uphold the right of each to offer an opinion. Senga argues her point that the story will be a positive one and won't threaten anyone's personal ambition or privacy.

Rachel adds that she too is skeptical but willing to go along until she has all the information. Sylvie is uncertain and leaves to dress for church. One by one the brothers who don't want to participate also leave, quietly or with a slamming of the door. Senga stands up from the mocha-colored velvet couch, where she and her mother have been wedged in the center of this arc of relatives, seated on soft chairs or on upright seats brought into the room. As she rises to her full six-foot-something height, she says, "Our father raised us like this. It was always a house of freedom. You can say whatever you want. You are free to make your own choice, but you must debate. You must state your opinion. You can also have what you want. My mother knows. If one wants chicken, one wants meat, one wants something else, we will have all of those choices."

Serge has been leaning back on the corner of the couch throughout the debate, not contributing. Like his mother—who was affectionately called "Queen" earlier in the evening—he has been watching quietly. Now he says, "I see this is an identity thing." He speaks of the discomfort of always being reminded that you are a refugee. No matter the freedom to succeed, to break class barriers, to raise a family of nine children, each of whom is productive and eagerly creating opportunity, the refugee stigma hovers over the in-migrants to this city.

But that's only Serge's opinion. He is one voice in a family in which walking out, raising your voice, or wagging your finger risks no long-term animosity. The remaining members gather round and laugh their way through the photo shoot.

112

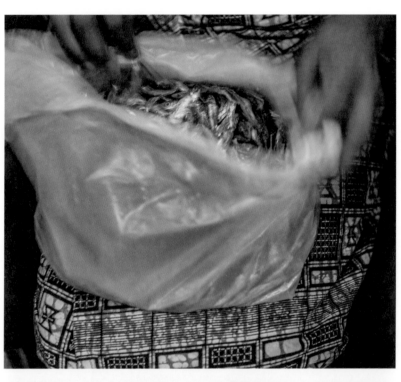

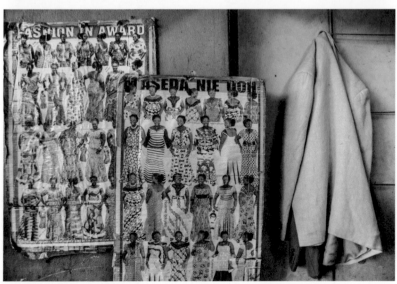

4

Zola

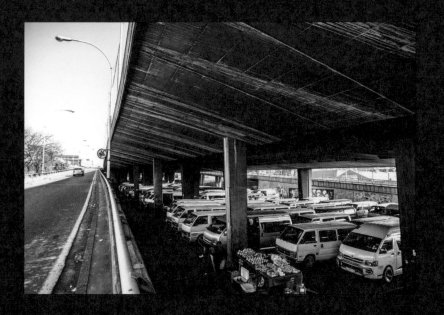

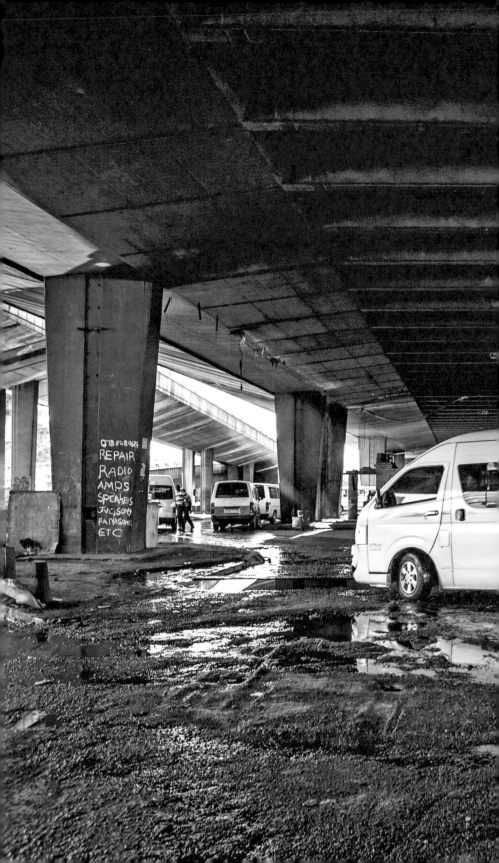

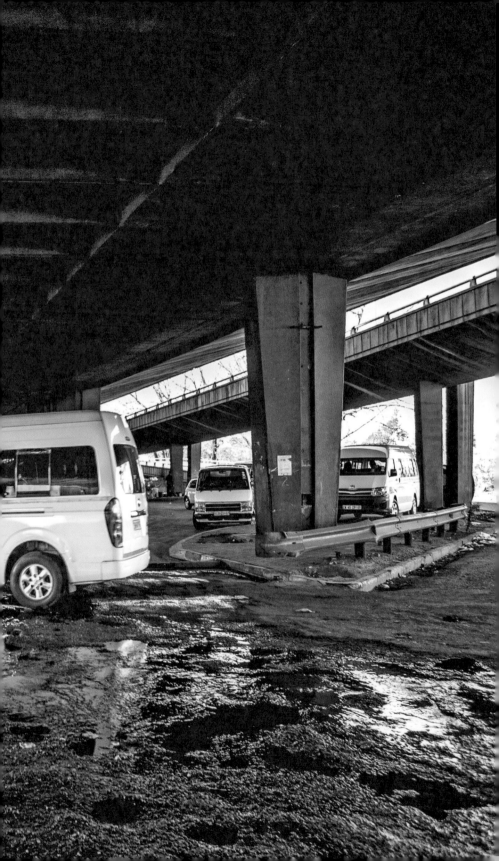

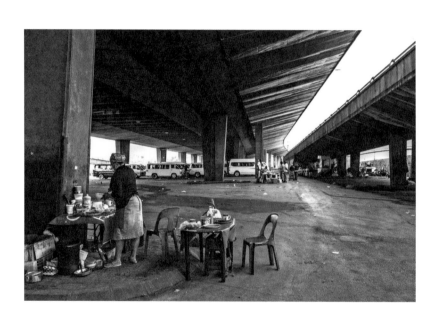

IF YOU TRAVEL EASTWARD ON THE M2 as it skirts the southern edge of the inner city, you are heading to what was the industrial heartland of Johannesburg. You can also reach the airport and even the coast along this route. And once you pass the Mooi Street turnoff, you can choose any number of loops and vectors to take you all over the city. As we look across to that intense intersection, I remember that in Planning School they told us that the 1970s engineers responsible for those enormous road loops maximized their profits by designing the least efficient but costliest solutions for turning corners.

But the Mooi Street off-ramp that we take hits a less ambitious junction. Here, signs offer a mix of distant destinations and parochial pursuits. The East Rand town of Springs is forty-eight kilometers away but is signposted here as if it were closer than the whole of southern Johannesburg that can be accessed from this road. Directions to the Pioneer Park musical fountains and Santarama Miniland—those peeling tourist attractions—are also indicated. The signs do not say Rosettenville or Turffontein, which are the next suburbs along the road. They don't indicate that a short distance from here is Ezinyangeni, the "Place of Healers," or Faraday Muti Market, where hundreds of traders selling herbs, potions, animal skins, charms, and traditional regalia share space with traditional healers. And they certainly don't point to the area under the highway off-ramp that is now the "Zola binding point at Faraday," where, every morning, six hundred taxi drivers bring their taxis to wait for the late-afternoon peak hour. And why should they? This is merely a highway underpass, a bit of land left over after the transport engineers had their way with the city. What is a city to do with land left over—when the very highway that

renders some land more valuable by improving access to it also devalues those land parcels that it dissects?

"*Hoza!*"[1]

"*Phakati!*"[2]

"*Ngakulu!*"[3]

"Seven!"

"Short!"

"Shit!"

On the first morning that we enter this "dead end" under the highway, we hear the shouts and the whistling from the pool table that is set up near the *shisa'nyama*[4] stand and Izilda Nzopene's kitchen stall. The taxi drivers who use Zola as their waiting zone have placed bets. The fee is R2 (US$0.14) to play and R2 per bet, and the players are being urged to win for their backers. Between games everyone orders food.

The single table and large wooden container that comprise Izilda's stall are deceptive. This is a busy kitchen, serving fish, chicken, pap, rice, and salad at R25 (US$1.70) a plate. Two pots are cooking on an open fire, and another is bubbling on a gas cooker. A kettle steams on the table. Izilda and her sister divide their attention between chopping onions and tomatoes, plating food, and washing the empty plates as they are returned.

A few plastic stools and chairs, a cable spool–turned–table, and two large metal grills mark Meicha Mlaebe's *shisa'nyama* stall in the blackest corner of Zola. Four men are sharing a plate of pap and a few cuts of meat served on a chopping board. The grills smoke incessantly, coating the walls with ever more soot and carrying the smell of smoky meat deep into the sea of parked taxis. While Meicha cooks, his assistant packages takeaway meals of meat with pap and gravy and delivers these to waiting drivers.

The vegetable stall between Izilda's kitchen and the eatery is well placed to take advantage of the demand from these restaurants as well as the customers. It is a large stall displaying onions, tomatoes, potatoes, cabbage, bread, oil, sugar, and mangos on two sheets of weather-beaten pressed wood that are balanced on buckets, oil drums, and bricks. Immediately opposite is yet another stall, selling tea, coffee, or Milo and peanut butter sandwiches.

1 Come!

2 Inside!

3 More!

4 *Shisa'nyama* means "burn the meat" in Zulu and refers to an informal barbeque where meat is grilled on an open fire.

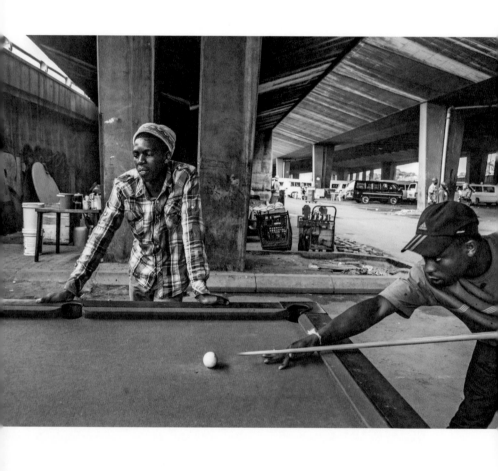

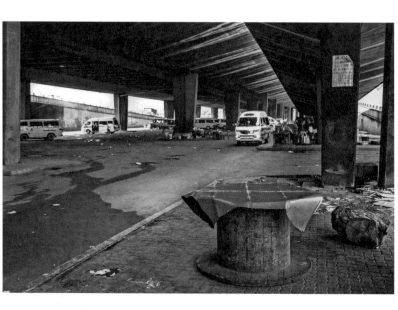

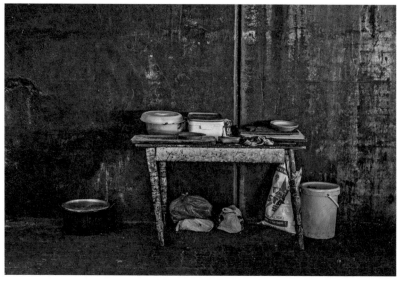

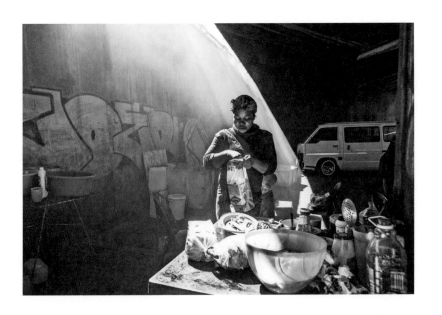

Monica Chauke, Zola, 2013

This density of food establishments continues around the rim of the binding point, supplemented by cooldrink stalls, biscuit sellers, and mobile ice cream and sweet vendors, who pass through all day. Each hopes to turn a taxi driver into a customer.

Monica Chauke's compact melamine fold-up table does not at first make an impression. It is located between the serving areas of three other "cooking mammas" on this secondary corridor of the taxi stand. In addition there is a fresh fruit and vegetable stall a short distance away on either side of her stand. But Monica is unperturbed by the competition for the appetites of the six hundred drivers. She knows that her offering is unique and that by midday she will have sold out and made her R300 (US$21) daily profit. Her niche is simple: she serves only breakfast. But there is nothing simple about what is on offer. For Monica has, over four years, worked out who likes what for breakfast and is happy to cater to the specific tastes of her customers. This means making six egg-and-tomato, three cheese-and-tomato, and four chicken-mayonnaise sandwiches as well as six cheeseburgers each morning. It also means baking scones, frying *vetkoek,* and preparing a soup of beans and bones as well as a meat stew. These are accompanied by a selection of hot and cold drinks: tea, coffee, Milo, juice, and warm or cold milk. There is also breakfast cereal and bread and peanut butter on offer. Monica learned the art of working an intense production line at the bakery where she worked before she started her own business. Her commitment to providing variety no matter how small the quantity has earned her loyal customers. But it demands a tight schedule. She wakes at 2 a.m. to prepare and package the food and the equipment she brings here before dawn. Each day she transports a Primus stove, two kettles, three pots, a large bucket for water, a cooler box, a flask, a jug, polystyrene cups, and paper plates, in addition to the food, beverages, and condiments. She doesn't mind the effort. "I want to work here because no one is controlling me. It's for myself. If I lose, I lose; if I win, I win. Every single cent I earn is mine," she says. How does she manage this for six days every week? "My boyfriend wakes up at 2 a.m. to help me. He also brings and fetches me each day." "In his car?" "No, in my car. He drives it."

"It's better to work alone," agrees Judas Buthelezi. He gave up being a taxi driver a few years ago because "to be a driver is to be a slave." Now he earns money by sweeping the floor of the taxi stand. The large calluses on his thumbs are preferable to the stress he suffered as a driver working for someone else. Not that his self-employment is entirely stress-free. This is an informal arrangement, and taxi drivers are expected to pay him

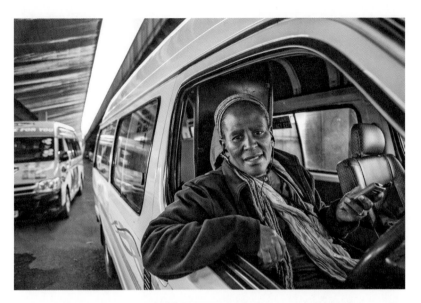

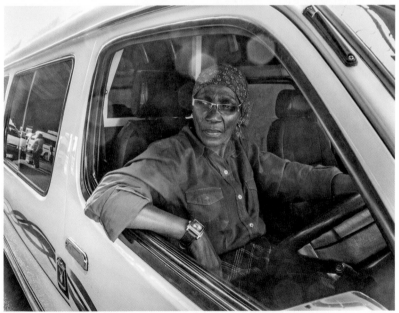

(*Top*) Mrs. Mdluli, Zola, 2014
(*Bottom*) Gogo Dudu Mathibela, Zola, 2013

R5 (US$0.35) each per week for sweeping and clearing litter from four to nine every weekday morning. Many don't pay.

To its hundreds of users, this holding area is known simply as "Zola," after the section of Soweto that is the morning commuter source and evening destination point served by these vehicles. "Zola [Soweto] to Town" is a daily route that Siyabonga Ndlovu has been driving for nine years. He says competition is intense now, and it's difficult to fill his fifteen-seater on each trip. At R11.50 (US$0.80) per passenger, one trip should raise R172.50 (US$12.00), but he says there are many times when he travels with two or three passengers and simply loses money. He starts telling me that he compensates for these losses by doing long-distance trips when he can, especially to KwaZulu-Natal during holiday seasons, but then he interrupts himself. "Let me go, I have been called," he says and walks to his taxi.

Mrs. Mdluli is parked next to Siyabonga. When we approach her, she removes the earphones from her ears and leaves them dangling from her mobile phone to tell her story. Her small frame is lost on the cavernous front seat of her four-ton taxi. She knows this industry well as her husband owned two taxis in the 1980s. When one was stolen and the other broke down, the family earnings dropped dramatically and there was no money for costly fees at Mondeor High, the suburban Model C school their twin daughters attended. Mrs. Mdluli had the remaining taxi repaired, and she began transporting children to and from school. She also won a contract to transport company employees late at night. She was able to pay school fees and support her children. But she hardly saw her daughters. "I left home at 5 a.m. and returned at 11 p.m. They had to cook, eat, and sleep on their own until they finished school," she says. She saved up, bought a secondhand Microbus, and joined WATA (Witwatersrand African Taxi Association) in 1991 to drive the more predictable commuter routes. The strain of long hours taxed her weak heart, and in 2005 she collapsed. She had a heart operation and, unable to work for a few years, had to rely on a small state disability grant. In 2009 she heard of the government's plan to scrap older taxis in favor of new safer and larger vehicles. She traded in her old Combi and started working again, her new white vehicle with the national flag on its sides identifying her with the taxi recapitalization program. Since then, life has improved. Her daughters have completed their studies and are working. But the monthly installments on the taxi are high, and there have been months when she has missed her payments, such as when the roads were closed for a few weeks because of floods. "The bank doesn't care about things like that. You have to pay anyway, or

they threaten to take the vehicle." But as she warms up the engine, counts out silver coins for the change needed on her next trip, and replaces her earphones, she says her vehicle is now almost paid off. And once it is, she plans to buy another.

Personalized decorations and talismans hang from the inside mirrors of the otherwise similar white taxis: a national flag, car freshener in a perfume bottle, dice, tassels, a *dagga*[5] leaf, a silver cross, and a shark tooth. Vusi Dube hangs a rosary on his mirror. He needs the blessings, he says. He is studying graphic design at night school and also supporting his brother, so he has to succeed. He says his weekly takings are about R900 (US$62). He makes six daily trips in his fifteen-seater Toyota Quantum. His fuel is for his own account, and he pays the owner of the vehicle R570 (US$39) per day. "Some weeks are good," he says, "but some are *mampara*[6] weeks, especially mid-month, then it's hard to fill the taxi." But it's not easy to get a job as a taxi driver. He says some people pay R50,000 (US$3,458) upfront to secure a driving job.

White smoke curls out of every open window of a taxi that is parked nearby. It's only 10 a.m., but the *dagga* is already being passed around in the stationary vehicle where six drivers are laughing and chatting while they wait for breakfast. We jokingly ask if they don't worry about being caught smoking *dagga*. "No ways," one driver says, "the police don't mind. Sometimes they come and have a joint with us." The men invite us to join their lively conversation about migrants. The driver sitting at the open door of the taxi raises his voice above the loud music and the chatter. "We are just waiting for the old man to die. Then we gonna chase these foreigners. You know these machetes?" he taunts, pulling out a six-inch-long knife from beside his seat. Mandela is on his deathbed, and somehow his impending demise feels as though it might pop the lid off the tensions, retributions, and hostilities that seep through this city.

The sound of a petrol tanker passing above shudders through the taxi stand and draws my attention upward. Zola is permanently enveloped in the shadow of the overhead motorway. On this rainy day, white streaks chalk the blackened pillars and the underside of the highway that are the walls and ceiling of this gathering place of drivers and survivalist entrepreneurs. The city's pollution, exhaust fumes, and smoky fires cast a mysterious chiaroscuro light across their activities. Smoke is funneled up into the

5 Marijuana.
6 Slang for "fool" or "idiot," used here as an adjective.

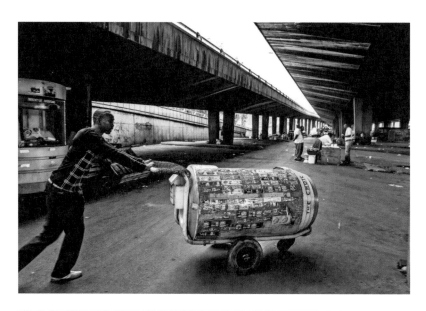

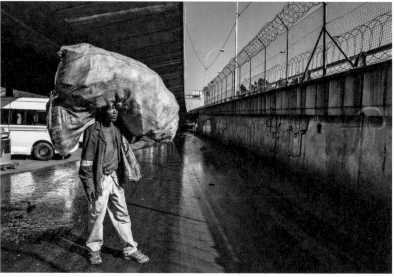

(*Top*) Mzethi Kubeka, Zola, 2014
(*Bottom*) Elvis Mkhwebane, Zola, 2014

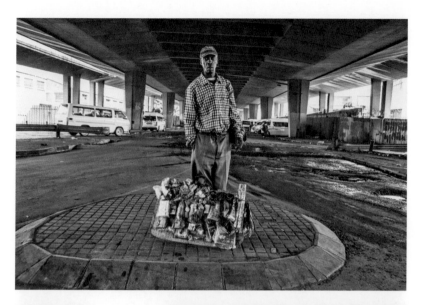

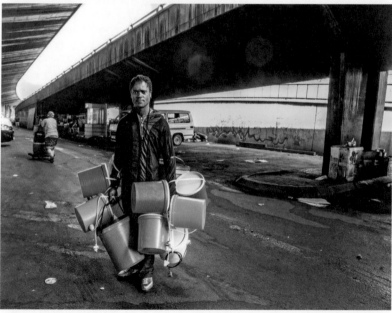

(*Top*) Jabulani Sibanda, Zola, 2014
(*Bottom*) Isaac Mambo, Zola, 2014

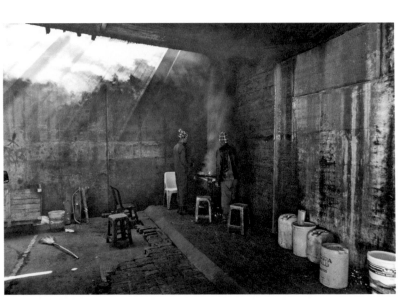

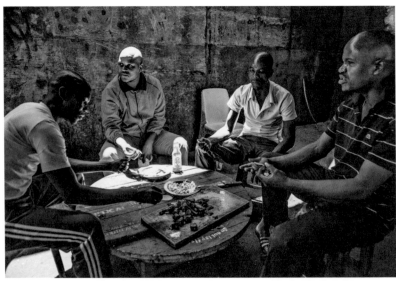

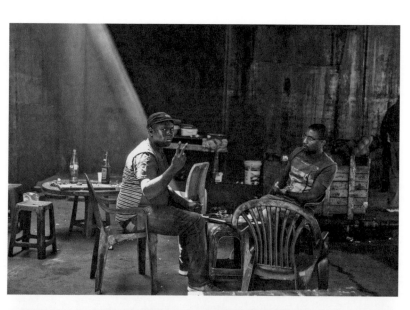

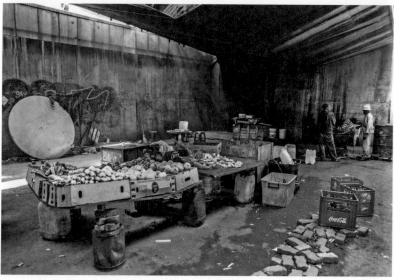

gap-turned-chimney between the highway edge and the retaining wall of the off-ramp. A thick, smoky film screening the highway is the only clue for the drivers of the vehicles noisily passing above to the existence of this unremarkable location.

"Why don't you come and talk to the *gogo*[7] taxi driver?" a voice commands from behind me. I turn and respond instinctively to what reminds me of my own grandmother's not unfriendly but slightly condescending scan over the top of thin-rimmed spectacles. She leans her elbow lightly out of the window, her heavy watch something of a contrast to her shocking-pink blouse. "Climb in," she says.

Gogo Dudu Mathibela says she has been in and out of the taxi industry since 1984, when she started driving. She bought three taxis. "They were all stolen. In 1994 I lost the last one, and for sixteen years I didn't drive. It was hard to start all over again having lost that much. But I came back in 2004." Since then Dudu has bought two taxis. She is the full-time driver of this one, waking at four each morning to start her shift at five. The two trips she does to the inner city finish at 8:30, and she parks her taxi at Zola until she is called at 12:30. Does she wait with the other drivers? "Definitely not. In that time I go to the gym at the Carlton Centre. I do an aerobics class every morning. And then I walk around, I window-shop."

Of some of the drivers, she says, "They are rude. Why don't they encourage you or congratulate you? Instead they say, 'Why are you doing this when you are so old? You must go look after your grandchildren.' They are not happy for you." Do those who sneer at her know that she raises her family on this income? Or that the father of her children was shot dead, perhaps because he disagreed with powerful figures in the taxi industry?

A hawker selling facecloths, steering wheel covers, phone chargers, and earphones walks toward us. His touting offers a relief to the tragic turn in Dudu's story. When he leaves, she talks of men in general. It may be that the driver making a pass at the woman who is washing his car has caught Dudu's eye. She says, "You know our men leave Zululand on trains. Nowadays they leave on electric trains, but in the past they left on coal trains and you could see the smoke. We would say that smoke gets in their eyes. It blinds them so that before the train goes around the Drakensberg Mountains, they have already forgotten where they come from. When a man sees you again, he will ask who you are ... even if you were once his own woman."

7 Grandmother.

This seems to establish good grounds on which to be undeterred by the opinions men may have of her work as a taxi driver. "I love this job with all my passion. Every day I want to say thank you, thank you for the job. I wasn't working and now I am. This taxi is my own thing. I don't owe anyone. I am hardworking and I love it. It's a unique job. Last week a child of three climbed into my taxi and said to his mother, 'Look at this *gogo* driving a taxi. Why?' At the end of the day it's like family, the passengers and even the other drivers. I feel that I am part of this city."

Another hawker catches my attention as I climb out of the taxi. He shows me an array of warnings and moral messages on yellow plastic signs intended for the rear windows of taxis: "Blaming others won't help," "Only God can decide," and the one he convinces me to buy, "*Nawe u driver masimba fokof*," meaning "You also drive like shit, fuck off."

On websites promoting South Africa, international tourists are warned to exercise caution if they choose to travel by minibus taxi, Johannesburg's most used form of public transport. Usually three warnings are issued: first, the unwritten lore of hand signals that indicate where the taxi is traveling to, combined with unpublished routes, makes navigation by taxi difficult for the uninitiated; second, many taxis are old and in poor condition; and the final warning, minibuses are driven by the city's most notorious drivers, who are known to duck wildly from lane to lane to allow passengers to climb on or off.

None of these sites that list the perils of taxi travel in the city complains of the state of cleanliness of these vehicles. And for good reason: minibus taxis are clean. "Rain is good for us," says Nomonde Chomko as she sponges down the door of a taxi with soapy water. "On those days I can wash eight taxis. At other times I am lucky to wash four or five." Like the other men and women washers, whose feet are covered in plastic bags and clad in Wellington boots, her most important piece of equipment is a forty-four-gallon drum that is wheeled around on the base of a shopping cart like the ones used by Johannesburg's informal recyclers. Nomonde fills the drum at the open manhole around the corner. All morning people line up with their buckets, tins, and even wheeled garbage bins to scoop the free water gushing from the municipal stormwater pipe that has been intercepted here. It is the life source for all the car washers and the cooking stalls at the binding point, as there is no running water under the bridge.

Nomonde steps back from the taxi she is washing and straightens her wet dustbin bag apron over her knees. "I don't ride these taxis," she says. "They are too expensive." The cost of a single taxi fare to Orange Farm,

133

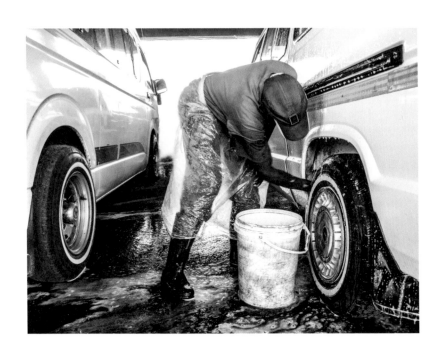

(*Top*) Nomonde Chomko, Zola, 2014
(*Bottom*) Jabulani Kkumalo, Zola, 2014

where she lives, is R16 (US$1.00). This excludes the R7 (US$0.50) cost of a local trip to the zone she lives in, or the R5 (US$0.35) it would cost if she caught a taxi across town from Faraday to Metro Mall, where Orange Farm taxis rank (look out for taxis going to Number 2 or Mshenguville or Nandos). She opts instead to wake at 4:30 a.m., catch a bus to the train station (R6 [US$0.42]) and then take a train into town, and reverse this pattern each evening. Her transport costs for her weekday commute are about R22 (US$1.53) per day. She earns R40 (US$2.78) per taxi that she washes. If it's a Quantum, she charges R50 (US$3.48).

The taxi-cleaning service is split into washing and polishing. Phumlani Khumalo is a polisher. He carries the tools of his trade in one hand: a cloth, a can of spray, and a can of oil. The pricing is uncomplicated: R6 (US$0.42) to have your dashboard polished to an even sheen, R6 for the seats, and an additional R6 for the oiling of the high-maintenance, heavily used sliding passenger door.

Other services are also attached to Zola. The biggest demand on the time of Lorenzo Gumbi, the mechanic who has set his equipment up near the exit of the binding point, is the repair of brakes. But he is sometimes required to weld a part, for which he has a blowtorch on site. He also undertakes other kinds of work, like drilling tiny holes into paving stones and filling these with gold-tinted piping to create decorative pavers. Occasionally a silvery lump is brought to him. He drops it into a small hollowed rock. With some blowtorching, the mercury is separated from the lump to reveal a bauble of gold. The tiny bead is the product of a week's worth of sifting and refining gold-bearing sand from the mine dumps across the road from Zola. These dumps are worked by a host of hopeful informal miners called *Zama Zamas*.[8]

Indecipherable graffiti in black, yellow, and blue competes with penis enlargement stickers on the walls and pillars around the open space where Muzi Hlope sets up his barbershop. Muzi lifts the razor and brushes the hairs off it. He squeezes methylated spirits from a cooldrink bottle onto the blade, wipes it clean, and plugs the razor into a car battery. He then drapes a blue sheet over the shoulders of his client and begins to shave from the back of the head. His lips are pursed in concentration for the close shave he specializes in. He only offers a *chiskop*—a complete shave—to the fifteen clients he sees each day, although the "International Haircut"

8 This term for informal miners is an isiZulu expression meaning "those who keep trying."

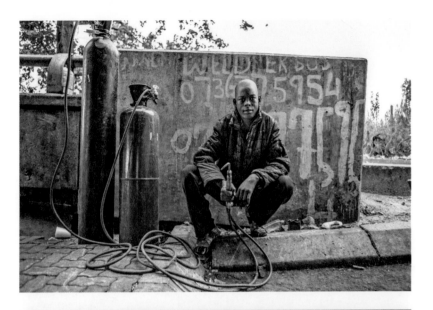

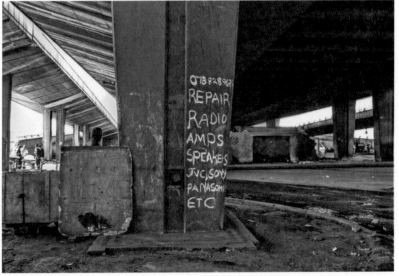

(*Top*) Lorenzo Gumbi, Zola, 2014

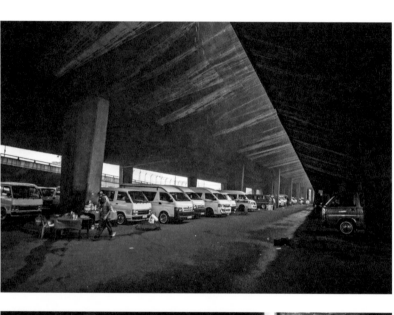

sign that he displays advertises thirty-two different styles. As he wipes the client's head with a dry cloth, Muzi complains that he relies on taxi drivers and has no passing trade. Business is much quieter at Zola than at Park Station, where he used to work, but there is less danger of metro cops taking his equipment here.

All day long opportunists pass through Zola in search of customers or resources. The irony of waste recycler Elvis Mkhwebane's carrying his bag on his head rather than transporting the bags on the familiar shopping cart base is not lost on a cleaner who wheels her blue tin drum past him.

A hawker carrying a pinboard displaying an assortment of rat poison, mothballs, insecticide powders, reels of cotton, hairbands, combs, shoelaces, bangles, batteries, ointment, toilet cleaning tablets, and unlabeled pills weaves through the stationary taxis. He is followed by a salesman who might have stepped out of a fairy tale, with no less than eleven pink, red, blue, and white buckets strapped to his body. An electric cord dangles from each of these water-heating containers that are essential for washing and cooking in much of the overcrowded inner-city accommodation, where shared rooms seldom have access to hot water.

The presentation of Abraham Radebe's goods is almost minimalist by comparison. He carries a neat row of razors on his left arm, sheets of batteries, and a bag of cotton reels on his right side, and around his neck a string of small rolls of insulation tape. The odd item in his product range is a single Snakes and Ladders set. He walks around the inner city in search of customers all day.

When we return to Zola a few weeks later, there is less jollity around the entrance to the binding point. Lorenzo says the pool table has been moved. He points to where it now stands a few hundred meters down the road, outside of the binding point. "The taxi association ordered the owner to move it away because of the gambling. Taxi drivers were using their earnings to gamble. And there were fights. People were always saying they had been cheated, and wanted their money back," Lorenzo explains.

As we head out of Zola later in the day, a man stops us. "Be careful at that robot," he says, pointing to the junction at the Mooi Street on- and off-ramps. "It's a smash-and-grab place. Those guys who are hanging around there want to see what's on your car seat. Rather stay here. It's safe."

This shadowed world under the highway is a veritable case study of an emergent informal business hub. But looked at from the perspective of the man who has failed to sell more than twelve cooldrinks here today, "Ag, there's nothing here really. Just a lot of parked taxis."

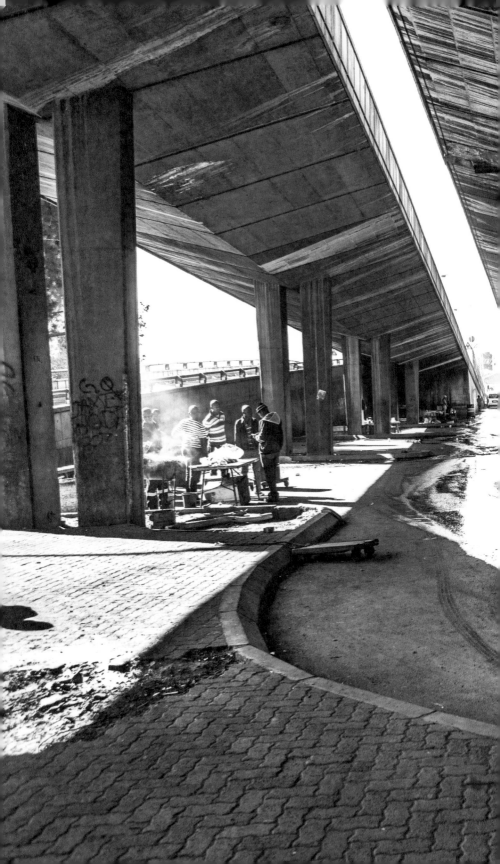

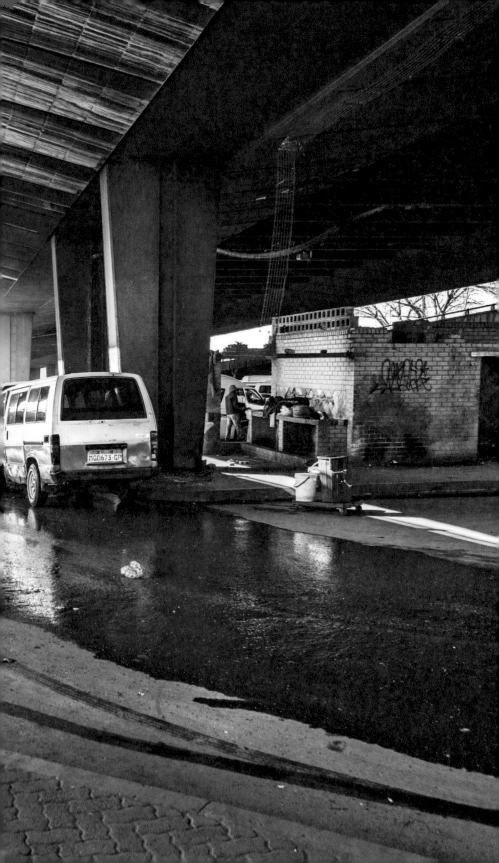

Good Riddance

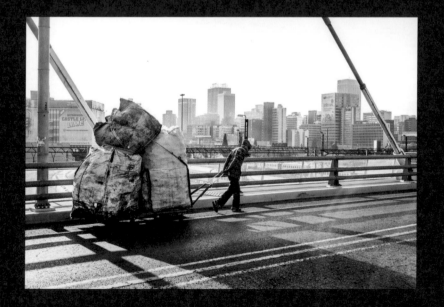

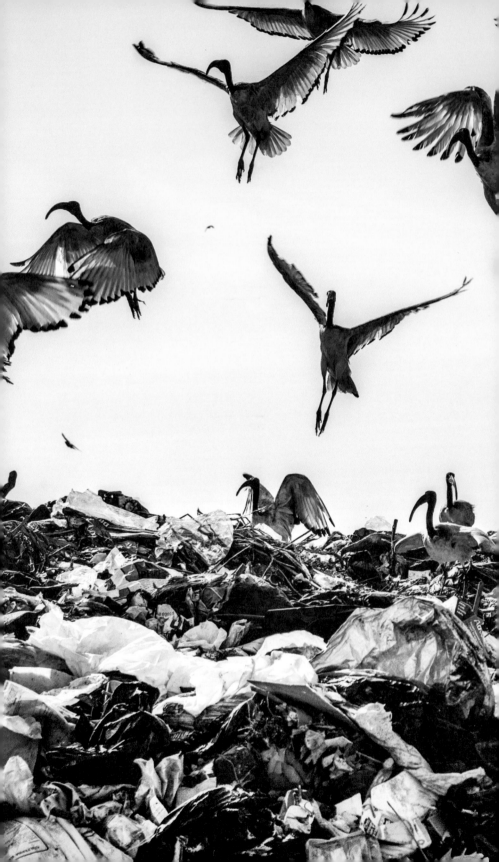

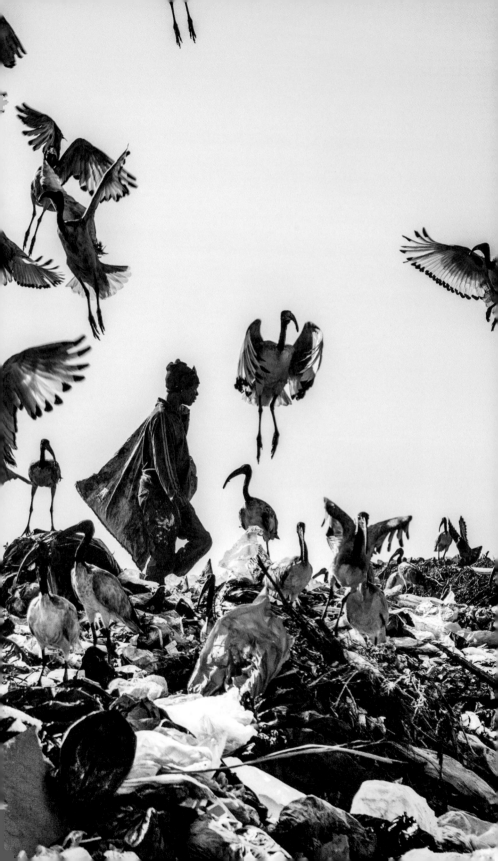

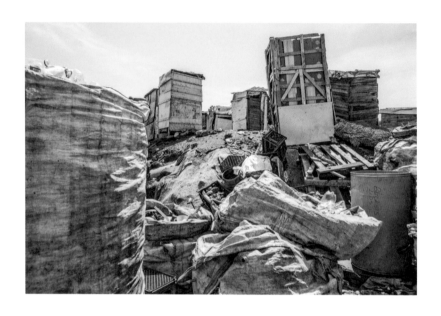

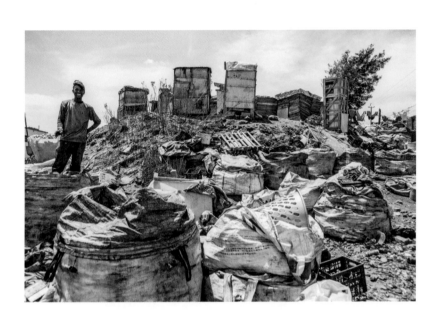

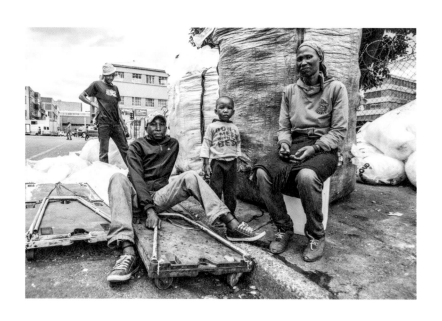

Lebo Selemela and Naleli Kgomo with their son Khotso, Doornfontein, 2013

A PROCESSION OF RECYCLERS, each pulling a cart towering with bulging burlap bags up Jan Smuts Avenue in the early evening, is a common Johannesburg sight. I hardly flinch as I swerve the car to pass the straining silhouettes filing uphill in the remains of winter light. But then one day, I do a double take as I pass. The tall figure at the helm of a group of five waste pickers is a woman. I am too curious not to stop my car a short way ahead and climb out to take in the scene. Naleli Kgomo's running commentary floats across the heads and loads of the men following her, her voice drowning out the sound of hard plastic wheels on tarmac. It seems to encourage the group and to distract from the weight that they are hauling. Her advanced pregnancy does not appear to slow her passage.

I try to interrupt her, and she calls out in Sesotho with enthusiastic gestures of her long arms, none of which I understand. The recyclers halt their trolleys behind my car. It's already late, and they must be quite a distance from home. One of the men speaks a smattering of English, and he interprets for the others my embarrassed explanation for why I have stopped. After some negotiation I arrange to meet Naleli the following week at the same point. I will bring a Sesotho speaker along, and it will be the first of several meetings.

At that first interview, it takes some convincing to get her to allow the interpreter to mediate my incomprehension, because Naleli wants to address me directly. "Look at our work," she says. "We work hard. We are feeding ourselves."

They are doing more than that. Over time I learn that she and Lebo Selemela—who always walks directly behind her in their procession and fills two massive sacks each day—maintain their families at home in Lesotho with their daily commute to the outer suburbs of the city and back. Lebo

is slowly building a sizable herd of goats and a few donkeys at a homestead in Matsieng, the traditional capital of Lesotho's royal family. The livestock helps him to build respect in a community torn by clan warfare that claimed the life of his brother and father on the same day a decade ago, and drove Lebo to Johannesburg.

Only weeks before their son Khotso is born, Naleli and Lebo are evicted from a building in Doornfontein. Two blocks away they find a two-meter-square makeshift room that will curiously be labeled a "flat" in the Supreme Court of Appeal's judgment in the matter between "The City and Landlords" and the "Unlawful Occupiers" of this building. Their "flat" is one of nearly a hundred living spaces in this warehouse. The City's legal counsel will speak of a building not suited to human habitation. He will mention the lack of toilet facilities and water and that electricity is sourced from illegal connections. He will note that refuse and human waste litter public places. The court application will not detail the neat interior of the room that this family inhabits. Or the relationships that allow Naleli to return to work a couple of months after the baby is born because the lady down the passage takes care of the child.

For Naleli and Lebo this is a convenient location, and at R150 (US$9.60) per month their rental to the committee that takes care of security and cleaning is very low. In a good month they can save R1,000 (US$64.00) of their combined income.

Lebo's Route

On one of my Wednesday visits, Naleli is not with Lebo. Khotso is a week old. The new father is smiling, but he shakes his head. He says that Naleli wanted to go back to work two days after the birth. He was forced to hide and then to sell her trolley to keep her at home.

It's 3 a.m. Lebo uses a piece of wire to strengthen the attachment of the thin metal ironing-board frame to the two shopping cart bases he has similarly hinged together. His route leads from Doornfontein, through Hillbrow, across the southern edge of Parktown, past Wits, through Melville, Emmarentia, Roosevelt Park, Linden, Northcliff, and Cresta to Windsor. The route is not direct but is chosen to maximize the down slopes. For these he moves behind the trolley, turns its ironing-board handle to face backward, and climbs on. His three companions do the same, and the trolleys-turned-skateboards sweep them at forty kilometers per hour down the long slopes of Barry Hertzog Avenue. It is an exhilarating speed

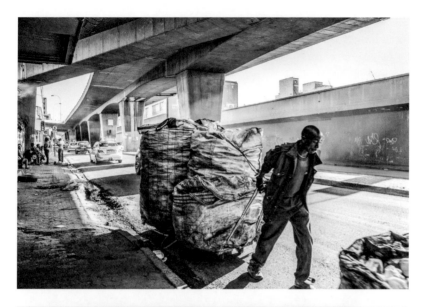

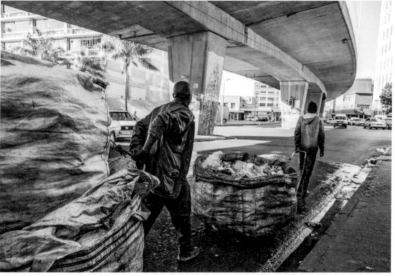

(*Top and bottom*) Lebo Selemela, Johannesburg CBD, 2014

that makes up for time lost on the many parts of the journey where they must drag the trolleys uphill.

Night is just lifting as Lebo arrives in Windsor at 5:20 a.m. He has walked seventeen kilometers to work bins that are not as overplundered as those of Yeoville and Hillbrow, much closer to his home. He pauses to smoke a cigarette with the other recyclers. Then they disperse down different townhouse-lined roads.

He begins his daily reckoning with this city of sprawl and excess. His work is focused. Bins have been wheeled into the road from behind high walls, where consumption is conducted in private. Lebo sifts through containers of half-eaten food, unpaid bills and bank statements, discarded packaging and newsprint. He is looking for white paper, plastics, and glass bottles. He shakes out two large concrete-colored woven plastic sacks, creating shallow cavities as he rolls the edges down, to be unfurled slowly as the bags fill during the morning.

He opens each lid on the queue of dustbins. Without gloves, he digs in and searches for the recyclable material. He works methodically, sorting everything into piles, then squashing plastic bottles underfoot and throwing them into his bag. No one pays him for the service he provides in compacting and removing this suburban garbage. The sour pungent smell of a week's household waste mushrooms from each bin as he lifts its lid. He is too nauseated to eat until he has finished his daily work, and he says when he and Naleli first started doing this, she vomited every day. When he is done, he cleans the area around the bins before moving on. Cleaning up includes returning useless items such as pamphlets to the bins. Advertising companies accuse recyclers of taking pamphlets before they are distributed, and so the recycling yards refuse them. And newsprint is not of much value. On one occasion when I tracked Lebo's journey through Killarney, I pointed out that one of the houses he had stopped at belonged to Thabo Mbeki. Lebo said he knew that but the dustbins of the former president were of little use to him: "They are always just full of newspaper."

His daily takings vary. He says the price for some material has dropped in recent months. In a good week he can earn up to R1,100 (US$77.23). And in such a week he pulls almost six hundred kilograms of waste across large stretches of Johannesburg.

After three hours of collecting, Lebo begins the journey of pulling the two brimming, one-hundred-kilogram bags—more than double his body weight—back to Doornfontein.

152

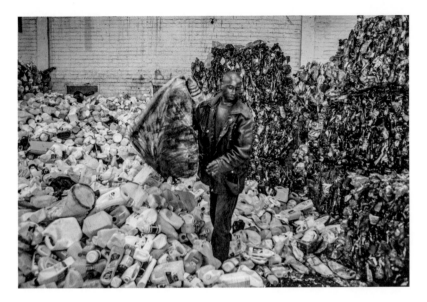

Lebo Selemela, Johannesburg CBD, 2014

The Depot

A cloud of pigeons erupts from the yard and reshapes itself into a westward-bound, airborne hierarchy, but then the restless formation changes direction and heads south over rooftops of forgotten factories. Lebo has been collecting for two weeks, and his gigantic bags now bulge alongside many others in the yard. He ties three bags to one another and to his double trolley with a long rope fashioned of canvas strips and cord. He maneuvers the load out of the yard and off the sidewalk, and faces it downhill.

The faded paintwork and rusted signage of the vacant workshops he passes hint at an earlier era of industry: Sunshine Macaroni, Rosana Modes, Industry House, Lion Leatherworks. Plastic bags drape laundry-like on the barbed wire that rims several roofs. For Lebo this route is an easy walk under the bridge, and his mood is light as he greets other reclaimers who join his journey in the shadow of the highway overpass. The concrete seam shelters taxi washers, waiting taxis, graffiti, and election posters, proclaiming, "Vote EFF.[1] Now is the time for economic freedom."

1 The Economic Freedom Fighters (EFF) is a left-wing opposition party.

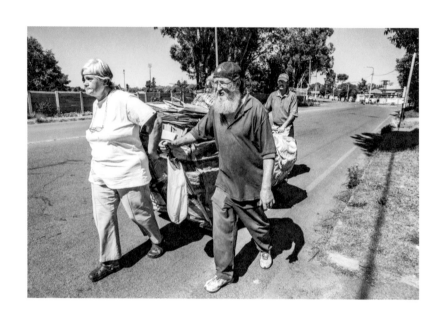

Frans, Marie, and Andre Fourie, Rosettenville, 2013

Ten city blocks later he turns right, past workshops offering spray paint-ing, car accessories, and gearbox exchanges. Crudely painted signs on several entrance pillars read, "No Job." He enters a driveway into a deep warehouse, where he pulls his sacks onto the scale. The weighbridge op-erator scribbles a note and places it into an empty yogurt carton. This is pulleyed up to a clerk who manages monies from an inaccessible raised platform.

Inside, forklifts push bales of compacted waste this way and that to make room for the new bales being created as plastic bottles are fed into the gaping mouth of a compressor. The skittish shifting as forklifts race, turn, reverse, and near-miss each other has the logic of a video game. A bang like a gunshot cracks the air as the wheel of a forklift pops a bottle.

Across town men are queuing outside a similar depot in the southern suburbs. Some have arrived with eight bags. After weighing their goods, reclaimers line up at a head-height hole in the brick wall. They reach up to cash in their receipts. The invisible paymaster is Michelle Harding. A high-security metal door shields her office. I ask her what the daily income of reclaimers is. She says the lowest is R50 (US$3.48) per day and the high-est, R800 (US$55.66). But she cautions that very few people clear the maximum. "It depends on having access to PET," she says, referring to the hard plastic that is the most valuable recyclable. "Recycling is good busi-ness, but it's very hard work. Some walk twenty kilometers to get good prices here." Michelle talks of the "interesting recyclers" she encounters each day: a teenager who works as hard as the toughest of the grown men, a recycler called Moses who insists on walking barefoot even though he has been given shoes.

One recycler comes empty-handed to the hole in the wall. He says, "I need a plan for forty rand. I am owing someone." Michelle opens her hand-bag and takes out the money to give to him. "I know each recycler's voice even though I can't see their faces," she says. "I love these guys."

No Charity

"I don't have to stand on the side of the road and beg with a cardboard," Frans Fourie says. "Every night when we get home, we have a plate of food." The family works wordlessly. All three pull the single large metal trailer that Frans has constructed. They are an unusual sight among the ranks of the reclaimers. They are white. And they work collectively, pulling their cart together and lifting and carrying items in silent cooperation.

For their dyslexic son, Andre, this is an opportunity to work. And it's the first work Marie has done since their daughter—who also lives with them—was born forty years ago. Their church is sponsoring their first holiday ever, but Marie doesn't rely on the church or anyone else for charity. "I bring money in," she says matter-of-factly. "And no one can look down on me." Frans is a pensioner. Reclaiming waste helps pay the rent on the family's small two-bedroom house that occupies a shadeless plot in Rosettenville. As we lean over the wall enclosing a backyard that is also a storage space for materials, countless small dogs bark frantically at us.

Frans looks blankly at children kicking a ball in the road in front of the property. The neighborhood has changed. Where once there were only families like Frans's, now there's a Pakistani family next door, black families across the road. Frans, Marie, and Andre keep to themselves.

Andre is up first every day. Some days he heads out ahead of his parents to do his rounds at regular suppliers. "The Muslim butcher up the road always keeps his boxes for me," he says. Andre has been to meetings of the reclaimers. He says they will be getting municipal smart cards and uniforms soon and will be registered.

At the recycling depot the family works silently to off-load and weigh their load of cardboard. Marie passes the invoice through the hole in the wall. Frans says he never talks to the other recyclers, and as he pulls on his long beard, he says, "They know not to talk to me."

Naleli's Route

Two years after I first met her, Naleli is working alone. Lebo is limping badly, and when he removes his sandals, he points to the black spots on the puffy undersides of his feet. He has not worked for seven months.

The family has moved again. They are living in a green-gabled building on End Street, and, no, we absolutely cannot go inside. Lebo says the man watching us outside the building is "one of the hijackers." Lebo is in trouble with him because he hasn't been able to pay the full R600 (US$41.74) rental for their room for two months.

Naleli straightens Khotso's T-shirt (which reads, "Don't mess with the best"). Lebo beams because it is his morning duty to take his "clever boy" to the neat crèche—a converted shop—around the corner from where they live.

Two schoolgirls emerge from the green building, and their mother follows. She kisses them and watches them walk up the road past the men

who are hanging about on the sidewalk. She waits until they have turned the corner. From here one has a view of Dark City, the notorious building recently fire-bombed by residents in the area. They had grown angry at the gangsters who attack and rob people and run into the building. "They will stab you if you don't give up your stuff," Lebo says. Dark City's bottom floors are now burned out, and the smoke-blackened walls accentuate the murky markings of wastewater and sewage that have leaked out of the building for years. A face stares out from a gaping space that was a window. Clothing is hanging on glassless frames. As in the rest of the inner city, the cardboarded windows are evidence not of a building abandoned, but of shelters being made in its cavities.

These days Naleli is working the nearby Hillbrow area only. She has a cold and an almost permanent headache. Her back and legs are sore. But none of this shows. Her lissome body seems to pull the trolley effortlessly across the road and up the Nugget Street hill. As she walks she shouts greetings and exchanges news with two other women reclaimers. Then she proceeds silently under the arched red pedestrian bridge and past the notorious tenement-style buildings that squat across the ridge and seem to taunt Johannesburg's efforts at gentrification. To the left, the Hillbrow tower begins its watch over her five-hour passage. The shadows of high-rise apartment blocks blacken the streets except where they are pene-trated with slices of blindingly sharp sunlight.

Naleli passes a crèche that advertises its hours—6 a.m. to 6 p.m., Mon-day to Saturday—and walks through the "city improvement district," where building owners are providing top-up cleaning and security services "for a better Berea." As she turns into Banket Street, she glances at the wall that is a noticeboard of handwritten offers of accommodation. Flats to share, rooms to share, beds to share, balconies, lockable rooms, and sitting-room spaces.

Naleli stops in the cold shadow of a thirteen-floor residential tower block adorned with satellite dishes. Several rough sleepers are rolling up their bundles of cardboard and cloth. Schoolchildren are making a game of blowing cold steam as they run past. A father walks by with a baby on his shoulders. A woman steps out of a building in her high-heeled boots. And a man leans against a lamppost, reading the morning paper.

Fifteen minutes later a cleaner wheels bins onto the sidewalk. A man saunters over and asks why we are following the recycler lady. We tell him. He says, "This work is not my style. I am from Ghana; I have come here looking for money, but ... I won't do this work." Naleli looks at him while she

Naleli Kgomo, Hillbrow, 2013

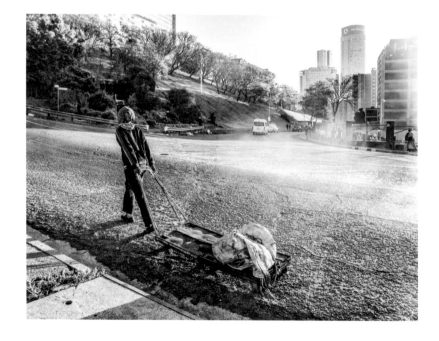

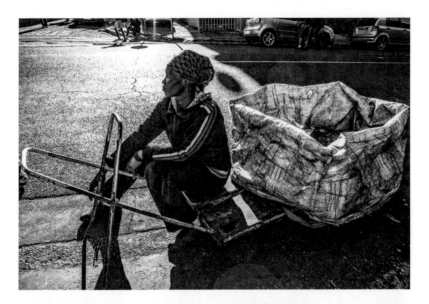

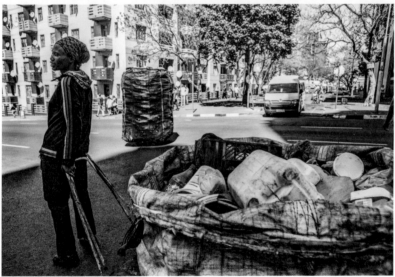

(*Top and bottom*) Naleli Kgomo, Hillbrow, 2013

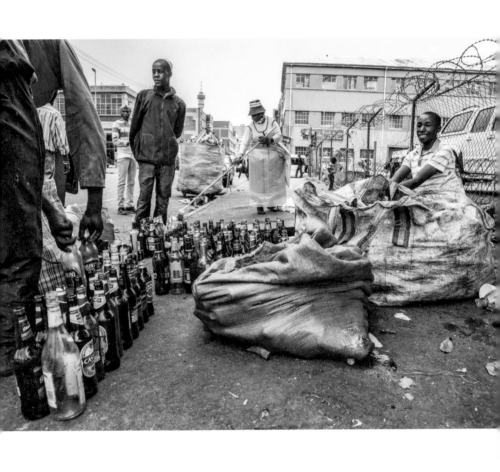

covers her hand with a plastic bag and plunges it into the bins. In addition to the usual paper and plastics, she is collecting glass bottles and picking up metal pipes and frames that lie near the bins. I ask if she is afraid of rats in the dustbins. She says the only rats she ever sees in Hillbrow are dead.

The bins from four buildings in this flatland generate enough waste to fill two thirds of her bag. She says if other recyclers come to "her" dustbins, she chases them away. When she arrives at a main intersection in the business area, she stops. A boy pulls his recycling cart close to hers, and they chat while they exchange commodities. She gives him glass bottles and metal, and he loads plastic bottles into her sack.

As she walks swiftly down the hill, Naleli passes hair salons, pubs, a butchery, a tuckshop, and a TV repair shop, and three mattresses stacked on the roadside. A one-meter shopfront advertises, "Phoneshop, camera sales, photocopy, Nigerian movies, ID photos, same time photos, and CV typing." Washing hangs on the balconies of buildings on both sides of the broad road. Classical music streams out of a third-floor window. A display of two roosters announcing "The Best Chicken in Town" masks the Byzantine dome of the Great Synagogue inside which the Star of David now shares space with a "Jesus is Lord" banner.

A reclaimer passes Naleli, pulling particularly laboriously on his trolley. She laughs. "That's one of the free municipal trolleys. No one likes them. They are too heavy." But in any case she can't get one because "they are only going to South Africans." Naleli says this is funny because many of the reclaimers are from Lesotho. Her own trolley is a repurposed quintessential vehicle of consumption. People sell these shopping cart bases on the street for R100 (US$6.96), often with the brand of the shop still embossed on their sides. "Look there," she says. "You can see 'Pick 'n' Pay' in the plastic."

Weeks later Lebo is sitting on the roadside overseeing rows of bottles. He has become an intermediary, buying bottles from reclaimers and then on-selling them. He makes 70 cents (US$0.05) on each bottle and is able to contribute R650 (US$45.22) to their monthly income. It's not enough to cover their living expenses and the crèche fees, so they have sent Khotso to live with relatives in Lesotho.

Lucas, Given, and Livingstone

Lucas Ngwenya, Given Mattatiele, and Livingstone Sekunda have lined up. It's 6 a.m., and there is a cold wind blowing on this open piece of land suspended between the private estate of the Oppenheimer family and the

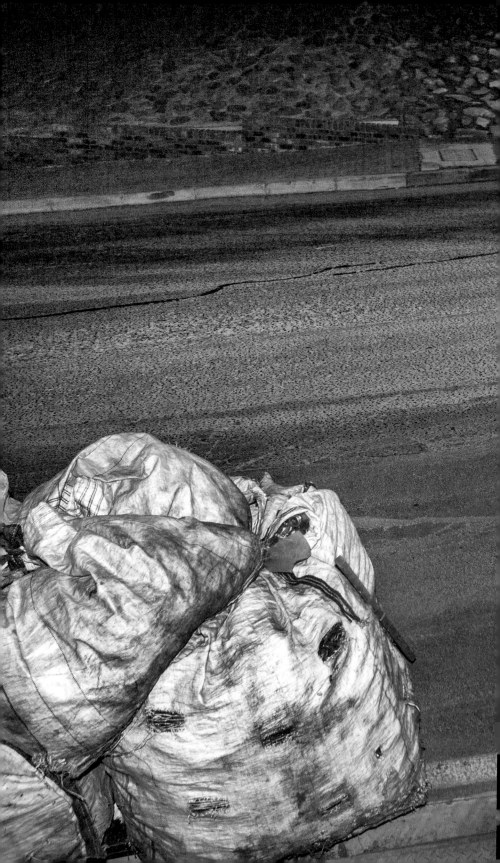

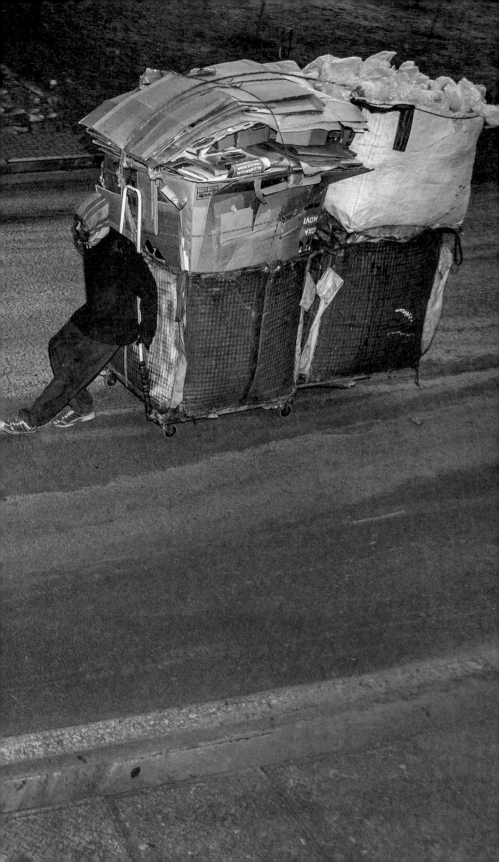

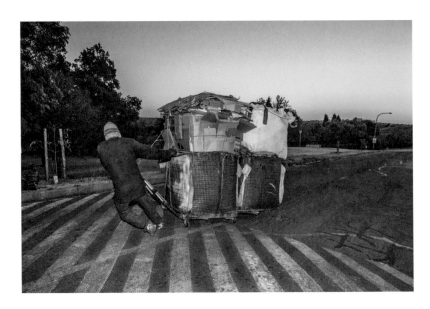

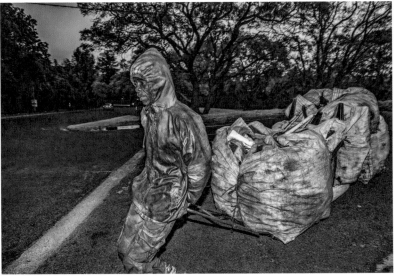

(*Previous spread*) Lucas Ngwenya, Forest Town, 2014
(*Top*) Lucas Ngwenya, Forest Town, 2014
(*Bottom*) Livingstone Sekunda, Forest Town, 2014

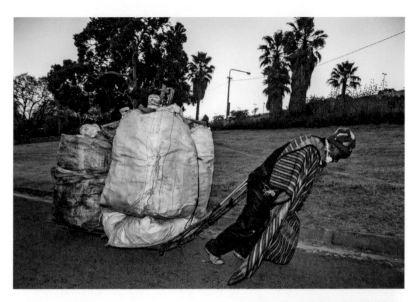

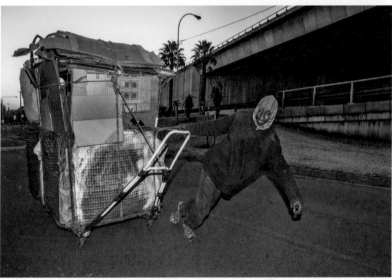

(*Top*) Given Mattatiele, Forest Town, 2014
(*Bottom*) Lucas Ngwenya, Forest Town, 2014

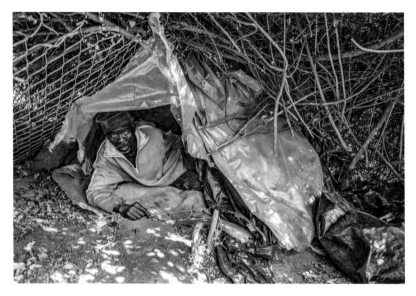

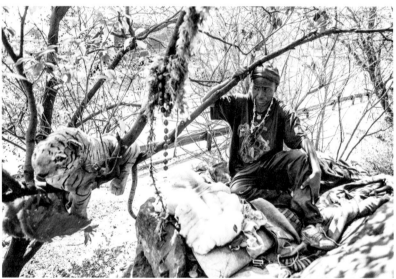

(*Top*) Livingstone Sekunda, Forest Town, 2014
(*Bottom*) Given Mattatiele, Forest Town, 2014

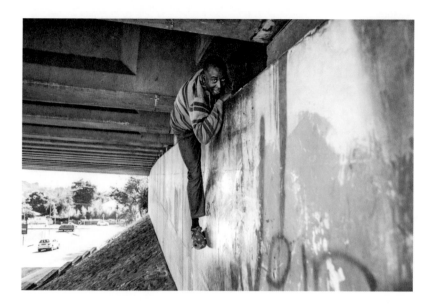

Lucas Ngwenya, Forest Town, 2014

head office of Hollard Insurance. The temperature is four degrees Celsius as the men begin their second trip to the recycling depot in Newtown. It's a five-kilometer journey, but it will take two and a half hours to drag their gargantuan loads over the top of the Witwatersrand.

Lucas seemingly has the lightest burden. He has a double trolley, whereas the others have three articulated trolleys. His three bags are out-numbered by Livingstone's five bags, and the metal objects sticking out of Given's bags add considerable mass to that load. But Lucas points out that the cardboard that occupies more than twice the capacity of the blue plastic quilted bag it is loaded into and on top of will weigh in at over 150 kilograms. And the plastic bottles and white paper will bring this to 265 kilograms. His body mass is 61 kilograms. When he arrives at the de-pot, he will be asked for R10 (US$0.70) "for cooldrink" from the cashier as he cashes in his load. Because, she says, she has been generous with the amounts she has recorded.

They collect waste from different parts of the city, sometimes walking over thirty kilometers in a day. It is more efficient to work together and to stockpile their materials for two weeks. Every fortnight they make the journey to Newtown three times.

They work cooperatively, although each lives alone. Lucas lives in the

167

cavity of a highway underpass, where the repetitive crack of traffic passing over expansion joints on the bridge above him mimics the sound of an evening train. He came to South Africa from Mozambique at the age of twenty-two, to earn money to support his mother and brothers back home. He started out working for his uncle, but when he wasn't paid, he left and started collecting waste. Now he can earn R400 (US$27.83) a week and send money home. "I can turn R100 (US$6.96) into 400 meticais."

The sixty-two-year old Livingstone has used plastic bags and blankets to create a tent-like shelter under a bougainvillea.

Given occupies a ledge on a rocky outcrop, where he is shaded by a tree and overlooks the motorway. "The noise helps relieve my stress," he says. His stress centers on his longing for his children who live in New Brighton in the Eastern Cape. Yellow, white, and red wax stalactites hang from the fissures in the soot-covered rock face. The speckled rats that forage in the surrounding bushes and peep into the burned tins on this ledge cannot reach the packet of rice that Given has hung from the tree branch. On the main ledge of this outdoor dwelling, a flattened teddy bear serves as carpet. A higher ledge in the light shade of a tree is Given's bed. It is covered with blankets, a soft jacket, and a pillow inner. Mobiles of beads, dried herbs, bones, and red feathers cling to branches around the sleeping area. And a fluffy tiger—the size of half a man—stretches across a branch overhead.

Lucas pulls his hoodie tight over his head. The steep descent onto the main road requires him to start his journey not by pulling the load but by resisting it. He leans against the front of the cart with the ironing-board handle gripped behind him. His entire body weight, the power of his legs, and the traction of his rubber-soled shoes brake the load. He skids forward gingerly. He can't look back and steers the uncooperative bulk with difficulty.

As Given passes him and sweeps his load into the more predictable uphill of Oxford Road, his blanket flaps in the wind like a cape. Soon all three bodies are taut and angled. They instinctively sway to counterbalance the rhythm of the carts. The incline is extreme, and bodies are now leaning forward at 45-degree angles, traversing the steepest points on tiptoes. A taxi driver hoots his annoyance as he speeds by, passing within inches of Lucas.

Along the more level side road, the men can take their time navigating the speed bumps. A group of joggers passes by. It's a suburb of chimneyed houses, many with national monument plaques that inform us of the early

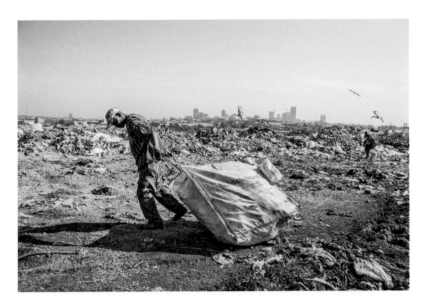

Mbuso Shabangu, Robinson Landfill, 2014

1900s genesis of these stately homes. But none of the materials in these trolleys have been collected in Forest Town. The men are prohibited from collecting here by the private security firm that guards the area. They have been threatened with pepper spray and chased out of the neighborhood. Livingstone says, "You will never find a recycler collecting on these streets." He says he would rather walk far to work where no one harasses him, and he can quietly do this job that he says he loves because he knows that he will never go hungry as long as he can pull his trolley.

They enter Jan Smuts Avenue, which will take them into the inner city. As they turn the corner, the front wheel of Given's trolley slides into the gutter, and the entire load tumbles over. Plastic bottles litter the sidewalk and the road. The pace and effort of pulling is interrupted by the tedious repacking and retying of bags. Then they move again.

For the steepest parts, the men combine their muscle power to pull a single load uphill. One man pulls the trolley while another pushes. It takes them thirty minutes to scale the three-hundred-meter incline of the hill.

The haul is finally at the depot. Between them they have carried 780 kilograms of material along this route. Their combined earnings are R1,200 (US$83.49). They return to Forest Town to collect the third and final load of the day.

Good Riddance

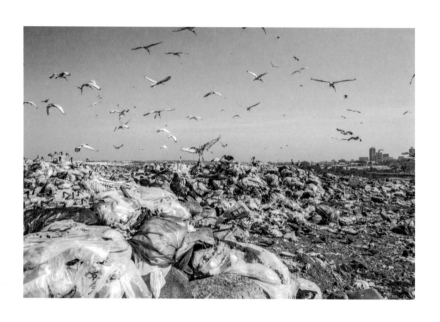

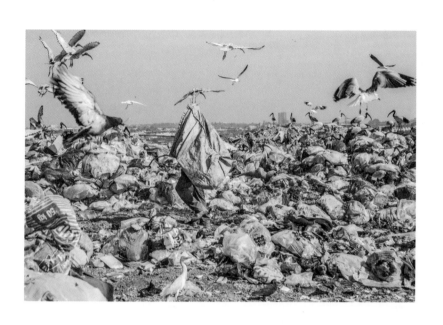

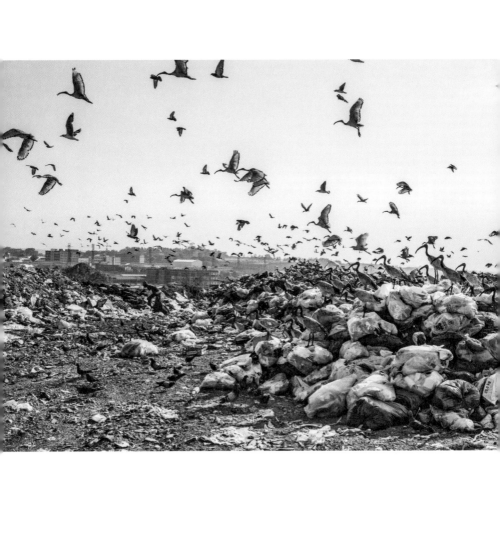

The Landfill

Mbuso Shabangu lifts a bag of clothing from his car boot. He changes out of his jeans and his sleeveless T-shirt that reveals the large THUGLIFE tattoo on his arm. In a soiled pullover, brown pants, and boots, he walks up the road that ascends the landfill site. He has worked here for eight years, since his father died and Mbuso took over his job at the age of nineteen. He is one of a handful of reclaimers who work this site where the City's waste arrives in huge dumpsters. Before the garbage is compacted, these men extract and bag the recyclable materials. Buyers arrive in trucks to collect the material. It's a straightforward and guaranteed income, and these are prized jobs. "I can fill up to ten bags a day," says Mbuso, holding up his first one-hundred-kilogram bag for the day. He employs two men to gather cardboard and plastics for him. "We make a ton a day," he explains. "Six hundred kilograms is mine, and they share four hundred." He earns enough to support his wife and three children in a rented room nearby. He has three cars and is saving up for his next dream—to start a buy-back center.

"We work together here," Mbuso says. "We know each other, and if someone wants a job here, the supervisor will ask us if we can take him in. We must be sure of the person. We want peace here and not stealing. And we help each other. If someone's relative dies, we collect money to help with funeral costs." But the real cooperation here centers on watching each other's backs. Literally. There are rules. Do not come to work sick or drunk; don't make fires; don't take another reclaimer's stock. But two rules stand out: never have your back to the compactor, and watch out for each other's safety.

The dumpster arrives, and for a moment birds and men cluster on the higher ground. As it spills waste, the men pull out the large cardboard sheets. The birds file behind the dumpster. They crowd and shuffle like rats on the ground, pecking for grubs that have been unearthed by the passage of the truck. A water tanker follows, spraying the ground. The driver stops to allow one of the men to fill his cooldrink bottle from the spout at the back of truck. More birds fly in and settle on the garbage as the compactor rolls up to squeeze the soft, acrid piles of rubbish against the latest layer of retaining wall constructed of building rubble. "The birds work six to six, just like us," says Mbuso. There are pigeons, white ibises, egrets, and, astonishingly, seagulls. A recycler laughs from where he is standing knee-deep in the rubbish. He throws his hands into the air and scatters birds, now pink against the light, across the city skyline.

Good Riddance

Tea at Anstey's

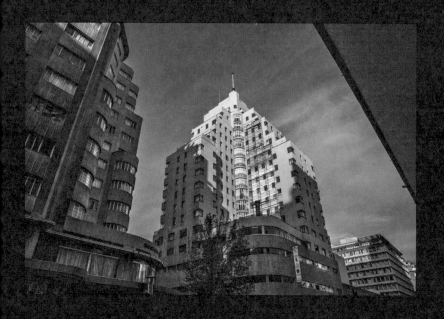

Flat 122

FIVE HOUSEHOLDS USED TO LIVE HERE in makeshift rooms along a dark corridor. Now there's an expansive lounge illuminated by sunlight through large north- and east-facing windows. Where patchy vinyl once covered concrete flooring, refurbished parquet shines and bird mosaics fly across the kitchen and bathroom floors. (I insist that you take your shoes off in the flat.) Glass cabinets in the oval room display books about Johannesburg. An art deco dresser that I bought in Brixton is painted shocking pink. This is my homage to Paula Barry, South Africa's first gender reassignment patient, who lived in this twelfth-floor apartment in the late 1970s.

The balcony overlooks Jeppe Street, which was once the Harley Street of Johannesburg. Now its high-rise medical towers pulsate with customers shopping for discount fashion in hundreds of tiny cubicle shops.

On the day that the last building contractor leaves my flat, there's a knock at the door. My visitor is about six years old, and he says his name is Sam. "Please may I come in?" he asks. "Only if you don't run," I say. The child takes his shoes off and walks around the apartment slowly. Then he stands with his back to the front window and points to the left. "I used to sleep there," he says. Then he points to the open room that was once divided into three. "My friend used to sleep somewhere there." He looks around once more. "Ah, but it's beautiful."

The Lifts

Plush apartments are not new to this old art deco building, which, at twenty stories, vied for the position of tallest building in Africa in the 1930s. It was

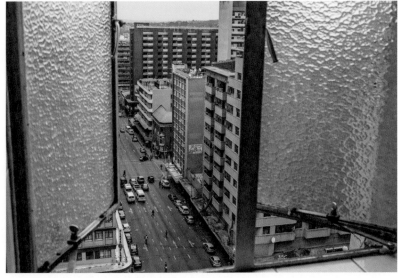

grand to live here among the actors and socialites in the two ziggurat towers that fanned out above an extravagant ground-floor department store. The store occupied the four floors of the podium. Its exquisite window displays were famous in a glamorous pre- and postwar Johannesburg. Brass monkeys clambered up the wall above the entrance to the lifts, or elevators, carrying shoppers from the lingerie or footwear sections to the tearoom on the fourth-floor terrace. Here a singer crooned at the piano while silent women, modeling the latest Parisian fashions, sashayed between tables festooned with teacups, silverware, and pastries. Tea at Anstey's was a treat, and people dressed up for the occasion. Gloves were essential.

By the 1970s, Anstey's was no longer a shopper's paradise. The department store gave way to smaller shops, tailors, and offices. During renovations, the brass primates descended, and now they adorn the lift lobby that services all but two of the fifteen floors of flats, artists' studios, an HIV clinic, and a crèche on the lower levels.

Today one lift is not working. Frustrations are rising in the circular lift lobby—the impromptu meeting point for residents. People blame the new tenants who carry furniture in the lift, the kids, the body corporate, the builders, the film companies doing shoots.

I wonder about the people living here and using the building, and for an hour I watch the passing traffic in the lobby. I make the following notes:

Mother with baby on back.
Teenager with finger in mouth.
Two young guys carrying backpacks and sporting big
 earphones under hoodies.
Teenage girl followed by toddler in pink tracksuit.
Man with cello case.
Man carrying child in Spiderman suit.
Woman wearing towel around waist and carrying
 bucket of water.
Tall, stylish man carrying three shirts and suit bag.
Old man with broken shoes carrying bulging bag on
 back.
Frowning nurse in navy trouser uniform.
Laughing guys carrying crate of beer.
Young woman in chef's top.

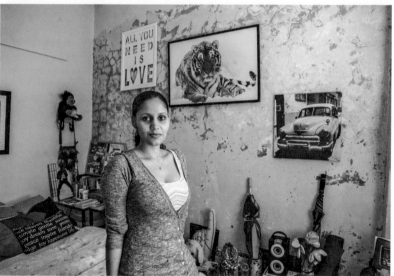

(*Bottom*) Nicole Damoense, Anstey's, 2015

Woman in large sunglasses rocking to loud music from
 phone. (Bright lipstick!)
Stout man with limp carrying two plastic bags filled
 with vegetables.
Small boy yelling, "Yay! New shoelaces! New shoelaces!
 Yay! Yay!"

Some days later, when both lifts are working, Mark and I ride them for a few hours, and when it doesn't feel too awkward to do so, I say to our coriders, "Hi, I'm Tanya, I own flat 122. We're doing stories about Joburg. Could we come and chat to you about Anstey's sometime?" And in this way we collect names and numbers throughout the building.

"No One Wanted to Live Here"

Brenda Damoense is the first to invite us to tea at her flat on the tenth floor. She and her baby daughter Nicole—now twenty-two—moved into Anstey's in the late 1980s. The grand building occupied a prime block in a plummeting inner city and was scheduled for demolition. But a campaign for the preservation of Anstey's, a hopeless property market, a fearful country on the brink of change, and a burgeoning housing demand in townships conspired to make it worthwhile for a pioneering property company to avert the demolition and test a model for home ownership. This would be one of the first buildings in which black people could own inner-city flats. "No one wanted to live here" was as true as "People were desperate to move to the inner city." Many of the apartments were converted into smaller, cheaper units affordable for working people like Brenda. But high costs stalled the renovation, so that what remained was a mix of large and small flats, which, serendipitously, would allow for a mix of households and incomes in Anstey's.

Brenda serves tea and cakes on a tiered cake stand. Then she sits next to her daughter on the arm of the couch. Surrounded by family photographs and the pinks and purples of the snug apartment, they finish each other's sentences as they list the things they do—often together—in the city. "Town is beautiful. There are such wonderful buildings, and you can get whatever you want at any time. We walk wherever we want to," says Nicole. Brenda adds, "We go to church at Central Methodist. We window-shop on weekends. People can't believe it, but there are shops where you can buy gifts for R10 [US$0.70] and clothes for under R100 [US$7.00]." Ni-

184

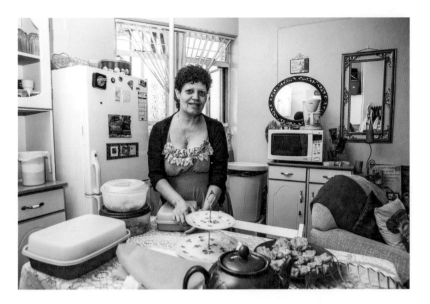

Brenda Damoense, Anstey's, 2015

cole laughs, "We go to movies at the Carlton Centre. It's great, it's cheap, and noisy! People talk at the screen. If someone onscreen behaves badly, the audience shouts at them!"

Brenda is impressed with the security guards in town. She explains, "If you stay in town, you must scream and security will run. My niece was in town, and a guy grabbed her earring. She screamed. Security chased him. The guy swallowed the earring, but they gave him a good hiding."

Everyone mentions crime or safety here. Margaret Mahlaele, who is bouncing her grandson on her knee as we sit in her family's expansive lounge later that day, says, "We came here for safety nearly fifteen years ago. We moved out of a township where there was too much crime. Now our three kids who grew up here say, 'Let's go stay in a township.' And we say, 'No!' We know they're safe here." But resident Sisi Mahlangu, who recently graduated in Australia, says, "We've heard screaming and seen muggings. Don't ever get comfortable in Joburg!" Raymond Mogale feels safe in his seventh-floor flat but is cautious about the area. Just a few months ago, on his way home, he was attacked. The muggers tried to garrote him and left him unconscious—in broad daylight.

The following week we visit Winnie Shabangu in her apartment, which is entered through a wood-finish, fitted kitchenette. The cupboard tops are

lined with shiny pots that the retired bank administrator fills with stews every Friday. She sees herself as one of the forerunners who breached apartheid divides by moving to town. "I was one of the first batch to move out of Soweto when they renovated Anstey's." She looks out of her fourth-floor bedroom window at Jeppe Street below. "I hear the city wake up with these loud taxis." She wouldn't think of living anywhere else, but she gets away from the city a few times a year with friends. "We're going to Plett next week," she says.

But Winnie did not move into a popular building. Within a few years many flats were practically given away on auction. In the early 2000s, as the building became indebted to the municipality, people picked up units for R5,000–R10,000 (US$350–US$700). Records show that in this period a few sold for as low as R100 (US$7)!

There are stories. Like the one about Isaac Radebe, who arrived in Joburg as a young man. He took a job as a gardener but soon learned to drive and to drive fast, which qualified him as a getaway driver for car hijackers. It is said he bought his flats on auction for a few hundred rands with the proceeds of hijacking, and sold them a few years later for a fortune. This was possible because the diminished allure of the building was deep but not lasting. In the 2010s flats would sell for R450,000 (US$31,308), and you would have to listen closely to whispers on the corridors to know if any unit was coming on sale. But that was the future.

In the 1990s the city was an uncertain place, and turmoil engulfed many of its townships. Tembisa, on the edge of the East Rand, was enduring desperate protests and brutal killings that we now call "preelection violence." Norman Ratshidi, a trade unionist, lived there and feared for his family's safety. In 1993 he arrived home just as a bloody street fight ended, and navigated his car around burning tires. He resolved then to leave. He and his wife, Sheila, found this large flat with its vast balcony— "Great for having friends over for a *braai*." Most flats in the building were empty. He shows us around while Sheila polishes the glasses she has taken out of a cabinet. "Dust," she says, pointing to the scaffolding outside the window, where workers are scraping and painting the building façade. Norman reflects on what it has meant to raise five children here. He feels the nearby schools are not good enough. "But they've all managed. And they play soccer in the park near the Mandela Bridge, or hang out on the rooftop of Anstey's—a favorite place for older teens. Or they occupy themselves in town." His son Karabo looks up from his video game: "I don't go out that much."

Neighbors

Palesa Ramatlo, who lives on the seventh floor, does go out. She crosses her bare legs as she sinks back into the cushions of her high bed. We sit on two beer crates facing the bed. It's a tight squeeze between the wardrobe and numerous suitcases, boxes, and piles of linen. Palesa says, "I love it here. The weekends in town are perfect. I go out all the time. I go to all the clubs—Buffalo Bill, Capellos, KissKiss (where men throw their car keys and wallets onto the table to impress you), Chisanyama, Fattis (in that hijacked building around the corner), and Jozi City." She strokes her waist-length braids. "Definitely I'm hot. And there are so many guys in this building. We chat in the lift. They call me Rihanna because I don't like to wear much."

Palesa's flatmate, James Amaoh, a clothing designer from Accra, learned his trade by watching designers and tailors. Surrounded by multi-colored swathes of heavy, wax-patterned fabrics, he pins the waistline of a bubble skirt modeled on one I have shown him. "It will fit perfectly. I am a very good copycat, Madame."

"Anstey's is a creative hangout, and it hosts community within community," says Achal Prabhala, a writer from Bangalore who rents my apartment when he visits Johannesburg. He lists the vocations of residents he knows in the building: artists, journalists, musicians, photographers, fashion designers, architects, a curator, a sculptor, and an urban planner. Where else could he have created an entire photo comic in one apartment, with props gathered from the building and characters drawn from resident impromptu actors? In two days!

Cellist Tshepo Pooe and journalist Sophie Ribstein are delighted to show us their sixteenth-floor apartment. "You never know, maybe Mandela stood here or here," Tshepo says, reminding us that when he was captured in 1962, Mandela was disguised as the driver of actor Cecil Williams, who lived in this apartment. Living in this historic building in the city center is a natural continuation of Tshepo's family geography that is utterly rooted in Johannesburg. "No one remembers any ancestor who ever lived anywhere other than Kliptown, Sophiatown, Fietas, Newclare, or Soweto," he says.

Masimba Sasa is securing tenants for the Anstey's artists' studios. On an early Sunday morning we visit him and Sisi Mahlangu in their fifth-floor flat. He turns off the gospel channel on the TV and pauses thoughtfully before describing his experience of neighborliness in Anstey's. "It's the most amazing thing: people talk to you and invite you. All sorts of people." He cycles with filmmaker Matthys Boshoff, walks around town taking photos

187

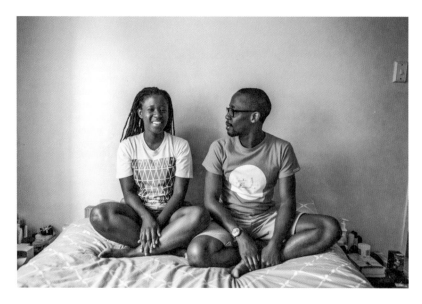

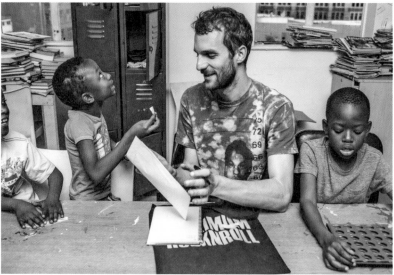

(*Top*) Sisi Mahlangu and Masimba Sasa, Anstey's, 2015
(*Bottom*) Gilles Baro with Keneilwe and Neo, Anstey's, 2015

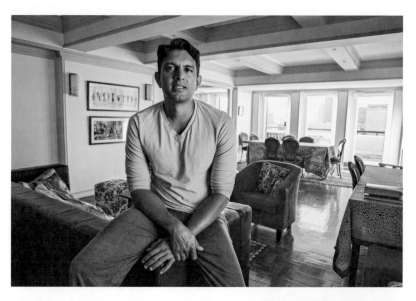

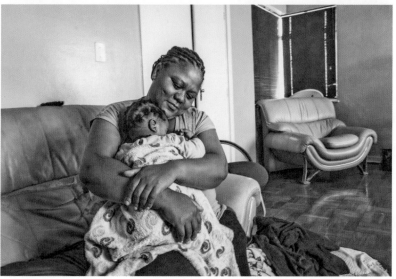

(*Top*) Achal Prabhala, Anstey's, 2015
(*Bottom*) Margaret Mahlaele with her grandson, Anstey's, 2015

with fellow photographer Calvin Copeling, goes to parties at Ma Sarah's, and has drinks and dinners with people in the building like Alex Cunningham, "who doesn't bother much with the cool kids but invites everyone." When they got Wi-Fi, Masimba and Sisi shared it. First one neighbor then another knocked on the door to say they needed internet for school homework or work. "I became the go-to guy for computer questions, setting up email addresses and helping people prepare their CVs," he says.

"This building is a test tube for a real community," says Tshepo. He and Sophie also do homework supervision and have many friends in the building. Sophie says that after three years of living in Melville, she didn't know a single neighbor.

"Hell no!" says Meghan Judge, when asked if she would consider moving to a trendy apartment in Maboneng, the upgraded and upmarket precinct that is fifteen blocks and, for some, a million miles from this building. Anstey's ticks the boxes for being "more central," "functional," "close to every shop and service you could need," "beautiful and historic," "more affordable," "more real," and "a community."

Sound

Meghan, who shares a flat with her partner Gilles Baro, chats to us in an open-plan bedroom-lounge that also serves as a study. Books, art, bicycles, computers, and a tabby cat reveal their lifestyle: Sophie is a graphic artist and Gilles a linguistics PhD candidate. She loves the varied soundtrack of the city: the calls of street traders and the cooing of pigeons feasting on sidewalk litter filter into her blue art deco bathroom. During the day she can hear boom boxes touting the latest disposable fashions, the peddlers on Jeppe Street, the hooting and revving of engines at traffic lights. At night it's shrieks of joy or drunkenness outside the twenty-four-hour café, sirens, and the occasional sounds of violence.

The building itself is not noisy. Raymond, an amateur DJ, often meets with friends in his flat to produce music. His neighbor is not even aware of the sound. Kiwith Phetla, who grew up in the front flat that he and his three brothers still share on the eleventh floor, says they have friends in other buildings who complain of noise, while here, "You can play your music as loud as you like without disturbing the neighbors."

Urban Living

They say if you hold a party in Anstey's, someone will try to move into or buy your flat. Soon after she arrived from New York to take up an internship in urban regeneration, Alex came to an event at Anstey's. She never left. "From Anstey's I walk five minutes in any direction and I'm in a different world." While she hands us glasses of wine—her graffiti-style wall murals behind her—we look through the fifth-floor bay window onto buildings skirted by high-end shops and street traders along Joubert Street. It's the road that she and Andries Mkhatshwa and their schnauzer puppy, Isabelle, take to Boundless Café on Gandhi Square. It's also the route to the mini basketball court in Ernest Oppenheimer Park, where Alex has started a three-a-side basketball tournament.

The couple know many people in Anstey's, including schoolkids who pop by for help with homework. "Our neighbors Sarah and Phil often bring us things. And I bake muffins for them. I've watched their kids grow up."

The Library

Richard Adin, the security guard, is doing his rounds. He pops in to watch the Connect Four championships in the fourth-floor library that was set up by volunteers in the building. Tonight there are fourteen kids, all under ten. It's Gilles's weekly shift of supervising kids, and they throng around him adoringly.

Gilles directs in a calm, measured tone: "Take your time, guys. Remember your strategy. This is like chess. It needs concentration." In the same soft-spoken tone, he gently admonishes the young audience standing around, eagerly offering suggestions to the two contestants. "You don't like it if someone talks while you are concentrating." The kids quiet down. Gilles focuses on the contestants again, encouraging them to be confident. "Play whatever move you want. Look carefully and then decide for yourself."

Sometimes Gilles takes the kids on outings to the public library or to exhibitions in town. He smiles about how he once had to tell them off for boasting that Anstey's kids were better than kids from other inner-city buildings. Stephen and Nthabiseng, teenagers who have grown up in Anstey's, confirm this. "We never hang with kids from other buildings. They aren't like Anstey's kids."

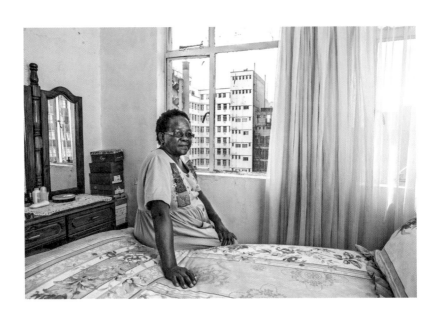

Winnie Shabangu, Anstey's, 2015

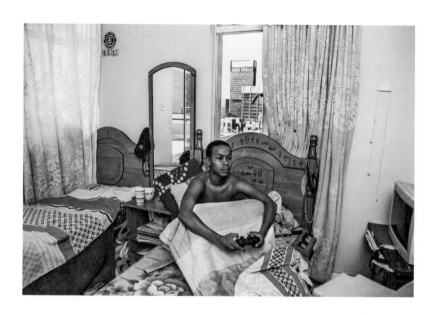

Karabo Ratshidi, Anstey's, 2015

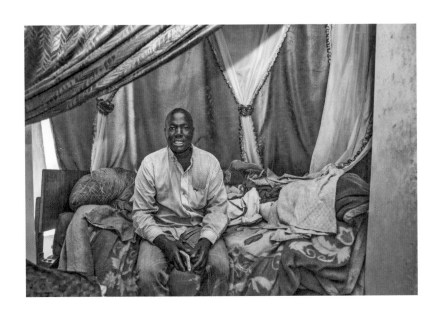

Papa Ndui, Anstey's, 2015

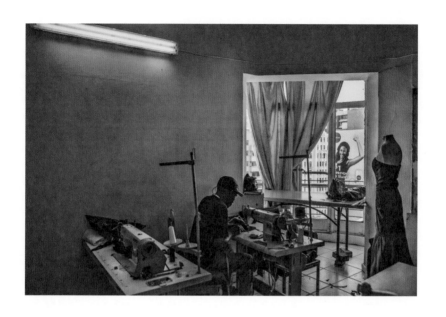

Praying

We go from there to Connie Seetelo's seventh-floor flat. When she and a few young neighbors have finished their Wednesday-evening prayer meeting, they talk about the building. "It's true. Anstey's is the center of everything," says Connie, who jogs to work in Braamfontein. She's been in the building for twenty years and has raised her children and her disabled niece here. She beams as she talks of her son, currently in Amsterdam, who graduated from film school and is a cameraman with a TV sports channel, and of her daughter who is heading to film school next year. The youngsters in the room reminisce about Freddy the drunken caretaker, about Susan who used to yell at them, about the Anstey's kids arts project run by volunteers for a few years, and about how they used to scream and run when they saw the lady with the mud-like lotion smeared on her face. Connie says, "This is not an anonymous building. Sometimes residents hold all-night vigils. Like when Madiba died. That night there was a spontaneous all-night prayer meeting with candles on the terrace."

"You can talk to Mohamed while I do my prayers." Papa Ndui unfurls his prayer rug next to where Mohamed Diouf reclines on his bed. I don't want to continue talking while he is praying in what is both sleeping space and living room. I sit on the edge of the easy chair beside Mohamed's bed, wondering if he regrets letting me come talk with the men who live here. My respectful silence has little point given that both television sets are flickering, one broadcasting football and the other, stacked on top of the first, a soap opera. The iPod at Papa's knees transmits news from a Senegalese radio station.

As in several other flats, the bay window is an alcove bedroom, its arc of glass made redundant by fabric draped tent-like over the bed. Papa sits there while he talks of his work as a clothing trader in an economy that is "down, down, down." To manage his cash flow, he buys and sells on the same day, every day. It makes the day long, and so the flat is just a place to sleep. There's little time for mixing with anyone in the building. "But it's a beautiful and quiet place. Even if you don't lock your door, you're safe here."

Bonze Seetelo, Connie's niece, sits on the arm of a chair in the TV room–cum–sleeping area for two of the six family members who share a fourth-floor flat. The tight space is compensated for by the large terrace, where Bonze's younger children play with the other preteens in the building. She used to live in a "managed building," where security was so tight you had to pay R150 (US$10.50) per night if a visitor slept over. At Anstey's

visitors don't have to hand over their ID documents. And Bonze's nephews, who are joining the throngs of recent matriculants in search of work, can stay with her while they job hunt. Bonze says the street trade outside is one of the benefits of living here: "You pay R16 [US$1.10] for tomatoes in a shop but R5 [US$0.35] for the same quantity from hawkers, and theirs are fresher because they come from the market every day."

Light and Dark

Vaughn Sadie (whose flat is famously spectacular) says there's nothing you can't get fresh and cheap on the streets. "Except baby spinach and rocket," he corrects himself with a laugh. When Vaughn scouted his options for accommodation in Johannesburg, it was a no-brainer to choose to rent on the seventeenth floor of Anstey's. For the same price as a cottage at the bottom of a driveway in Melville, he has an apartment that opens onto two private balconies, each a large outdoor living room. For a lighting sculptor, this is perfect. From one of the retro chairs in his lounge, Vaughn gestures toward the windows and walls. He explains that Johannesburg's incredible light tracks through the flat throughout the day: "At sunrise the flat is a wash of orange. That shifts to blues and then white. If you leave the blinds open, the whole flat is bathed in changing colors."

Sarah Nare's only complaint of her abundantly filled apartment is that there is too much sun. She has dealt with this by turning the living room's back against the northern light. It's 9:30 a.m. and Sarah has just walked in from her night shift as a pediatric sister. She's been away from home since 4 p.m. yesterday. Now these closed curtains and the large wall unit—heaving under porcelain curios, crockery, glasses, photographs, personalized Coke cans, and plastic animals—flank a cove where Sarah sinks into generous couches.

The closed room is in no way a metaphor for seclusion. While we have tea and biscuits in the lounge, several teenagers drop in to play Xbox with Sarah's sons. The balcony is permanently ready for a *braai*, to which everyone is invited. More than one person in the building says, "There's always a party at Ma Sarah's."

Of the furnishings and appliances—some in duplicate—that crowd the apartment, Sarah says she buys things that last and buys them while she can. The decisions to purchase the fridge and the TV and the enormous sound system that is always party-ready were made collectively. "If there is something to plan, we have a family meeting. We work out

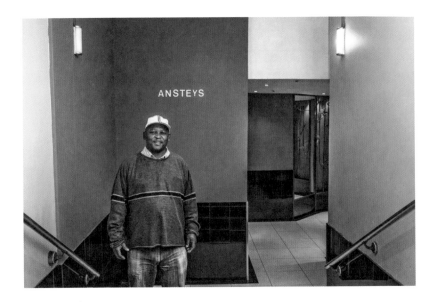

Humphrey Lenong, Anstey's, 2015

the budgets together. We save up over the months for that school trip or that thing that is needed." In this way money has been saved for special items like the sleek dolphin coffee table sculpture displaying mementos and acquisitions.

Caretaking

Thirteen years ago Humphrey Lenong stepped into the caretaker shoes of the likable but capricious Freddy. He tells us, "Lots of people in Anstey's were sewing clothes. They paid rent to Freddy. He banked the money. Sometimes he kept a bit to buy liquor. Someone ran a *shebeen* on the third floor, and Freddy ran another on the second. People from surrounding buildings came here for drinks. And there was drinking in a music studio on the second. Singers and choirs used to come—you know how artists have a thing about drinking while recording." Under Humphrey's watch these things were slowly turned around.

He walks us around the building, pointing out the heritage plaque at the front entrance and less obvious historic details, such as plastered reveals at apartment doors that show where the milk hatches used to be. Few complaints or building defects surprised Humphrey, who had man-

aged a workers' camp at Mossgas for years: "The building is great, but it has a lot of defects. The downpipes from top to bottom are leaking. And there is vandalism—people unscrewing balustrades or painting graffiti in the stairwells. And of course the lifts always give trouble..." We ask him if the rap jumpers who leap down the side of the building once a month—in a sort of bungee jump–cum–rappelling extreme sport—are responsible for loose chunks of plaster that occasionally tumble off the façade. But he says, "That's a waterproofing problem."

Marshalling the resources for these mundane but critical things takes energy and a deep devotion to the building. The task goes beyond maintenance. The effort required to direct the municipality's focus toward the interests of the building when these compete with the concerns of street traders, taxis, or surrounding businesses has strained the charm and feistiness of urbanist and heritage architect Brian McKechnie. Passionate campaigner for inner-city revival, youngest member of the Rand Club, and pioneer hipster investor in Anstey's, Brian has helped locate the building firmly on the city's heritage trails and social pages. Several tenants say they may have differences with the body corporate, but in Anstey's they report problems to Brian, whose phone number they all have.

"It Was All So Erotic"

Before its demise in the early 1960s (did the family really lose the eponymous building to a gambling debt?), the Anstey's store had expanded to a full city block. Signs found in the building's basement show that in the years thereafter the fading structure hosted low-grade offices, a school, tailors, *sangomas*,[1] and the Maria van Riebeeck Club. None stayed for long in the decades during which the inner city stumbled from optimism to pessimism and back again.

By the early 1980s, the state and property owners were falling over each other to flee the inner city. The investment drain ensured that still-glamorous buildings lost value to the point that young people seeking escape from the constraints of home and regime could afford to move there. In the basements of these buildings were gay and alternative clubs with names like Anaconda and the Dungeon, whose patrons included goths, punks, Rastas, and New Romantics. "It was all so erotic," says Lenard Korner, who moved into an apartment in the ship-like Astor Mansions on Jeppe

1 An isiZulu term describing traditional healers.

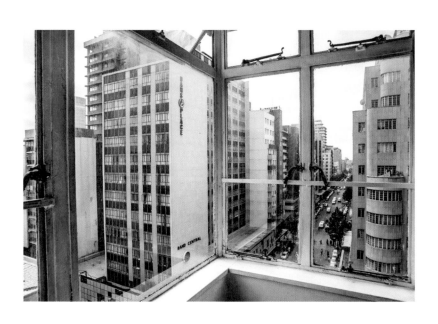

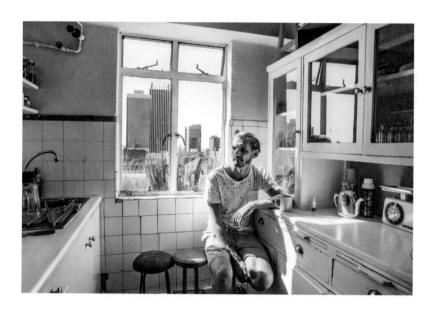

Vaughn Sadie, Anstey's, 2015

Street. The spaces there and in buildings such as Anstey's were turned into glamorous apartments where, Lenard says, "we did everything and everyone. It was a rich time."

In the 1970s Lenard had spent a high school year at Studywell College, then located on the seventh floor of the building. He recalls watching from the doorway of Anstey's as people got off the bus outside the cylindrical, glass-fronted Smokers' Corner ("an island of luxury, selling cigars and lighters and pipes") on the ground floor of Manners Mansions. There were coffee shops, an American-style diner, the Flame Grill Restaurant, and clothing stores like Scotts and the chic Smiley Blue, where Yvonne and Thandi worked. "I looked out for them every day. They were so gorgeous in their platform shoes, their fur-collared leather jackets, their sunglasses, and their Afros. I had never seen black people like that, and I fell in love with them."

Once a year, Lenard watched the decorated floats of the Wits Rag pageant go by from his grandparents' glass-and-marble flat in Africa House, just behind Anstey's. "My grandmother would serve hot croissants bought at the downstairs bakery."

The Answer to Every Modern Woman's Prayer

In a glass cabinet in the elegant octagonal lift lobby of Anstey's is the last remnant of the grand department store that opened its doors here in the 1930s. It is an advertisement that reads: "The grocery floor is full of good things to eat ... full of things you've wanted. The things you've been denied.... Take a walk around the store, cast your eyes around the counters and shelves ... your search for the better things ends here. Everything you want ... get it at Anstey's." It concludes with a promise: the store's fashions are "the answer to every modern woman's prayer" (Macmillan and Rosenthal 1948, n.p.).

The corridor from the lift lobby leads through glass doors to a sidewalk of broken paving and gaping holes. The cavity directly outside Anstey's has been partly covered with a slab of granite, presumably left over from the renovations of one of the grand apartments on the upper floors. I look up. Then I walk the length of both sides of the Anstey's street-front. A group of women and children are eating and chatting at a ten-seater plastic table wedged between the vegetable stall and the food stand to the right of the building's entrance. The intersection of this Joubert Street sidewalk with the highly designed Kerk Street Market—with its zigzag roofing

and canopy of trees over neat stalls selling everything from bananas to goldfish—is a prized position. It is occupied by a veritable general dealership of pocket-size items on a makeshift countertop displaying loose cigarettes, makeup, glue, snuff, biscuits, toothpicks, stationery, toothbrushes, batteries, needles, cotton, combs, facecloths, and small mirrors. Like the yogurt and sour milk stall on the sidewalk opposite, this trader is delighted to be at the crossroads of two lines of hawker stands, on the busy street that leads to the station. "Everyone is my customer," the yogurt seller tells me. His commentary is interrupted by the cry, "Thirteen rand burger. Burger thirteen rand!" from a tout who flashes a picture of the burgers for sale at two food stalls. Beyond these, a hair braider watches over her shoe stall while she leans over the plaits of a customer's hair. She shouts at her friend, "Go home now! Stop standing here talking; time to go home!"

Further along, neat rows of psychedelic nail polish, costume jewelry, and makeup compacts are displayed on tables and boxes near large bags of yellow and red corn puffs. Toy helicopters and cars share a stall with combs, hair bands, sweets, and avocados, and a vegetable seller close by displays tomatoes, bright spinach, beans, and onions.

The once-a-week spice vendor offers me a recipe for chicken curry. "You will need Durban curry, biryani masala, curry leaves, dhania, and crushed ginger and garlic." She packs these into a bag before I can protest. I stoop to read the handwritten labels on the small packets of yellow, red, and green promise: parsley, celery, dhania, and garlic powder, "all in one," "Durban masala," "pickle fish," and "mother-in-law." "Don't you know this one?" She raises her eyebrows as she points to the latter. "Everyone knows it's a hot curry." She begins to recite the recipe but is interrupted by a preacher whose voice booms down the entire block. "Oh Jesus oh Jesus oh Jesus. . . . But when we see him!"

The preacher's call crescendos alarmingly: "If you walk outside of your purpose, you will *never* find fulfilment in your life!" he warns from a tiny television screen on a counter in a cubicle shop that is also a hair salon. As the spice vendor reads the last line of the recipe—"Serve with pride and joy!"—the preacher lifts his eyes toward the tiered building opposite him and proclaims, "All things are possible." 205

(*Top*) Brian McKechnie, Anstey's, 2015

From A. Macmillan and E. Rosenthal, *Homes of the Golden City* (Cape Town: Hortors, 1948)

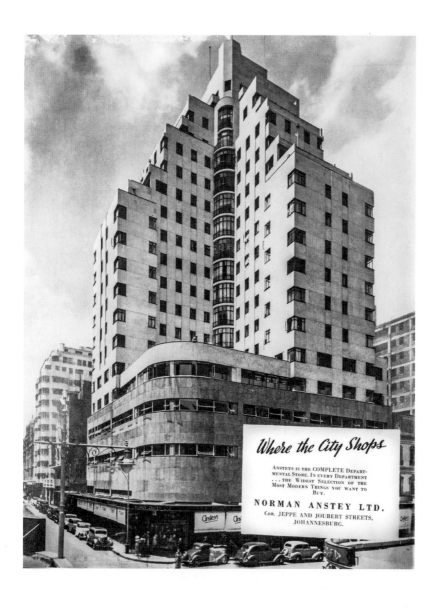

Bedroom

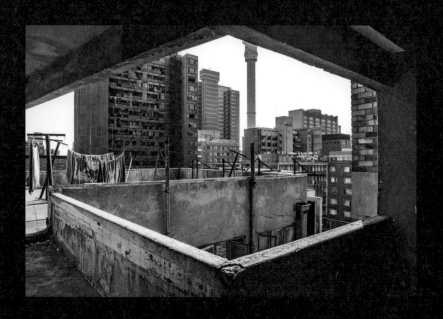

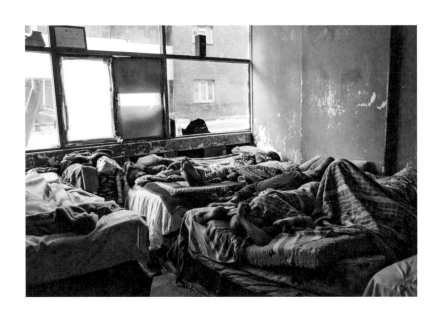

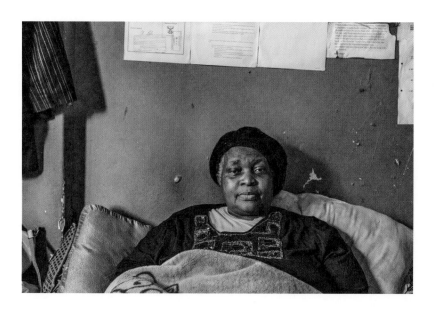

Birthial Gxaleka, Hillbrow, 2016

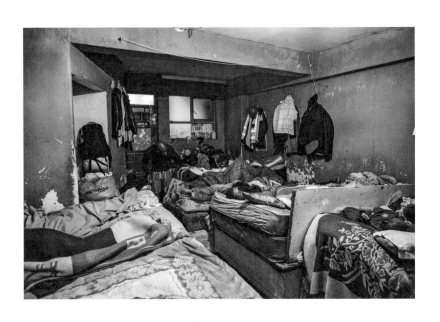

Finding a Place

BIRTHIAL GXALEKA'S EYES LOOK TIRED. She lies sideways, leaning heavily on one forearm. Her languid pose belies a sharp attentiveness. From her vantage point on the bed at one end of the room, she misses nothing. She watches each person thoughtfully, now and then joining in or interrupting conversations.

"Here, let me hold that bowl while you get the baby to sit nicely."

"Hey *wena*, have you got your CV?"

"Ai, be careful of those girls!"

"Come sit here with Gogo."

She turns to me: "I know all their languages. Even these young ones. They are surprised, but I can talk tsotsi taal to them! I tell them my rules in their own language."

I'm sitting on Birthial's bed, curious to understand this place that David Majola, a writer friend, has told us about. When he's down on his luck, David sometimes spends nights here.

Birthial's bed is one of eleven flanking the walls of this one-bedroom Hillbrow apartment. The only standing room is a narrow corridor between the raft of beds, which means when people are home they are on the beds.

Today the apartment accommodates thirty-four people and their belongings. Some days there are more. Birthial explains, "I have never chased anyone away. I'm living with the world here. All religions, all genders, all states of health, all ethnicities, even qualified gays, they're all here. This is a place for people who come to look for work. I help them and then they move on. Except that some don't because they can't find work. Others come back because things go wrong for them."

This is not typical of Hillbrow's dense living, where people often share rooms in apartments subdivided with curtains or drywall. This is different. Birthial begins to tell me about her flat and invites residents to add their stories. Mostly we talk on one of the corner beds that the older women share.

Sbonakaliso Madlala always knew he would head to Joburg straight after matric:[1] "I really want to be a mechanical engineer. I came to my granny whose pension supports ten people. Five are here and five are at home in Nkandla." I look around to match him with one of the women, but he says, "No, my granny doesn't live here. I left her place because it was overcrowded." That surprises me because he now shares a bed with four others. "In my grandmother's flat there are only women of the family. I can't stay with them. And I must look for a job as a man. Even if it's crowded and we share rooms with men and women here, it's not family so it's OK." Sbonakaliso came here because he heard on the street that Birthial helps people find jobs. "I go with the other guys to look for work. But most days I just stand outside this building."

"I was so confused when I arrived in Joburg as a young man," says Malindi Yeko. "I stayed in Yeoville, and I did a course in sound engineering. Friends helped me find work. But I lost my way. I became a coke addict. The industry does that to you. They all do it, the whole crew. They're all sniffing, but it's never talked about. I've been in rehab and am still clean after three years. I'm trying to move on. I work to conscientize kids to stay away from drugs. In this flat I sleep on the end bed. Five of us squeeze in to accommodate one another."

I notice that most of the beds are really layers of beleaguered mattresses.

"Hillbrow is worse than the Hillbrow I knew. It's the crime capital. It's the dirt capital. It's the drug capital. It's a devil's paradise," says Malindi, who was stabbed just outside the flat.

Sandiso agrees that Hillbrow is a place of crime. "You see, too many people hang around Hillbrow. I was escorting a friend to a taxi when a guy stabbed him. For R50 [US$3.50] and a phone." Sandiso has fallen on bad times. At thirty-nine, his impressive CV includes doing infrastructure assessments for hospitals, managing sidewalk upgrades, and being operations manager at a construction company. "But nowadays I have to hustle to eat," he says. When he lost his job, he headed to Joburg. "I've always had buddies from Transkei in Hillbrow. We meet at amaXhosini tavern just

216

1 Final year of high school.

around the corner, which is where I heard about this flat." I'm surprised there is a Xhosa tavern, but Sandiso says, "Of course there are taverns where we can speak our own languages. There are also taverns known as benBatswana, emaShanganeni, emaZulweni, emaVendeni."

Mkhokheli Nojoko shares a three-quarter bed with four other men. When he's not selling recycled trash, he's looking for work. "Sometimes I get a piece job for three days, then I deposit money for my kids. I have two children, aged six and two. I have responsibilities at home, and I'll never give up." At twenty-three Mkhokheli is also trying to help his mother in Qumbu to support his five younger siblings. But he often has nothing for himself or to send home. "This grandmother is a hero," he says quietly. "She sees I'm hungry and gives me something to eat."

Birthial may offer food when she has it, but equally important is her navigation of state processes to get assistance for her tenants. Like Stella Manoqalaza, an elderly woman who was brought to Birthial by a church. Stella had been abused and abandoned by her family. After ten years of living on the street and in drainpipes, she was almost deaf. It took some time to understand her story, but once she did, Birthial pressed every agency she could to get help for Stella. In the process Stella was reunited with her grandchildren, who had been removed from the abusive household by social workers. "After ten years this old lady saw her grandchildren. I took her there. Look, here is a photo of them together. We'll now try to help her get a disability grant. And we'll work with the social workers to ask if the children want to stay with her, and with the housing department to try to get her a house."

Lindiwe Skosana, who is visiting the flat, tells me that she came from the Eastern Cape and stayed until she found a nursing job. "Gogo has a directory of organizations. We phone and we go, we phone and we go. She gets you on the go. I've improved my life and am renting my own flat in Hillbrow."

Sindy Mlangeni wants to be a social worker. But today her pink slacks suit, wig, and blue eye shadow hint at her other dream to be an actress. She had never been to Joburg before she matriculated. "My friend invited me to share her shack next to Jeppestown hostel. It was OK for a while, but she was a partying person and we didn't get on." Her slight body takes up little space in the flat, and her belongings fit into a single bag that she prises from the tower of luggage blocking the thin light from the balcony window.

Bulging plaid shopping bags and tog bags heave like soft hippos on top of swollen suitcases.

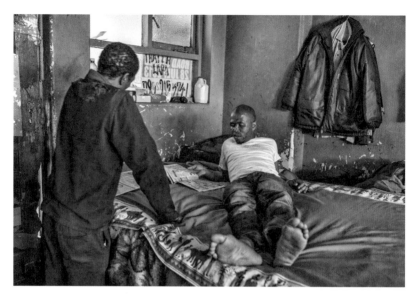

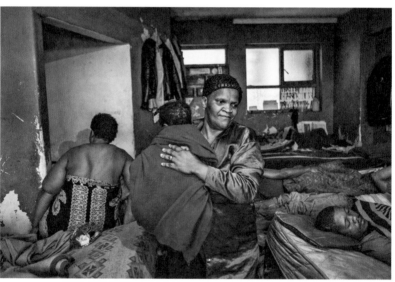

(*Top*) Siya, Hillbrow, 2016
(*Bottom*) Grace Martens, Hillbrow, 2016

Ablutions

Sindy is not unaccustomed to crowded living—she comes from a big family in a small home in KwaZulu-Natal—but she struggles with the lack of privacy here. "Sometimes we ladies go wash at the public bathhouse. There you can wash your whole body."

"But not here," says Noluthando ("call me Jojo") as she fills a kettle from a large plastic drum. When it has boiled, she pours the water into a green basin and squeezes past Wellie Hankombo, who is carrying his basin of used water out of the bathroom. "Those who need to leave early for work or job hunting go first," says Jojo, "and some wake at 3 a.m., wash, and then go back to bed."

In the bathroom there is no water flowing from the taps. The boarded-up windows offer neither light nor ventilation; the cracked basin is a surface for soap or facecloths. Black streaks of mildew are ingrained into the once white tiles. The equally blackened bath is not used for washing—its reservoir of brown water is bucketed out for flushing the toilet in the adjacent cubicle.

When she emerges from the bathroom, her pink *kikoi* wrapped around her body, Jojo explains, "You have to hide yourself to dress. We ladies hold a sheet for each other." She opens her suitcase and places it and her clothing, mirror, and toiletries on one corner of the bed she shares with four women. Today she is relying on me to shield her body as we talk. Still, she keeps a lookout, doing an elaborate dance of winding and sliding and tugging limbs and underwear under her *kikoi* until she is dressed and the cloth drops to her waist. She reaches for her deodorant, all the while telling me her story. She is from Lusikisiki. She trained as a health care worker, and when she could not find work, a friend told her about Birthial. In Joburg she worked whatever jobs she could, as a street sweeper, a data capturer, a volunteer in a surgical ward, a night nanny.

"In 2012 I got a call. I had to go home to care for my sick mother because my sister was too ill to help. They both died in 2013. My mother had been taking care of my child. Now I had mine and my sister's to care for. I came back here to earn money." She got short contract work serving tea to construction workers on the municipal pavement, upgrading projects in Hillbrow. "I saved to go home in December, to put something on the table. When I arrived, the situation was worse. I had to use all my money. My cousin helped me to get back to Joburg." Jojo returned to the construction site. She is trying to save money to buy a school uniform for her child.

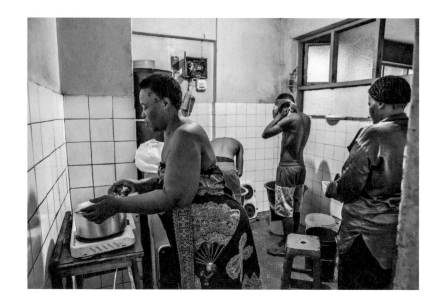

"My dream is to become a nurse." Jojo pulls skintight black leggings over her large thighs and tells me, "It's crowded here, but that's OK. If you're lonely, you can be suicidal. When I sit alone, Gogo says, "Hey don't do that." I'm coping because of her. If I miss my child, she says, "Maybe I have airtime for you." But there are challenges in this flat. Some guys take nyaope. And they steal, so you have to sleep with your phone. Someone stole mine—my photo of my child was on that phone."

Rules

"Oh I see someone has been careless, leaving her panties and facecloth hanging in the bathroom," observes Birthial as she shuffles past the open door. "When you have washed, you must leave things clean for the next person. That's a rule." Birthial lists other rules, "No smoking. No alcohol. No fighting. Respect each other. And if you are in the room here, we talk English. Because you need English to qualify to work."

Under her pillow, Birthial keeps lists of names of people she has helped. The chest of drawers—the flat's only nonbed piece of furniture—holds the precious items (mostly CVs and ID books) that current tenants want her to hold for safekeeping. She also stores their secrets: who is burdened with illness, who needs to safeguard a frightening or shameful story, who is afraid of this communal living.

There's a flurry of movement as everyone climbs off beds and squeezes into the narrow passageway between the rows. They shift and shuffle into two lines, faces inches away from one another. And they sing. Nomandla Hanisi's voice rises above the rest: "We praise your name, we glorify your holy name." Two young men leave quietly while the visiting reverend prays, "God of Abraham, God of our ancestors . . ." The reverend will tell us later that he lives under the bridge near Ponte. After the prayer and all-round hugs, the residents resume their earlier positions.

"We pray together every morning and every night," Nomandla tells me as she squeezes past a clutch of people to join me at the foot of Birthial's bed. She is from King William's Town and has been in the flat for ten years. "I came here because of my burns. I've had many operations." Her face is her life. In the months when she is not having surgery, she is waiting for calls from doctors. Her most important possession is a letter from her doctor that tells the story of the accident when, at fourteen, she had an epileptic fit while making tea for her grandmother and fell onto the paraffin stove. The letter describes the reconstructive surgery she has undergone and the current difficulty of making a nasal prosthesis for her. The letter also recommends her for any employment.

"The problem is unemployment," explains Birthial. "Even with a grade twelve, you can't find work. You don't know what to do. But if you are also homeless, it's impossible. My plan is to give accommodation. With that stability they can try to find work." As they navigate the labyrinth of everyday routines in the congested flat, the disparate job seekers are bound by the same concerns. "Have you tried . . . ?" floats between the bodies passing one another at the bathroom doorway, the glances in broken mirrors, the fixing of hairstyles, the constant undoing and retying of bags of clothing, the sharing of a plate of food, the laughter of the men on the corner bed, the buckets of used water thrown into the toilet. Have you typed your CV, improved your CV, prepared for interviews, enlisted for piecework, applied for courses, volunteered?

Jojo says, "The clerks at the internet café charge us R10 [US$0.70] a page to type our CVs. I have an account there, but I don't have money now, so I can't check if someone has responded to my email applications." 221

The State of Buildings

Internet access is a luxury beyond the reach of Beaconsfield Court, where basic services are improvised. The water source is a red fire hose that snakes into the building from the spigot on the sidewalk. Each day it is un-

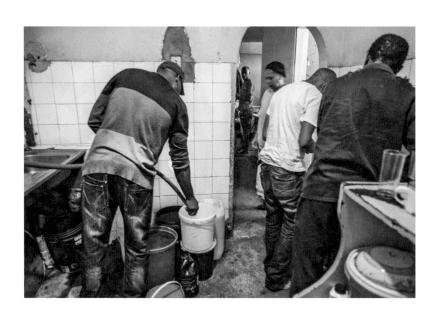

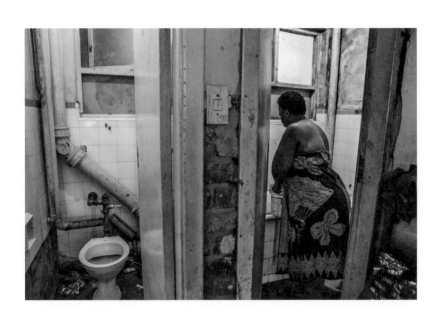

rolled from its reel on the fourth-floor corridor and fed through the kitchen window to fill twenty-liter containers. The electrical distribution board is a spaghetti of wires. A cable hanging out of it leads to a fan of taped cords that snake into each living space. Mobile phones hang like barnacles from multiple adapter plugs on a corner bed.

"There are far worse places than this flat," says care worker Boikhutso Monnamorwa. "When I came here from Mafikeng, I lived in that hijacked Fattis Mansions building in town. We each paid R250 [US$17.40], but it was crowded and full of crime. They cut the water and electricity." The building she is referring to is where Johannesburg's first locally made pasta was created. A century later it had become a notorious inner-city hell, controlled but not managed by a criminal gang. In a city where few crimes are newsworthy, Fattis Mansions featured for stories of death threats to flat owners, of the rape of a teenager, of a five-year-old who fell to his death in a lift shaft.

Daniel Shabalala is sitting on the wide windowsill. As he urges the precarious window open, its improvised pane—a plastic sheet—tears away from the frame. He leans out to retrieve the takkies he has left to dry outdoors overnight. He is getting ready for his afternoon shift at McDonald's. It's a nice job, but it's part-time and insecure. He has been listening quietly, but now he frowns as if what he has overheard is missing the point.

"If I was president, I would close buildings like Standby," Daniel says fervently. My ears prick up at his mention of another feared building that staggers under the weight of brutality. It stands in view of a public artwork described on the Johannesburg website as "a concrete angel [that] looks after Hillbrow and its residents, standing opposite Constitution Hill with its arms widespread, reminiscent of the Christ the Redeemer statue overlooking Rio de Janeiro."

"I was staying in lots of different flats before, but Standby was the worst." Daniel's account of the building he felt lucky to get a bed space in (his aunt let him take over the room she shared with five others) rattles like gunfire. "There were criminals, robbing us, kicking doors down, there was killing. There's no toilet, no water, no electricity. People shit in plastic bags inside buckets and throw it in the streets. Last year they raped a woman and threw her over the balcony. She died. In 2013 they shot a guy and left him under the bed. A woman came to tell us she couldn't find her husband. We found his body under a bed. We called the police, and when they investigated, they found he'd been shot with a police firearm. You can't go past that building if you're a woman. They will drag you in and rape you."

On another day I'm sitting next to Daniel on the elderly Grace Marten's

224

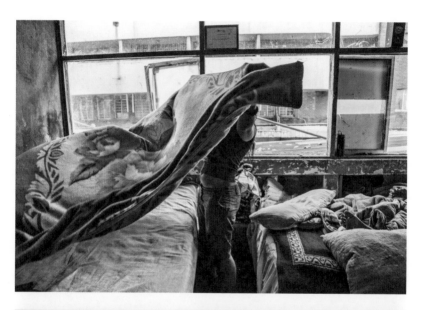

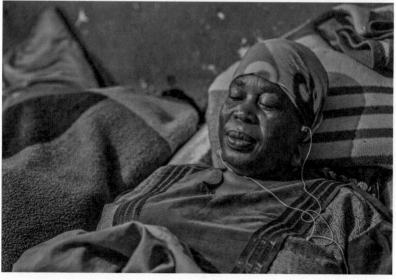

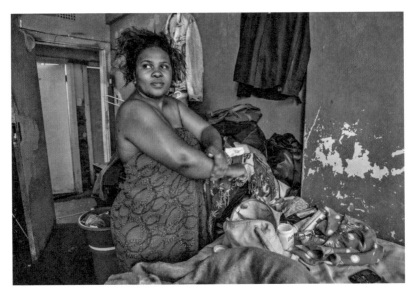

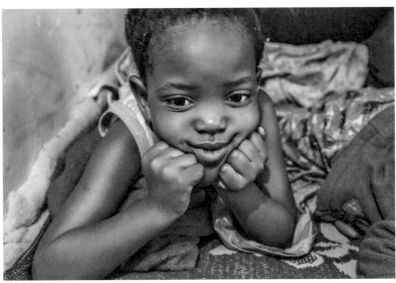

(*Top*) Noluthando, Hillbrow, 2016
(*Bottom*) Sinhlanhla, Grace Marten's grandchild, Hillbrow, 2016

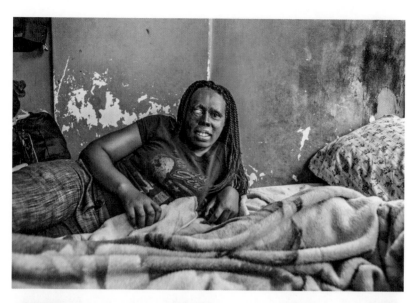

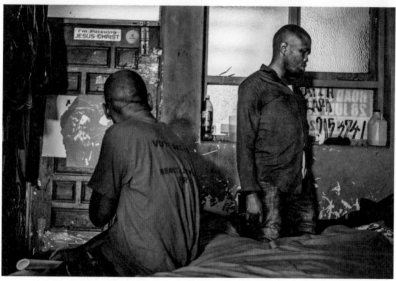

(*Top*) Nomandla Hanisi, Hillbrow, 2016
(*Bottom*) Sandiso and Siya, Hillbrow, 2016

bed at the back of the main room. I ask him about himself. "I am a child of God," the young man says. "I go to church at Carlton Centre, and I read my Bible for relaxation." He and the four men he shares a bed with cook together. Daniel talks of his family. Violence, unbearable loss, and isolation fill his short history. "My parents died in 2003." He has also buried children and every month sends money to his KwaZulu-Natal home for his third and only surviving child.

Morning

In the dark of the early morning, people are cocooned in their blankets, revealing only tops of heads or toes. A few are shuffling, feet first, to the bases of the beds. Someone lifts his head, scratches himself, murmurs, "The bedbugs are killing me," and descends back, pulling the blanket over his head. Everyone sleeps fully clothed. David has told us he finds it difficult to sleep, especially when it's hot and when "the rats chow your feet."

There are neither spaces nor partitions between the beds. Except that at night a board is placed between a row of adults who sleep in quartets and quintets on beds along the long wall and the bed that two children share with their grandmother, Grace.

Everything happens on the beds. "Except sex," says Fezile Cuna. "Even if you are a couple and you share a blanket, if you want to have sex, you go to a hotel." He is interrupted: "Hey, fuck you! What do you want here?" The voice comes from a heavyset elderly man. He wobbles between the rows of beds, falling this way and that, toward me. "Talk to me, don't talk to them," he slurs. Before he can get to me, Grace has descended from her bed and is standing military style in front of the old man, her knuckles pressed into her waist. "This is noise! You are disturbing us old man, bloody fucken shit, and you have no respect! *Voetsek, you hond!*"[2] He swears back at her. Her cheeks quiver in rage. "This is a Xhosa place . . . get out of here!" She spits at him. More women are now lining up in similar postures down the length of the room. The neighbor leaves with a "Fuck you all!" and Stella urges me to carry on with my work.

As light filters into the flat, the density and activity increase. One young man is washing his feet in a basin in the kitchen. Another stumbles in. "What's the time now?" He looks dazed. I count fifteen buckets in the kitchen. Some are filled with water, some with dry food.

2 Afrikaans expression meaning "Get lost, you dog!"

Two young guys bob to the sounds in their earphones while they adjust their jeans to sag significantly below waist level. One takes Mark's camera and shoots a picture of him. Fezile, a beautician from Mozambique, is checking his hairstyle in a piece of mirror.

Outside on the multifunctional balcony, a man sleeps, wedged between pots, boxes, trays of cutlery, and plastic drums containing food. Laundry floats above him like prayer flags.

Hillbrow Street

The balcony offers no view of the street below. The Bus Rapid Transit (BRT) station's suspended roof meets Beaconsfield Court at first floor and blocks what street views are not obstructed by the building's own canopy. It's hard to know where the loud argument we hear is coming from. It could be from the forecourt of Hillbrow's much-used bathhouse across the road, or from any of the trading spaces right below the flat, those spaces that demonstrate most starkly how this dense modernist flatland has transformed. It is on the ground floor of this building that Hillbrow's once famous Milton Pharmacy stood for forty-two years (see Gluckman 2007). In 1955 the pharmacy shared the block with a large shoe store, a German delicatessen, and a hairdressing salon. Around the corner was the Lily Marlene restaurant. Up the road the hub of this high-rise café society suburb accommodated restaurants whose names ring like automated wordplays if Hillbrow is introduced into middle-aged white Johannesburg conversation: Café Paris, Café Wien, Pigalle, Café Kranzler, Café Zurich, the Florian. And less exotic but no less evocative: the first Milky Lane, the first Porterhouse, the first Exclusive Books, the first Look and Listen. Or the clubs: Chelsea, the Summit Club, Bella Napoli, and Boobs. By the mid-1990s these and Milton Pharmacy had shut their doors on a cosmopolitan city-within-a-city and given way to an unambiguously afropolitan Hillbrow. In the 1970s the municipal bus stop on Edith Cavell Street boosted Milton Pharmacy's trade, but now its replacement BRT station—which casts a thick shadow across the small stores, barricaded shop fronts, and To Let signs—does little for the city block that skirts the building. The security turnstile marking the dark entrance to Beaconsfield Court shares the sidewalk with the Meat Festival butcher, a *spaza* shop,[3] a pawnshop, a drycleaner, and a cell-phone

3 Small shop operating from a residential property, typically selling food, drinks, and basic groceries.

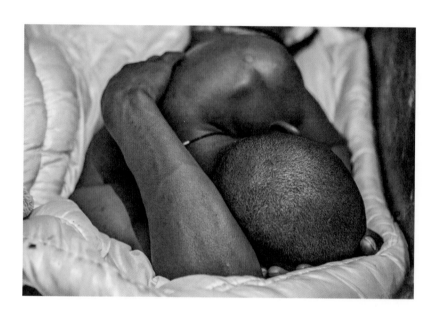

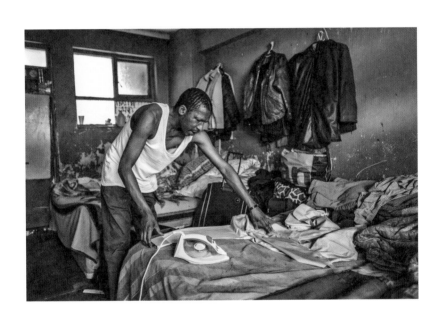

Malindi Yeko, Hillbrow, 2016

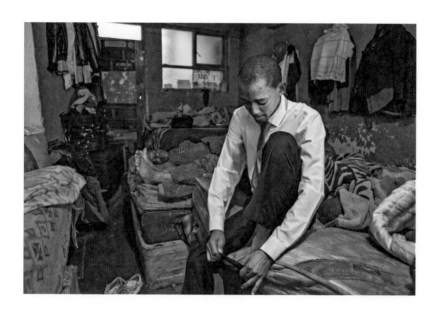

Mongameli, a.k.a. "President," Hillbrow, 2016

counter. Trading hours are sporadic. Adverts for CVs, IDs, and cell phones beckon a transient population.

Hillbrow is a cocktail of uncertainty. Today the slick red poles and clean lines of the BRT station taunt the street-level reality. The street is a mess. The municipal garbage workers' strike has entered its fifth week, and the rubbish not heaped at street corners is strewn across the tarmac. The morning wind is making tumbleweed of whatever litter will float.

Chilling

A few residents are sitting or lying on the beds. I wonder out loud how people cope with the cramped living. "I spend my days looking at soccer magazines. Or I go to taverns to watch soccer. And I bet on soccer—five rand almost every day," says Sandile Joka. "I chillax at Joubert Park," says Mkhokheli, "and I play chess on the big board." "I go to the library," says Boikhutso. "The last book I read there was *The Curious Incident of the Dog in the Night-Time*. It was a bit weird, but I enjoyed it." "We play football in Yeoville," says Sbonakaliso, "and if we have money, we go to the movies around the corner. It costs R6 [US$0.42]. There are chairs in the cinema and a big screen."

I look around. There are no chairs in the flat.

"I go to the taverns to drink," Malindi Yeko says, "I hang out in Melville, Rosebank, Norwood. Basically wherever there is booze," he laughs. He adds candidly that he is one of the few who make trouble in the apartment: "In the middle of the night, when we come home tripping, we talk too much and disturb the others." He knows that no one will complain, but in the morning he will have to sit on Birthial's bed (her "office" as she calls it). "Right here on Zuma's face," Malindi says, pointing to the motif of the president that decorates her ANC campaign-issue blanket. There he will endure a verbal beating from her.

The Student

Wellie is laughing at Malindi's story. A graduate from Zambia, Wellie could easily have been overwhelmed when he arrived, "It was the first time I had seen this kind of living arrangement. With men and women." But he adapted. And he found a role, helping Birthial with fundraising applications. He struggles when someone comes home drunk. "But in those times you must keep quiet—even if you're insulted. You must know your own pur-

pose, then you can accommodate what is around you. These are minor things." His goal is to qualify and to raise his children well. "I talk to my kids in Khayelitsha every day and on Facebook."

There are a few very young men in the flat. Phetho "Rasta" Mzwakali arrived a few days ago. The twenty-year-old had been living with his brother in a backyard room. Before that the brothers lived on the streets. "It was hell." He recounts how terrified they were of being attacked, and how they looked for sleeping spaces close to security guards or night workers. Rasta came to Johannesburg to help his brother support their family. "The situation at home was tough. In 2004 my mother died. I was eight. We were all depending on my grandmother's pension. There isn't money for uniforms for my siblings to go to school, but I managed to pass matric. My brother got me a job at Ocean Basket, but I quit. I see myself making it big in the future. I've seen a lot of people who have passed the road and are now celebrities. I can do it because I have been through hell."

Andile Dlomo also needs to find a job. He can't pay the R200 (US$14) rent for his bed space. The young man has no family. "I came to Gogo with no food and no blanket. I came here with my bare hands," he says, his voice breaking through lumps in his throat. "She told me about computer courses and she'll send me. I'm scared to ask for food, but she sees that I'm hungry and she gives me something to eat."

"My name—Mongameli—means 'president.' With a name like mine, you don't need a surname," grins the fine-boned older man, who is slipping an arm into a crisply ironed white shirt with blue trimming. "My parents had very high hopes for me," he winks. He flicks his wrist and deftly buttons his shirt cuffs. "At work I am the damager, not the manager." He lifts his chin in a mock air of self-importance. "But they can't fire me. Because of BEE [Black Economic Empowerment]! I'm one of those guys who don't do any work, I just get paid." With the elegance of a *sapeur,* he loops the ends of his wide blue tie into a neat knot. "I have seven girlfriends. To escape them I stay here." "It's true," says Birthial. She herself is fully clothed, beret on her head, and is propped up on her bed, blankets up to her shoulders. "Ja, this Xhosa. He's supposed to have one wife but yo!" "Read the Bible," Mongameli retorts, "It says seven women hang on to one man, saying, 'We only need to be called by name and we will come.'"

235

(*Top*) Emilina and Thabo, Hillbrow, 2016
(*Bottom*) Wellie Hankombo and Sandiso, Hillbrow, 2016

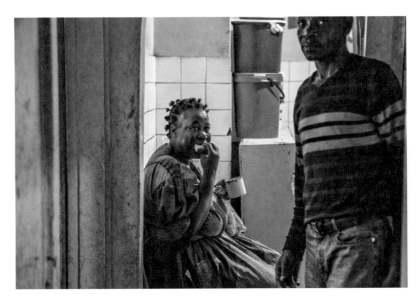

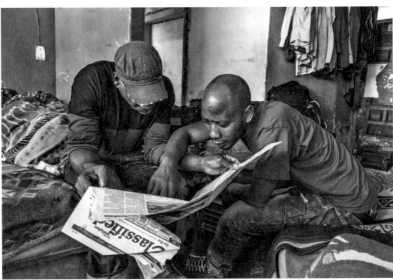

Birthial

On her bed, Birthial is sharing a bun with Andile. She balances the bun and her tea mug on a broken tray. "I need power," she says. Grace walks toward the opposite bed, where her grandchildren are sitting among the blankets. She mixes Morvite porridge into a bowl of boiling water with the repetitive motion of years of morning routine.

In the airless flat the sweet smell of porridge mingles with body odors, soap scents, the stale smells of musty blankets, and the stench of the toilet.

Birthial tells her story. "I was born in 1949. I qualified as a nurse and worked at Bisho Hospital. In 1994 I had a car accident. I was pensioned in 1996, but I felt I could still work. Mandela had been released. I came here and volunteered at hospitals. There is that thing if you work hard, someone will believe in you. They asked me to bring more people." She pauses to send a young man to buy Panado, then continues: "Nursing agencies got to know me. I would call nurses and place them. Go to any hospital, from the matron to the porter—it's my network. Beaconsfield Court is one of many sectional title buildings that became a slum before the City took it over and handed it to an administrator to manage. When I asked social services for help, they arranged for me to move here. But I pay rent like everyone else. I started to have people stay. Nurses came. And others. The rule here is if you have some income, you pay. It's R200 [US$14] per month per person. But some people dodge me, and others can't afford to pay," she shrugs.

Counseling

The young guys in low-hanging jeans are leaving. She shouts to one, "Hey, have you got your CV and money? Come get some here." She turns to me: "They must not borrow from each other, otherwise they'll fight." She looks at the people in the room. Then she says, "You know, I spend a lot of time counseling. Because I never get someone who is solid. Everyone has a problem. Some come here shouting or swearing. My own children tried to interfere to stop people, but I said no. I live here with a community. I need to know their troubles. Like if someone has HIV, I must know, because they must have food."

A week later I receive a phone call. "Hello, Tanya. This is Nomandla, the lady with the burned face. I am phoning you just to tell you the bad news. That Gogo passed away in hospital this morning. As you know, the situation here is bad . . ."

Bedroom

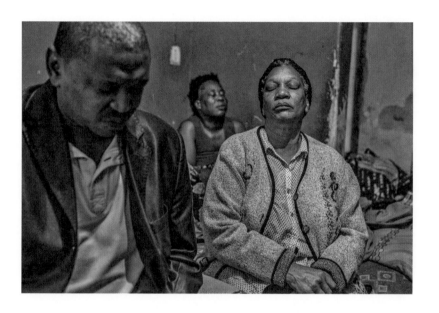

David Majola, Emilina, and Stella Manoqalaza, Hillbrow, 2016

Master Mansions

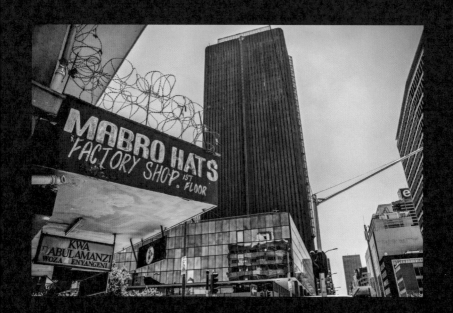

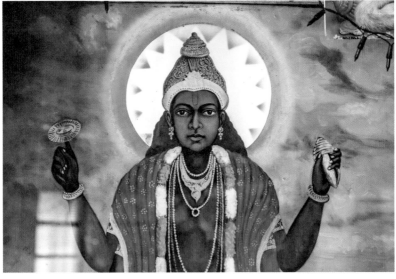

A Passenger Indian

When my grandfather arrived from India, all he brought was his faith in the Lord and absolute honesty.
Rajnikant Bhikha (a.k.a. RB)

IN 1895 A MAN BY THE NAME OF Uka Prema Prajapati sailed from India to South Africa as a "passenger Indian."[1] He quickly found work as a "vegetable Sammy"[2] in Krugersdorp. The job would give him firsthand experience of the divisions of his new homeland since he sold his wares in all the sections of this sharply segregated town: on the British mining-town side with its late-Victorian buildings, and across the *spruit*[3] among the wagonloads of Dutch-speaking farm families who would later become the residents of the Boer town with its church houses clustered around the large Nederlandse Gereformeerde Church. From 1897 he would have lived next to the Boer town, in the *koelie lokatie*[4] to which Indians were relocated from the mixed-race area in the center of town, at the same time as Africans were sent to the *kaffir lokatie*,[5] a mile away. His Boer neighbors resisted

1 The term refers to Indian traders, merchants, artisans, and professionals who paid their own passage to South Africa (as opposed to indentured workers who were brought from India by the state).
2 RB explains that whatever an Indian hawker's name, he was invariably known as "Sammy."
3 Afrikaans for "small stream."
4 Afrikaans, racist reference to quarters within the town that were reserved for Indian occupation.
5 Afrikaans, racist reference to quarters within the town that were reserved for African occupation.

the site of the Indian location but had to yield to the pressure imposed by the London Convention that all British subjects (including citizens of the British colonies of India and Natal) had to be treated "fairly."[6]

The story of Uka Prema—which every member of the family knows by heart—goes that one day he saw a gold watch in the garden refuse of a customer in the British part of town; he salvaged it and took it to the lady of the house. Impressed with his honesty, she recommended him widely, which helped to ensure the growth of his business. Thus, he was able to remain in South Africa but returned often to India, maintaining a family and close ties there. "And that," says RB, Uka Prema's grandson—now eighty-seven and our guide to the family history—"is how we came to be in South Africa. Even though he wasn't a Master, or involved in hats, Uka Prema was an entrepreneur, and without him, there would have been no Master family and no Mabro Hats."

We are visiting RB at the suburban home of his son, Ajit, where RB reluctantly moved in 1999. He is sitting in an easy chair, a blanket over his legs, modeling a seal fur Russian ambassador–style hat for us. "It's a Dr. Zhivago style. Mabro Hats was famous for it," he beams, all the while keeping one eye on the televised cricket broadcast.

Uka Prema went back and forth between the Transvaal and Aat, his village in Gujarat, where his wife lived. On one of those visits, RB's father, Bhikha Uka Prajapati, was conceived. In 1905 a plague struck the village, and Uka Prema's young wife died, so he traveled back to fetch his three-year-old son. Bhikha remained in South Africa until he was nine and then was sent back to India to attend school there. "My father stayed in India until standard six," RB tells us. "When he had sufficient English, his father brought him back to South Africa. My father was a clever man; he had enterprising ideas. He learned bookkeeping and did the books of Muslim merchants from here to Musina. He was known as Master Ji, a title usually reserved for teachers."

In his early twenties Bhikha Uka Prajapati, who came from a caste of potters, changed his surname to match his occupation, in keeping with a tradition in his village. From then on he was Mr. Master. He soon brought his two cousins from the Mistry family out from India to join his business. They named it Master Brothers and also opened a general dealership in Brits. When this burned down, Bhikha rebuilt it, and when the business grew, he moved to Johannesburg to open in Market Street.

6 Details of the early history of Krugersdorp were found in Dugmore 2008.

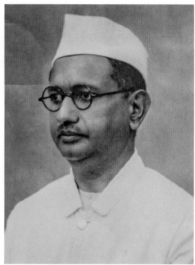

(*Left*) Uka Prema Prajapati (father of Bhikha Uka Prajapati)
immigrated to South Africa in 1895
(*Right*) Bhikha Uka Prajapati, founder of Mabro Hats,
father of Rajnikant Bhikha and Harshad Bhikha

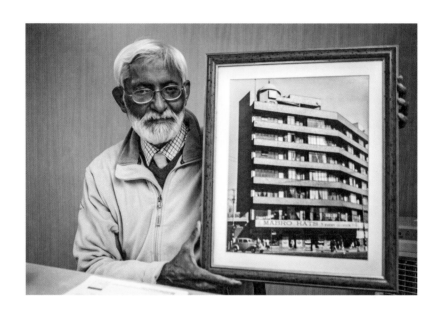

Harshad Bhikha, holding an image of Master Mansions, 2015

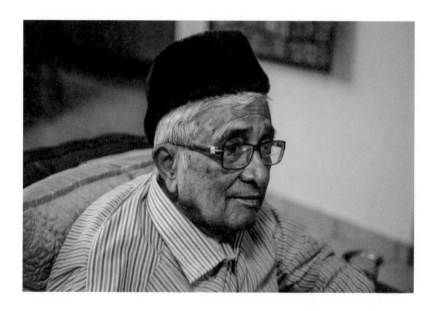

Rajnikant Bhikha, Northcliff, 2015

It was at his supplier, Elephant Trading, that Mr. Master saw people buying felt hoods that were used to make hats, and, intrigued, he bought a hat block. Without a press to mold the shapes, he applied steam from a kettle to the hoods and pulled them over the block. And thus was Mabro Hats established in 1932. Mr. Master imported French presses and German and British hat blocks, and hired more staff. *Smouse*[7] were commissioned to sell hats across the country, and within a few years, he was able to raise a loan of £20,000 (US$26,800) to develop his own building.

West and Commissioner

The building's footprint is a trapezium that mimics the diagonal of West Street (where Diagonal Street ends) and seems to lean away from the intersection of West and Commissioner. This creates a wide sidewalk at the southwestern point of the three-cornered *uitvalgrond*[8] between three farms where the six hundred stands of the mining camp that came to be known as Johannesburg were laid out in 1886. The brass plaque that recorded this history has been stolen. Now a barely legible, theft-proof mosaic marks the spot.

From the angular balconies and windows of this building, three generations of Bhikha Uka Master's offspring had an excellent view of the developing postwar city.

Mr. Master had acquired this property in the no-man's land beyond the western limits of early Johannesburg, where officials, faced with the relentless deputations, protests, petitions, and pleas of Indian occupants, had implemented an ever-expanding raft of laws against Indian property ownership. Indians responded with determined resistance and schemes, including purchasing property via white nominees. In 1936, after years of pressure, the Asiatic Land Tenure Act legalized Indian land ownership around Diagonal Street, and Mr. Master was among the first merchants who did not hesitate to create a building boom in this corner of the city. In 1941 he and his two business partners completed a six-story building topped with a temple set at one end of a lush roof garden. But his true aim was realized six years later with the construction of the apartment on the seventh floor, immediately adjacent to the temple. This was the fulfilment of his dream to build a home just like the king's palace in a story he had loved as a child.

248

7 Afrikaans, meaning "traveling salesmen."
8 Afrikaans, meaning "leftover land."

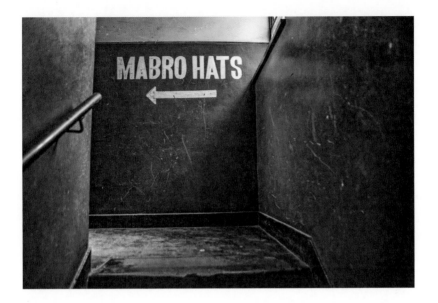

Marriage in India

Mr. Master and his wife Manek decided to educate their children away from the apartheid system, and so he sent them all home, where they would learn Gujarati, Hindi, Sanskrit, and English. His son RB completed his schooling and went on to a bachelor of commerce degree in Bombay. Remembering back to this time, RB tells us the story of his youthful marriage. He was twenty-one and in the third year of his degree when his father arranged a marriage for him to the school inspector's daughter Jyotsna, who was fourteen or fifteen. "I had seen her. I agreed," RB tells us. "My mother said, 'It will look like father and daughter.'" In South Africa the apartheid government was preparing to prohibit Indian girls from joining their suitors, and so his father cabled and instructed him to marry in India. So in 1951, eight days after Jyotsna's sixteenth birthday, they were married in Dadar. After the marriage Jyotsna went back to her family to complete her schooling, and RB returned to Bombay to finish his degree. They traveled by ship from Bombay to Durban in 1952 and went to Johannesburg to settle at Master Mansions, just months before the state prohibited the entry into South Africa of Indian women who had married South African Indians overseas.

RB soon became the buyer for Mabro Hats. All the trimmings were imported, and there were fashions to watch. "I used to travel to Europe to buy new shapes and styles that we would copy here," he recalls. His sons say

249

Master Mansions

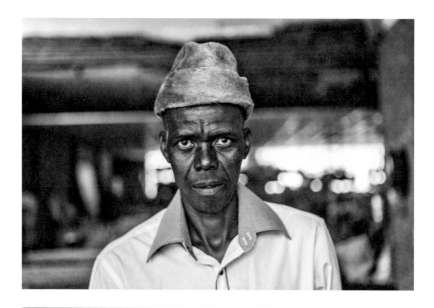

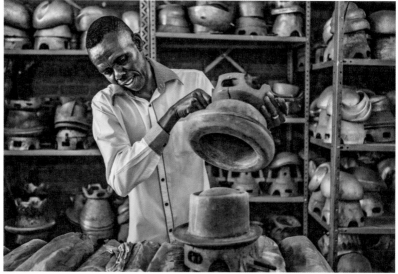

(*Top and bottom*) Jimmy Baloyi, Master Mansions, 2015

they had piles of calendars with Swiss Alpine and German village scenes from their dad's trips.

Mabro Hats

We enter Master Mansions with the caretaker, Cassandra Manickum. The name board in the foyer, never updated, indicates that this is the residence of the Master and Mistry families. We ask to see the space that the hat factory once occupied, and Cassandra shows us a sign to a closed-off corridor. We press her for access, and she says the factory space is next door but now houses the Chinese medicine company that HB Master and his sons manage. Hoping to see an old machine or any evidence of the hat factory's existence, we head there.

Harshad Bhikha is the youngest of Mr. Master's sons. He and his children were the last relatives to manage the factory. He invites us to sit in the lecture room of the herbal medicine enterprise. He doesn't sit himself but stands erect, his slim body, full head of hair, and sharp wit belying his seventy-seven years. He is softly spoken, patient, and commanding. First he tells us about the healing properties of the medicines. Then he talks about the impressive hat factory. With its multiple elevator entrances allowing for entry and exit on different floors, and its large delivery shafts leading directly from the sidewalk, the building was designed to accommodate a booming enterprise. At its peak it employed over eighty workers, including *smouse* and part-time trimmers. Two apartments upstairs were dedicated to the business. Flat number seven was a tearoom for workers, and another was stocked to the brim with items waiting to clear customs. The whole operation closed in 2007.

HB escorts us to the first floor. As our eyes adjust to the dim light, we see far more than the ghost of a defunct factory. Everything needed for a major millinery enterprise is here. Except the hats.

One side of the room looks like a slice out of a medieval armory. Aluminum casts line up like knights' helmets ready for war. They fill fifteen steel racks, each with six shelves, the legacy of immense productivity. "We made a hundred hats a day," says HB. His son Manoj joins us. In his descriptions the factory floor comes to life. We hear of machinists stitching ribbons and lace to hat brims and seamstresses sewing pearls and cherries and freesias to church hats, or satin ribbons to wedding hats.

Manoj looks around at the materials that never became hats: large bags of silk flowers covering the length of one wall stuffed with red, lavender,

251

pale yellow, and light blue roses, and green, pink, orange, and white daisies. "This is about a third of the stock of flowers we had. We would steam them to make them come alive," explains Manoj.

Folds of chiffon, lace, and sisal and fabrics with names like "Marseilles" are jam-packed into the recesses of the warehouse. Labels on long tubes of satin, taffeta, and silk ribbon declare that they were made in France or Switzerland or, more intriguingly, simply state "foreign manufacture," or "made in occupied Japan." The wheels of gold, maroon, pink, black-and-white stripes, bottle green, olive, mauve, wedding white, cream, and purple are measured in yards.

HB picks up a dusty lace hat. "Look at this price—R7.99 [US$0.56] for a hat!" The 1950s and 1960s were a grand time for millinery. "In those days ladies had to wear hats when they went to court. And women wore hats to church. It was also fashionable—you could have a hat to match every outfit," HB recalls. "We sold to John Orr's, Ackermans, OK Bazaars, to hawkers, and to individuals. We were the first people to start making the French beret in South Africa."

How to Make a Hat

"Jimmy Baloyi is the kind of person you just give a job to and never have to supervise," HB says on the day that Jimmy comes to the factory to tell us about his hat-making days. He has a day off from his cook's position at Baragwanath Hospital. "I came to Johannesburg in 1982, from the *bundu*[9] in Tzaneen. I went straight to my brother in Orlando East—and I'm still staying there! I had to find a job, and then I met someone who was coming to work here, so I followed him. There was no interview, no CV, nothing. I just started working. My friend taught me how to make hats, and when I finished a hat, Mr. Master would come and examine it and say, "How did you do it?" My bosses couldn't make hats, but they could tell if it was a good hat!" Jimmy describes the process. "The base material is felt. We can form that starter hood into any shape or size. We had many molds of all the popular shapes. We spray the mold and fit the hood on top. There's a gas flame underneath to heat the mold, and we tie the hood with string and press it down onto the mold with a pressing machine to give it shape. The hood gets very hot, and we must make sure it sets but doesn't burn

252

9 South African slang for "wilderness" or "the wilds."

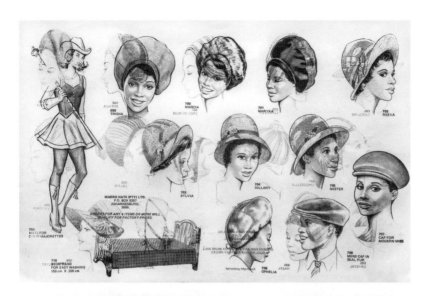

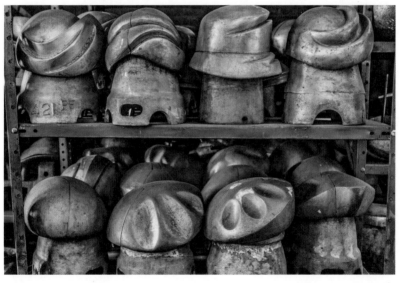

before we take it off. We burned our fingers often! The brim is molded separately, and it is joined and finished by the machinist."

Jimmy flicks through an old catalogue. The names come back easily to him as he reads, "There were granny-type hats called Consuela, English Rose, Brenda, Mary, Alice in Velvet, Melody, Hazel. We made hats called Lady Dis, Ashleighs, Femina. And French berets with names like Trish, Marcia, Maryka, Ophelia, and Zed Girl."

Many hats were custom-made. "Especially for the July Handicap," Jimmy remembers. When customers came for a special hat, he would be called to reception. "I would scratch around for materials and find something similar to the customer's picture or description. I could make a sample hat on the same day. It was a challenge I loved! When she came back, she would say, 'Yes. I want that hat.' Then she would decide on colors and trims. I used to see people on TV wearing hats I had made, and I'd think, 'That's from my hands!'"

But the hat that stands out for him is the one that he helped make for Winnie Mandela to wear to the presidential inauguration of Nelson Mandela. "It was a great hat, with a sort of horn on top that twisted round. After she wore it, it became very popular, and we made it in many colors. We called the design 'Winnie.'" It would be one of the last designs that Mabro Hats created.

HB says the factory could not withstand the competition from low-priced imported Chinese hats. "And the unions killed the business just like they killed all manufacturing with their conditions and demands." But he concedes that times also changed: "Today hair weaves and styles have replaced hats."

Home

The three original Mabro partners each had his own residential floor in Master Mansions. Bhikha and Manek raised their three sons Rajnikant, Arvind, and Harshad there. In turn RB, AB, and HB raised their children and accommodated members of their extended families in the building. "On our floor it was my dad, my two uncles, and their families. We were nine kids just on the sixth floor," says RB's son Sharad.

Ferreirastown Primary School backs onto Master Mansions, and the youngest of RB and Jyotsna's children, Ajit, never had to cross a street to go to school. "My mother used to wave to me in the playground while she was making rotis in the kitchen!" remembers Ajit.

HB reminisces, "When we weren't at work, we listened to *Squad Cars* on the radio. The whole family sat at my grandfather's large dining room table on the seventh floor. It can seat twenty people, and we still use it for family gatherings at Sharad's house in Norwood."

"All the gurus used to stay at the house," says Sharad's wife Linda. "And not just swamis," Sharad adds. "I remember someone who stayed for months. I don't know who he was." Sharad's grandmother Manek and mother, Jyotsna, often cooked meals for twenty people, including young men who had arrived from India in search of work. "It became a sort of doss-house for Gujarati Indians—it was like Jesus at the inn. Because, you know, there was no place for Indians to stay in town, so Indians who were arriving and needed help to settle or who were passing through also stayed." Linda rolls her eyes. "And it was a place for white alternatives. They would flock there to hear the swamis in the rooftop temple."

The Temple

Ajit fondly remembers the centrality of the temple in their lives. "My mother would make puja there every day. And during festivals people would come from Fordsburg. For the Holi festival my father would arrange permission from the Fire Department to build a bonfire on the roof."

Ajit and his wife Meena Vallabh agree to show us the site, but Ajit warns, "It has not been used for almost fifteen years. It's no longer intact."

We climb the seven flights of stairs and enter an unremarkable apartment door at the end of the corridor. We are immediately inside the intimate space of the maintenance manager's bedroom with its shining parquet, large-screen TV, and floral-quilted double bed. This was originally a meeting room for devotees. Ahead of us is a bank of hexagonal art deco doors with opaque, fluted glass fronts and mahogany frames.

As he releases the latches at the top of the doors that have not been touched for over a decade Ajit again tempers his and our anticipation: "There will be little of the original temple," he cautions. We assure him that to look inside the small domed structure will satisfy us. He draws open the doors. Already we see the gold. "It won't be intact," he says. Except that it is. We fall silent as we realize we are seeing the first-ever Hindu temple of the inner city, perfectly preserved. No one steps inside, but now Ajit, Meena, Mark, and I are in tears. Ajit leads us, taking off his shoes and stepping silently into the nostalgia, splendor, and intoxicating charge that bursts from the room. Mark breathes out a low, "Wow."

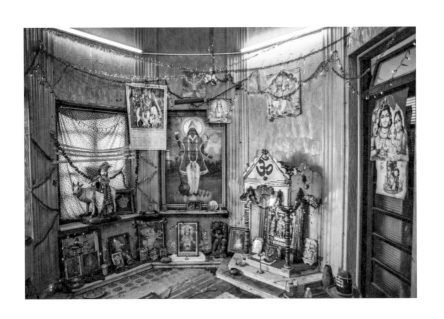

Family photograph of Jyotsna Bhikha

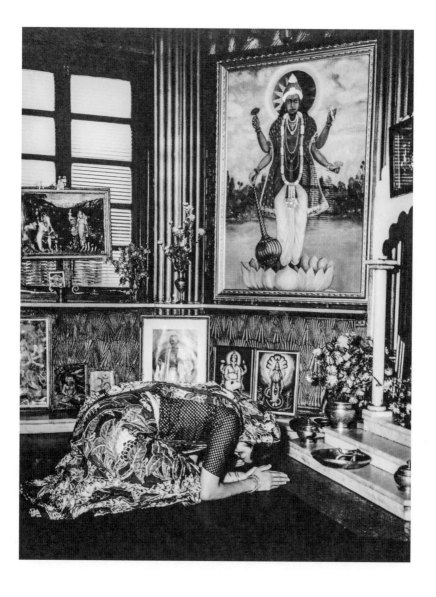

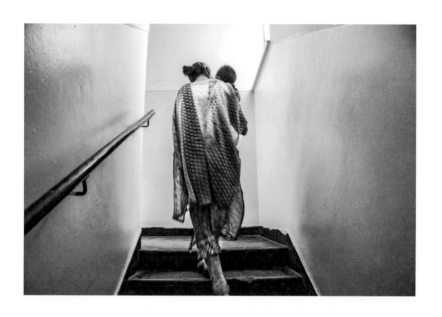

The exquisite temple is poised as it was the last time Ajit's late mother, Jyotsna, prayed here. It is a perfect, full-color replica of the family's photograph that shows her performing puja in front of the marble altar. The tinsel and fairy lights and solidified flows of candle wax have kept vigil over this tiny bejeweled shrine long after the daily rituals ceased.

Jyotsna prayed in the precious sanctuary three times a day for half a century. Here the large portrait of Lord Vishnu, protector of the world and the moral order, would have watched over her kneeling figure—in *panchanga pranama* pose of forehead, hands, knees, and crossed feet touching the floor—brass vases of fresh flowers, a tray for offerings, candles, and oil lamps. The room is suffused with the soft colors of a ceramic statue of the cow herder Krishna and the holy bull Nandi and decorated with brass figurines and large and small colorful prints bearing the likenesses of family members' deities—Ganesha, Nandi, Manasa, Hanuman, and Naga. Durga, astride her tiger, features in several pictures. A portrait of Mahatma Gandhi, whose daughter-in-law Sushila consecrated the temple, fits seamlessly into the displays. The altar frames an ornate silver embroidery of the Hindu triumvirate. Rippled gold pillars flank the windows and the altar, and embossed gold paper clads the walls.

Removals

Reprieve for Indians in the inner city was short-lived.[10] A mere nine years after the construction of Master Mansions, the Group Areas Act stripped them of their rights. The previously unfashionable western side of town came under the gaze of white developers, and in the 1970s wholesale forced removals were carried out. The bustling "African outpost of Bombay" was shattered (Benjamin 1979, 84). There was mass demolition. The Master family watched as historic arcades and decorative buildings that had housed shops, businesses, and flats across the street were bulldozed and replaced with a hostile high-rise tower called Life Centre. The removals ripped through Master Mansions and forced the family to split up. "My dad and his brothers bought property in Lenz," says Sharad. "My uncles built homes there on the same street and left Master Mansions. My dad also built a house. He kept it just in case. But he never moved there."

10 Details of Indian occupation and removals in Ferreirastown were found in Benjamin 1979.

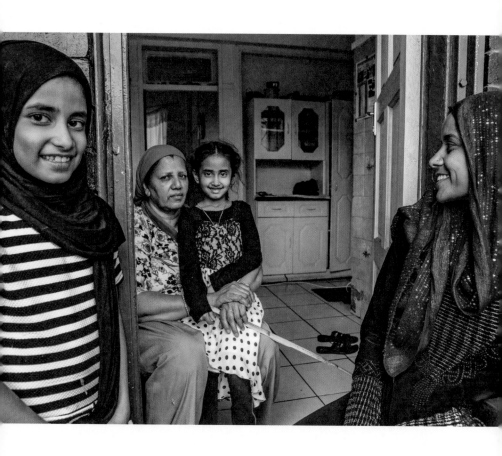

Labaika, Sabana, Salima, and Fatima Mirza, Master Mansions, 2017

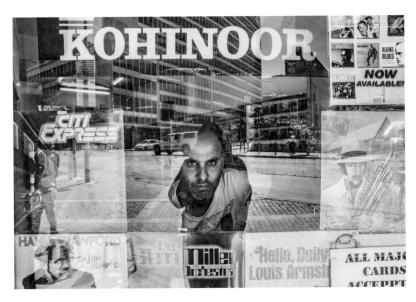

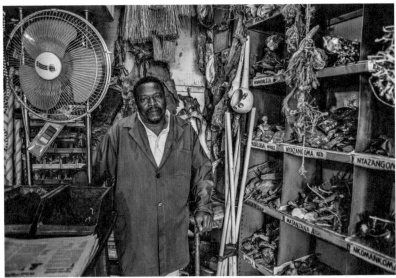

(*Top*) Mohamed Pakwashe, Master Mansions, 2017
(*Bottom*) William KK, Johannesburg CBD, 2017

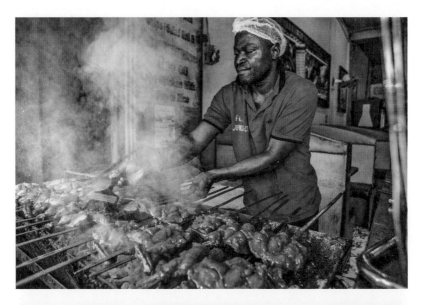

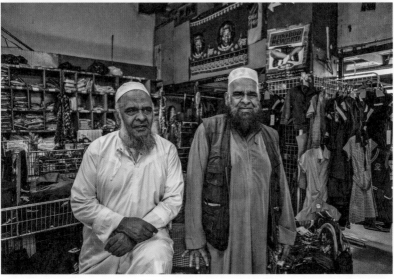

(*Top*) Frances Semu, Johannesburg CBD, 2017
(*Bottom*) Hassan and Hussein Bulbulia, Johannesburg CBD, 2017

The Flats Today

A few weeks later Cassandra shows us around the apartment block, introducing us to various tenants. As we pass apartment doors, she offers snippets about the current occupants. "Most are Indians from India. Some have lived here for over fifteen years. The families in flats one and two are related to one another. They're from Gujarat. The mom makes poppadoms. In flat four there's a young couple with a small baby. The family who runs the vegetable shop downstairs lives in this flat. Their one son is educated, and the other still studying. The Patel family arrived from India recently. Four guys from India live here. They spit *paan*[11] all the time. I have given them letters of warning. Pakistani guys live here. One imports old furniture from India; one boy just got married so his wife is coming soon. These guys get arranged marriages and go to India or the bride comes here from India or Pakistan. And about six guys live in this flat—they're all related. They work in a curtain shop."

We stop in the corridor to talk with Simiso Tshuma, who is leaning over the balcony to hang four dripping school uniforms on the washing line. She and her husband, a street trader, have raised their family in the building. Her children play in the corridors and on the landings. These are the same spaces that two generations of Master children shared. We are invited in to Vijay and Rekha's apartment on the third floor. Vijay has cleaned the temple since we were there and wants to use it on special holy days. At other times the couple and their adult sons perform daily rituals at the small shrine in the flat. The little cupboard outside the kitchen is filled with images of deities. This morning's offering of grapes and rice is placed alongside a tiny oil lamp. Vijay feeds pigeons on the second-floor landing. But more often he feeds birds in the street because he loves the crowds and smells and noises that remind him of Bombay.

Soeba Sheikh also invites us into her flat. Her family came to Johannesburg from Gujarat in 2008, when she was fourteen. She went to Ferreirastown Primary for two years. "It was like hell. My English was weak. They put me back three years. For high school I went to JSS, a girls' school. It was better. Then in 2012 I married. My husband is a cousin from India. Our family decided to get us married." Soeba enjoys living near many Indian and Pakistani shops, her child's crèche, and the public library. "But it's dangerous to go anywhere at night," she says.

11 An Indian after-dinner treat that consists of various ingredients wrapped in a betel leaf.

The Street

It's early morning on West Street, but already the sunlight is throwing re-flections across every shop window as Mark takes the final photos to wrap up the story of the building. "So a hat brought three generations of a family together," says HB, who has come downstairs to point out interesting de-tails. He looks up at the painted sign that still announces that Mabro Hats Giant Hat Market offers "wigs, berets, angoras, straw hats, sports busbies for drum majorettes, maces, boots." Mabro's millinery factory is gone, but around us the street-front shops are fully tenanted. They include a clothing store, a chicken tikka den, a homeware store, a hair salon, and a grocery shop. Some have been here forever.

Kwa Dabulamanzi has occupied the corner store for eighty-five years. William ("call me William KK") opens a filing cabinet with labels like Kha-limela, Simanye, Snama, Phumalelo, Isidigite, Madhlozana, Vum-obomvu, Ibonisele, and Shongwe. "I often have to teach the *sangomas*.[12] I know everything about these herbs," he says. "We have herbs for headaches, stomach cramps, broken hearts, body itching, stroke, insomnia. Herbs for all diseases except AIDS." His granny taught him about herbs, and he started working in this shop at the age of twenty-one. That was forty-one years ago. William points to the street. "In those days there was a tram stop here, and the tar was black and shiny early in the morning after the municipality had washed the streets. And I remember the Indian shops around here that sold curries and samosas."

Just then the Sura Yasin Sarif Islamic blessing peals deafeningly through the doorway of a new store. This is not an unusual sound on the western side of town at this hour. "I play it before I start my work every day," says Mohamed Pakwashe, who came to South Africa from Gujarat in 1996. The rest of the day he plays African and jazz tunes. The newly fitted shop is the site of rebirth of the legendary Kohinoor music store that re-cently closed its doors on President Street. Kohinoor was founded around the corner in 1956 as a sideline business in the Azad Café grocery store. There, amid the bags of sugar and crates of vegetables, Rashid Vally and his family pioneered the importing of jazz LPs, held impromptu jamming sessions, and launched record labels.

The whole of Johannesburg's history can be told in the few city blocks that surround Master Mansions. It is a cauldron of tumultuous repression,

267

12 An isiZulu term for traditional healers.

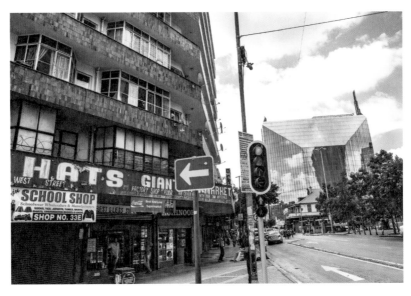

defiance, destruction, and construction; of tight ethnic communities and of wide diversity; of parochialism and of globalization. And yet there are shops in this area that appear never to have had a moment's disturbance. Unmoved by development, politics, or even fashion, their store counters, window displays, and shopkeepers have hardly changed for over fifty years. Each shopkeeper has a Struggle Story. Some ate with Nelson Mandela; some knew Walter Sisulu or visited Ahmed Kathrada. The ANC held secret meetings in the basement of Minty's fabric shop. Hassan and Hussein Bulbulia invite us to sit on a chair that a young Mandela sat on when he used to visit with their father in the school uniform shop they still run in the area.

The signwriting above a small shop that HB is keen to show us promises a remarkable range of goods: "clothing, footwear, underwear, traditional dresses, dress material, haberdashery, bags, blankets, industrial workwear, safety footwear, graduation gowns and hats, wedding dresses, tuxedo suits, flower girls dresses, page boy suits, bridesmaid dresses, invitation cards, wedding and engagement rings, wedding shawl, umbrella." Below the sign a glum bridal manikin stares hopelessly through the window of Impilo Cash and Carry and Bridal Centre. Her tiara balances precariously over an ill-fitting wig that covers one eye. An unglamorous blue stripe is painted above the other eye. Her pearl necklace looks stubbornly opulent against her cracked shoulders and neck. The full-length white glove that covers her only arm hangs limp where once there was a hand. The other glove is simply pinned to her shoulder and falls onto her brocaded white dress, pointing to the bridges and tiers of the richly iced cardboard wedding cake in front of her.

But this shop's real tale of romance lies behind the window display. HB tells us the space that is now occupied by an array of traditional blankets, school uniforms, white suits, and lobola coats was where Walter Sisulu's estate agent office was situated. It may be the exact point where he and Albertina first met. And the site where Mandela was first introduced to his mentor, a man whose formal education ended at standard six but for whom Johannesburg was an outstanding university of life.

We climb the stairs of Master Mansions to look again at the view from the rooftop. A sea of silver waterproofing clads solid concrete, where once a garden fronted the temple. And as we walk toward the edge that faces central Johannesburg, we notice the hand-scrawled declaration etched into the silver sheeting: "I love my India."

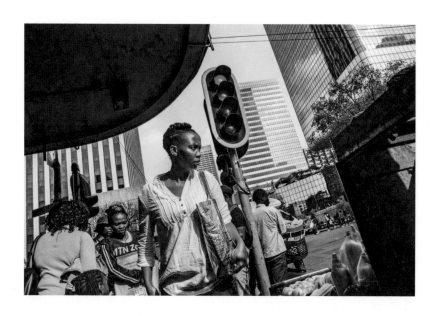

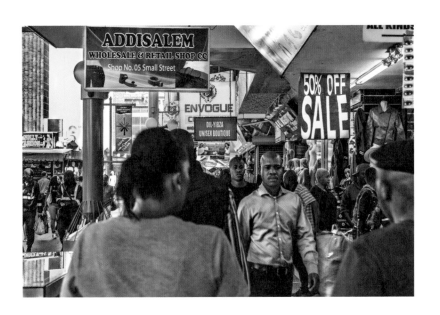

"SO I'M SHOPPING AND SELLING and shopping and selling. It's my best thing! I've been doing it for twenty-four years now—since I was twenty-one!" Lucy Chakale shouts over her shoulder to us. We are trying to keep pace with her as she threads her way through the crowds along Jeppe Street. "I come once a month to get new bags," she adds, heading into the labyrinth that is Lancet Shopping Centre.

On the lower floors we pass shops that are little more than single walls displaying rows of T-shirts or shoes; large shops with room to browse among the shirts and dresses; shops displaying plastic dishes, porcelain tea sets, 3-D pictures of Jesus, mirrors, buckets, blankets; curtain shops; L-shaped shops; kiosks tacked onto the fronts of shops that are themselves only modest-sized rooms. We peep into stores that use only the lower halves of manikins. These trunkless figures, lined up in squadrons, display tight-fitting jeans. We pass archipelagos of brand-label shoe shops, each just a corner or an inlet packed to the brim and separated from its neighbor by a row of display shelving.

If Lucy has had any doubts that she'll find what she's looking for, they are immediately dispelled in a tiny shop at the far end of the third-floor passage. Once he has been reassured by his regular customer that her two companions are not from the authorities, Ahmad Gwangul, one of several Ethiopian men leaning over a counter, agrees to chat with me and to allow Mark to take photos. He says, "I'm stocking new things every day. Because if I keep a bag even for two weeks, it gets cold and it will have to sell at cost price or less." Lucy is buying handbags for her customers in Lusaka. "What's your stock price?" she asks Ahmad as she picks up a shocking-pink bag. "Seventy rand [US$5]?" She tests the zipper and slings the bag over her shoulder, measuring its length against her waist. "I'll take it," she says.

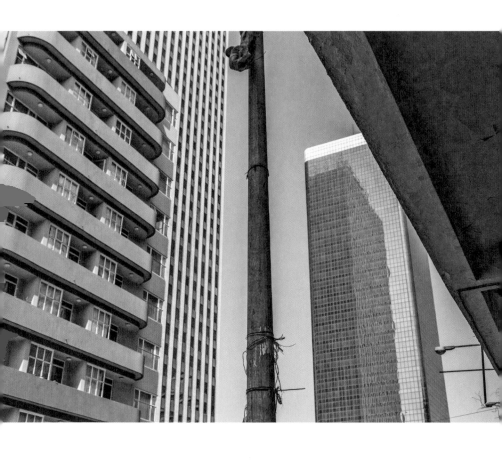

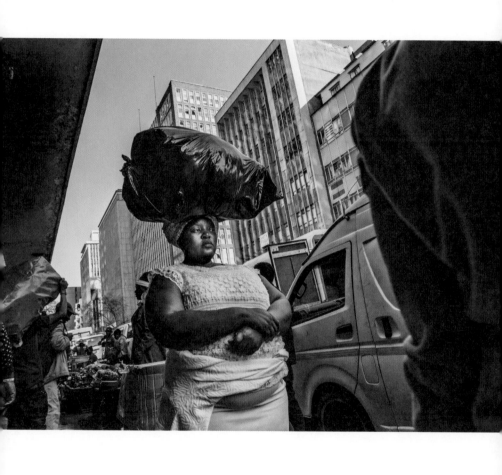

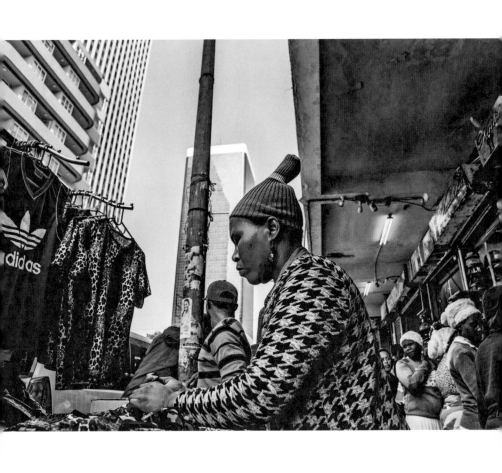

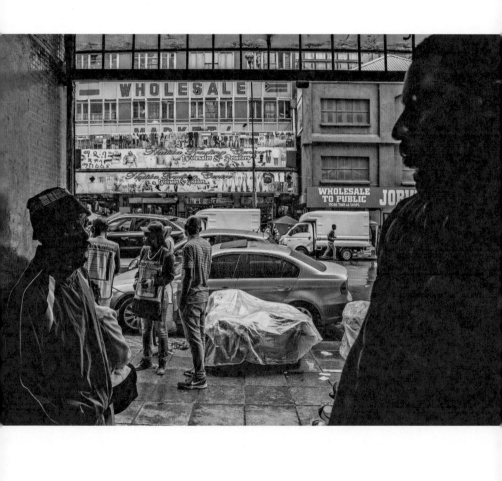

She also captures a photo of the bag on her cell phone and deftly sends a message. "You'll see, I'll put this on Facebook today and get lots of orders," she winks at me. "My network is on Facebook," she says. "So, I go to shops here, and I take pictures. I put them on Facebook and take orders. Then I'll come back tomorrow and buy the stock. I take my orders from people at home. Sometimes they show me a picture on Facebook. I come to look for that thing. Or I might send them a picture from here to say this is what I have found. I'm their eyes and hands in Johannesburg. Because you must touch and feel for quality. You can't just order without seeing. And you must compare prices. That's why you will see all of us shoppers who come here from other countries, we spend one whole day just looking around in town and at China malls, just to compare prices. The next day we start shopping."

"Jeppe"

Ahmad fled Oromia in central Ethiopia, where oppression against Muslims has escalated. He feels free in South Africa, but I ask why he has crossed the continent to come here. Why not work in Kenya, where he would not need even a visa? "The main thing we need is to be able to do business. There are many Ethiopians doing business in other African countries, but here is the highest concentration. Because in Johannesburg the laws are easy; you can just open a shop . . . the laws don't chase you here."

And open shops they have. In fact, half the traders in the thousands of stores that occupy secret high-rise shopping centers and alleys on many city blocks in this northeastern part of the Central Business District (CBD) are Ethiopian. Shoppers and shopkeepers simply name the whole area "Jeppe," after the intense movement route that is its backbone. Jeppe Street, east of Eloff Street, was not traditionally a shopping area. Rather, its preponderance of medical specialists once made it Johannesburg's equivalent of London's Harley Street. Indeed, building interiors were designed specifically to cater for these uses. Over time, medical suites suburbanized along with the few men's outfitters, tailors, and furniture stores that had occupied the ground floors of the buildings.

In the early 1990s, many of these skyscrapers fell into disrepair and residential "slumming." The needs of slumlords and new entrants to the inner city coincided in the creation of "bad buildings," with attendant overcrowding, exploitative rentals, and health and safety risks. Over the last two decades, however, the area has witnessed another recycling of prop-

282

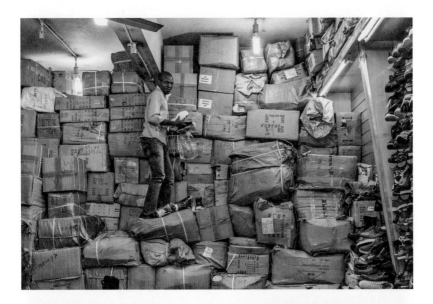

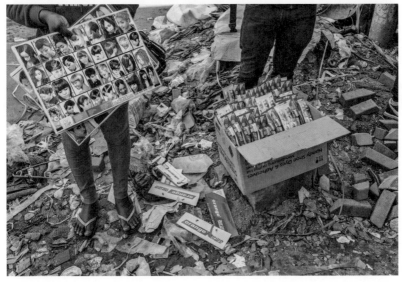

erty. In the late 1990s the demand for retail was met by enterprising Ethiopian traders who led the way. Now, buildings in Jeppe, with names like Lancet Hall, Medical Arts, or Medical Chambers have been renamed Johannesburg Wholesale 1 and 2, Majesty, Abyssinia, Merkato, Joburg Mall, or Nadibas. Their signs beckon consumers into compact buildings, where thousands of tiny stores offer a Chinese-scale promise to satiate the consumer hunger of people shopping with single-minded determination for anything from designer jeans to rat poison. It is here that a retailer operating from a shop the size of a doorway told me, "In my country, it is hard to sell anything, but in South Africa, if I put a toothbrush on the pavement, someone will buy it."

There is no distinction between retail and wholesale here. Shops face outward to the streets and inward onto multiple passages in the building. Even stairways are used for display or as coffee shops. Deeper inside buildings there are more intimate cultural and ethnic spaces: restaurants, barbers, and even churches and prayer rooms. Storerooms are on the upper floors.

Back at street level, we pass shops whose displays and product lines compare with the best department stores in the CBD. A retailer who owns four women's clothing shops in Jeppe maps the area as he sees it. "Ground-floor rentals are highest. Smal Street is hot. It has higher-quality stuff. Bree Street is very busy because it has cheaper but lower quality. Market has lots of fashion shops. Jeppe and von Wielligh is the busiest place. Plein is better than Delvers. There's no profit in Delvers any more. It used to be 'Brand Street' [selling counterfeit-label clothing], but the police and SARS [South Africa Revenue Service] are always going there. And they still raid too much. The risk is high and people don't want shops there."

"It's a Half London"

We follow Lucy back to her hotel. Like the other cross-border shoppers, she returns there often during the day to store goods she has bought.

At the Kwacha Hotel we meet Sylvia, Maggie, and Helen. They speak animatedly about Joburg, and about the business they share. "Joburg is a great place, it's a half London," says Maggie. "Whatever you need, you'll find it here. You can never say, 'I couldn't find it in Joburg.'"

"We started small," says Sylvia, "but we've grown. We take orders from shops in Kitwe, and we come here to buy food, Pampers, blankets, plastics, whatever they need. We are mostly shopping for groceries. But we

also shop for cosmetics. In a good month we each contribute R40,000 [US$2,565] to shop. We also go to Dar es Salaam. That's a good place for perfumes." She outlines the business ambitions of the trio: "Our plan is step by step. When you are small, you come here and buy jeans and shoes to sell to individual clients. Then after about ten years, you grow like us to be distributors for bigger shops. The next step for us is to be wholesalers. Then we'll open a big warehouse in Zambia and we'll import. Our dream is China—to import directly from China."

The three women work together. "We come from the Kitwe copper belt. Our trip takes forty hours each way, including the long wait at the borders," says Maggie. "Our dreams are big and our contacts are big," says Sylvia. "We all gather our orders before we come. We get orders on WhatsApp. Sometimes our clients will send us internet pictures or we'll send them internet pictures of what we can source. We shop in Jeppe and in China malls. And we keep the market honest," she laughs. "We shoppers know each other. I can ask another shopper where I can get Pampers or jeans or suits for a better price." Helen interrupts, "And for ourselves, we shop at Eastgate. I love the escalators!" She says the three of them come to Joburg once a month. "Every third trip, we treat ourselves and fly in." But this is followed by the refrain we hear again and again from shoppers: "We are scared of Joburg. . . . In our country we are safe, as women. Even at midnight we can go out." In Joburg the women make sure they are locked inside their hotel rooms by 5 p.m. They have a TV and shower cubicle in the room they share here.

The "Metros"

Retailers are not immune to the crime that plagues cross-border shoppers. Ketema Teshome, who owns a large clothing store in Jeppe, says crime is getting worse: "I have been robbed four times. Once I was robbed by the metros.[1] I was on my way to stock up at Dragon City.[2] The metros stopped me and searched me. They took the money I had put in my sock. It was R50,000 [US$3,206]."

285

Stories of police crime are common: of South African Police Service

1 Shoppers and retailers refer to the officers of the Johannesburg Metropolitan Police Department as "metros."
2 Dragon City is the largest of the Chinese wholesale malls west of Johannesburg's inner city.

(SAPS) and Johannesburg Metropolitan Police Department (JMPD) offi-
cers illegally taking money and goods from shoppers and shopkeepers,
of their confiscating counterfeit goods from one shop and selling them
on to another.

Shopkeepers have taken defensive action against the frequent autho-
rized and unauthorized raids in this part of town. The multiple points of
control (with roller shutter doors at the ground-floor lobby, on each floor,
and at each wing) allow for rapid sealing of the building or of individual
shops in the event of raids. A hushed signal ripples through Jeppe when
JMPD cars stop and the "metros" begin to search hawker stalls or shops
for counterfeit goods. Without any warning to customers, the signal is fol-
lowed by the immediate silencing of all music. Lights are turned off, shut-
ters unrolled and clamped, and both shopkeepers and customers know to
remain silent as the shops, now turned hideouts, pretend not to exist. As
police vehicles pull off, the shopping frenzy resumes.

Jeppe has moods. On days when shutters are locked down and every-
one has a skittish look, there is an oppressive sullenness, the promise of a
bargain or of a sale sucked out of the boom boxes. But at month-end, and
when no police raid is expected, Jeppe bursts at its seams!

On such a day I try a new route into this so-called Ethiopian Quarter be-
cause Solaiman Brihar—who shows samples of Chinese apparel to shop-
keepers in Jeppe and who has often interpreted the area for me—has told
me, "You can only understand Jeppe if you understand Smal Street." He
laughingly describes it as "the big brother of Jeppe." In every shop cus-
tomers are choosing and buying. Shops are so busy that staff members
are now funneling people in a one-way system in and out of the door. I
enter a shop and scan the crude price tags: jackets for R50 (US$3.20),
cardigans for R24 (US$1.53), leggings for R5 (US$0.32), blouses for R14
(US$0.90). I head to the tight row of stalls backing onto the Jeppe Street
Post Office, where the calls of cross-dressing touts are more aggressive
than along the rest of the street. At first I don't see anything I want to buy
here, but then I spot it, and, without even thinking to negotiate for a lower
price, I hand over R70 (US$4.48) for a black T-shirt with psychedelic writ-
ing emblazoned across the front: "No one in my city has swagger like me."

Not since the days of Fietas[3] has Johannesburg had quite this intensity

3 Slang for the Johannesburg suburb of Pageview, which was a racially mixed, dense
 shopping and living area, from which most residents were forcibly removed under
 the Group Areas Act.

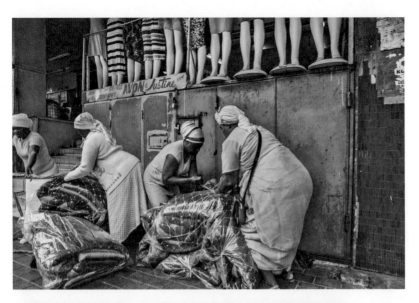

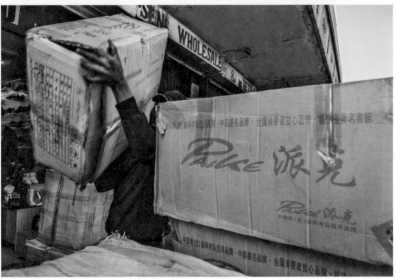

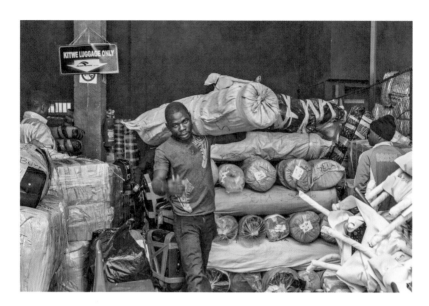

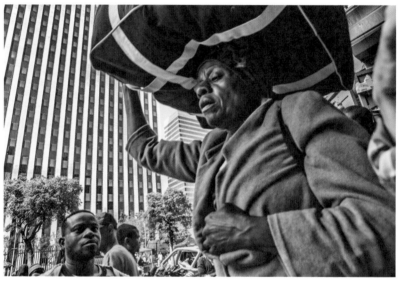

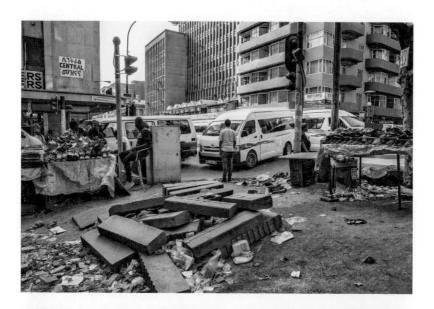

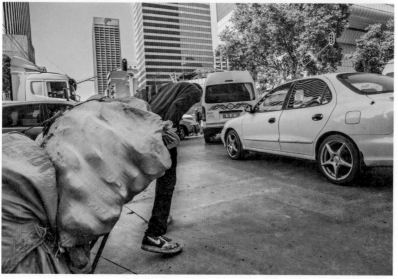

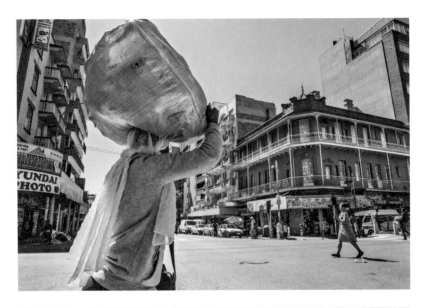

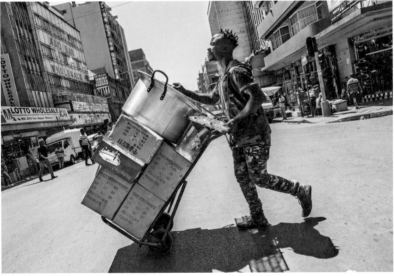

of trade and entrepreneurialism. In an extreme display of agglomeration economics, multiple traders sell similar branded and unbranded goods. It is an unglamorous tapping into the psyche of a nation of nonsavers for whom fashion is king. Nike-labeled shoes for R100 (US$7), Lacoste shirts for R60 (US$4), Bafana soccer shirts for R30 (US$2; a price that dropped 30 percent after World Cup fever lifted).

Asanda is a street trader from the Eastern Cape. She's pleased with her position in front of the Joburg Mall. "Don't you think it's great?" she asks. "Look down the road. I'm the only South African here, but I'm making business." She says cross-border shoppers are her main customers: "They buy in bulk. Locals only buy one-one." Like many hawkers here, Asanda's stall is really a shop front. She stores her stock in a nearby building and can supply an order of any size within minutes. She also has deals with shops, and if a customer asks for more goods, Asanda can get supplies. It works both ways. Shopkeepers have told us they share customers with street vendors, and Asanda says shops sometimes even stock from hawkers who have access to a special item. As we say goodbye to her and walk on, she calls out, "Watch your bag!"

The Hotels and Buses

Early one morning we try to talk to shoppers at the Grand Hotel. We get a steely reception. Tired shoppers crowd into the lobby. They have just arrived on the overnight bus from Maputo and are not interested in talking to us. "Are you here to spread the gospel?" asks a woman who is sitting on her suitcase. She is looking at my black notebook. When we say that we aren't, she assumes we are from the City Council, so she snaps at us, "We are coming from many countries bringing so much money here, but your system doesn't cater for us. Doesn't keep our stuff safe. We lose things, cell phones, all the time here. You see now we can't go out to shop yet. We must wait for ten or eleven o'clock when the streets are full of people, so that if we scream, someone will hear us."

Luiza Faife is sitting next to a blanketed woman on a bench under the hotel notice board, where hourly and daily rates are advertised. She says, "I can talk with you, but I haven't got much [English]." She says she is a *vendedor ambulante*[4] from Maputo. I ask her how she manages without the language in which many transactions are conducted in Johannesburg.

4 Portuguese term for traveling salesperson.

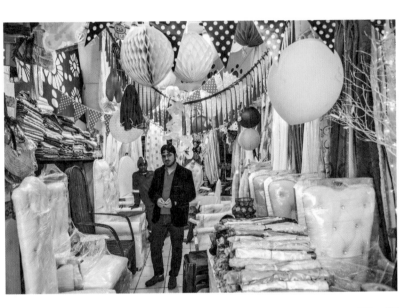

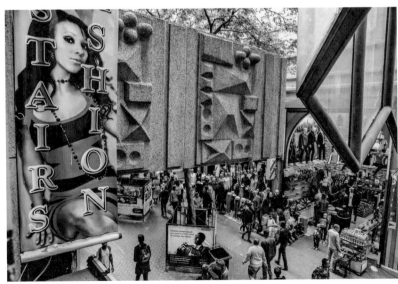

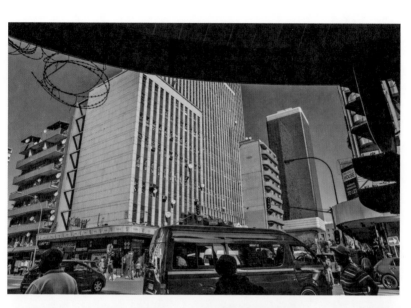

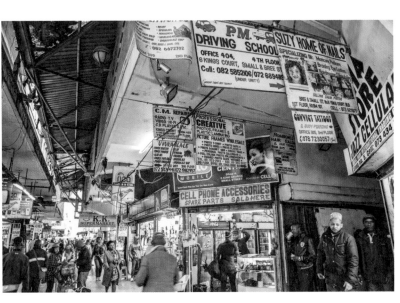

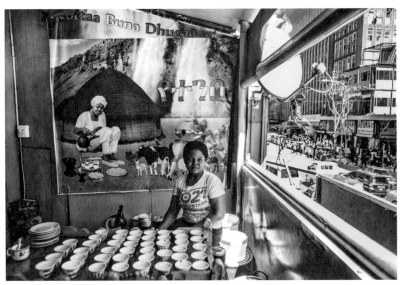

She says she doesn't need many words: "I say to the man, 'How much?' I know numbers, so money is no problem." And so we uncover another reason why shoppers travel to the city to shop directly. Language barriers require face-to-face contact. Transactions are conducted and deals made with a few words and many gestures.

We head back toward the various Zambian-run hotels and bus depots on Kerk Street. Richard Jali, a manager of one of the coach lines that services Lusaka and Kitwe, says his company sends five buses a week out of inner-city Johannesburg. These are sixty-seaters. They are often full. "At Christmastime we often have sixty-five traveling. Some are standing." He says customers are even more dependent on the bus services than on hotels. "It's not just about transporting passengers. We store their goods, we help them with customs, and we even help them find accommodation. We also have a taxi service for those going to China malls." "This is helpful because . . . people follow you and steal from you if they see how much you have," says Natasha Bupe, whom we meet while she's having breakfast at the restaurant alongside the bus depot.

Transnational Shoppers

Natasha has her own shop in a small town near Lusaka. But her business depends mostly on collecting money for specific preorders before embarking on her bimonthly shopping trip to Joburg.

Natasha considers herself an experienced and successful shopper. But this business is not her dream. "What made me start cross-border shopping was my inability to find employment. I'm a flight attendant by profession. But Zambia doesn't have a national airline. I didn't want to end up as a housewife, so I decided to go into cross-border trading, because I used to hear people talk about Johannesburg and about their shopping here. I first came to Johannesburg five years ago and started buying curtains. But by my next trip I had moved to women's clothing. . . . I found it challenging. Whenever it was time for payment, [the customers] always came with stories." Now her niche is formal men's attire. "I mostly buy men's clothing, like suits, trousers, and shoes. I take orders from men at their offices in Lusaka. I keep coming here because there are always nice things to buy. And other shoppers help. We meet each other when shopping because we recognize our language, and this gets us talking and comparing products and prices. I shop in Jeppe, Carlton Centre, and from the Nigerian street vendors on all the streets (they have good quality clothes). I'm not shopping

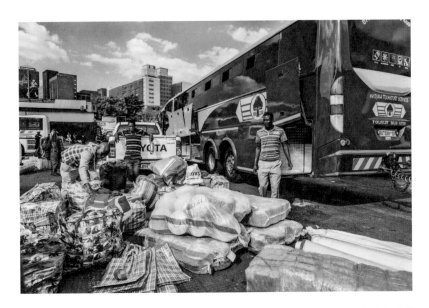

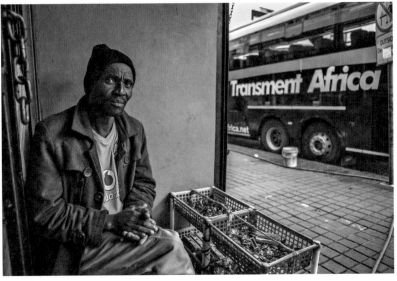

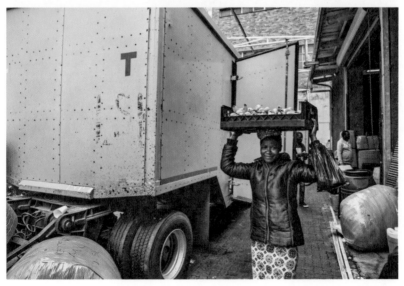

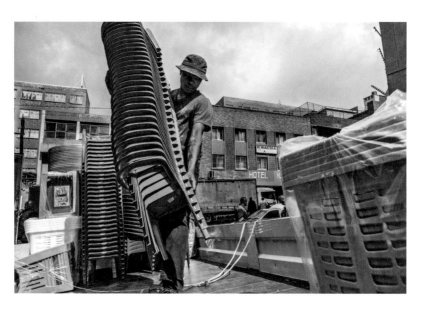

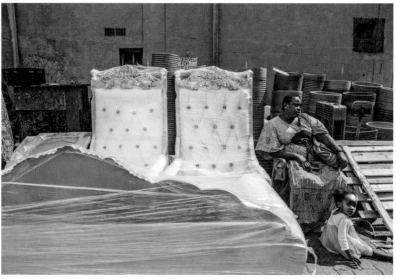

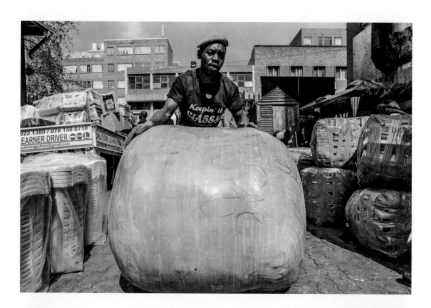

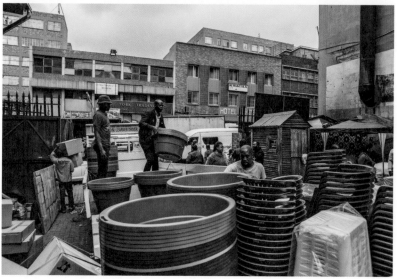

for small profit and low quality. I find quality men's clothes at a profitable price. High-quality goods give me a lot of profit. If I buy a pair of shoes for R500 [US$35] here, I can sell it for R1,700 [US$118] in Zambia. But if I buy a low-quality suit for R500 [US$35], I will only sell it for R600 [US$42]."

"I am usually away from home a week in a month traveling," says Natasha. Her transnational shopping is not confined to the Lusaka-Joburg bus line. "Sometimes I shop in Dubai. Last year someone told me that suits there go for US$70. This means that I can resell them in Zambia for US$130. I did that a few times. The challenge is that I am limited in my amount of shopping as the plane uses kilogram measurements. The other option is for me to ship in what I buy, but this takes about a month and a half to reach Zambia. So, I usually buy extra kilos for the flight. The last trip I bought forty kilos. It was a good experience, and I plan on going there again because of the texture of the clothing and the prices. I also shop in Tanzania because they have good shoes and handbags. The issue I have with Tanzania is that we travel by bus, and there are many hills and poor roads there so it is not safe, and there are many accidents. I also go to Botswana to shop for shoes, particularly men's shoes. To compare Gaborone with Johannesburg: I have a lot of choice here, but in Gaborone security-wise, it's safe to move around with your money."

I think of Alex the packer's analysis. Although he talked of how busy he is, sometimes using fifty reels of packing tape a day to secure shoppers' parcels for the trip home, he said, "I'm telling you Joburg has competition. Since things are getting expensive in Johannesburg, they are going to Tanzania and China. Once a customer was having his leather shoes wrapped when he started comparing prices with another customer. The other guy called his people in Tanzania to find out the price. Next thing this customer decided to return those shoes to the shop here, and he went to Dar es Salaam to buy the shoes. They are all going to Kariakoo Market in Dar es Salaam, which we hear has been recently renovated with a lot of shops and many different floors."

Natasha says Joburg is "hot." She spends R25,000 (US$1,603) on each trip here. For her business, face-to-face customer contact is her most important avenue for sales. "When I get back to Zambia, I pack things into my vehicle, and I do door-to-door sales. Whatever is left from my trip, I put in my own shop," she says.

Although she still hopes to work one day as an airline attendant, she says, "My life has changed a lot since I started this business because I'm

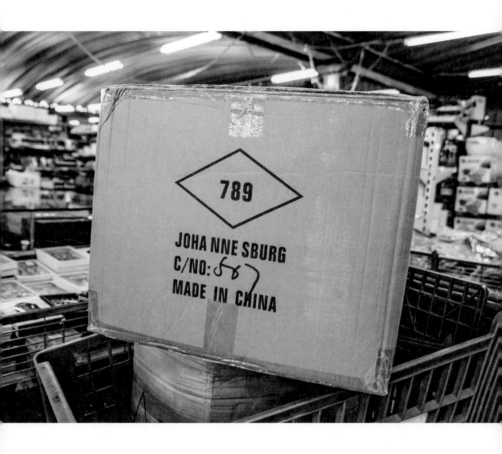

not a dependent any more. So, if I want to spoil myself and go to Zanzibar, I can go. I spoil myself once a month, sometimes with my husband or friends, but other times it is just myself."

The Streets of Joburg

We follow Natasha as she goes from shop to shop in Jeppe. I ask her about the streets and buildings of Joburg. "I find the environment okay," she says. "It's congested and there is a lot of litter, but it's not as bad as Zambia." This is the same comment we hear from many shoppers and shopkeepers. Some laugh and say, "Joburg is so strong! Have you seen the streets of Addis?" My eyes are drawn to the broken paving, the fallen traffic lights, the stormwater flooding street corners, the piles of garbage spilling into roadways, and the sidewalks that have been dug up and partially repaired in a mess of haphazard paving. I point out the hazardous new water meters that protrude into the air like balancing bars stretching across half of the sidewalk. The public environment is indeed inhospitable as neither landlords nor municipal entities pay much attention to pedestrian comfort in what is the most intensely walked area of the inner city. Building conditions are variable. Robust trading and turnover and high rentals do not translate into investment in buildings. Lifts work intermittently, and fire escapes are often blocked up.

I don't find the comparison with the streets of Addis a compelling reason for this neglect. I want to tell the landlords, officials, politicians, I want to tell the mayor that this is no way to present the face of sub-Saharan Africa's shopping hub. This is no red carpet for people spending billions here. And it is billions. I'm working on a separate research project in this part of town, and the big question my colleagues and I ask is: How much money are these shoppers spending in Joburg? There are no balance-sheet entries to assist us in answering that question. But we've interviewed hundreds of shoppers and shopkeepers; we've asked how much each shopper spends on each trip. We've counted the buses and taxis that leave Joburg every week to go to Zambia, Mozambique, Zimbabwe, Swaziland, Lesotho, Botswana, and Malawi. We know how many of those passengers are shoppers. And we've estimated the turnover. When I call a leading professor of property economics to explain our method and our result, he cannot contain his excitement: "Cross-border shoppers are spending R10 billion [US$694.8 million] a year in the inner city? That's equivalent to the annual turnover of

302

two Sandton City shopping centers. And you know that's Africa's biggest and top shopping mall ... Go tell the mayor that!"

Natasha, however, has moved on from talking about conditions in the city. She is talking about the importance of quality goods. She says, "I have not bought any products made in South Africa. Nor have I ever shopped at the Chinese malls. In Zambia there are a lot of Chinese shops and the quality of the products is low, so I trust these suppliers in the CBD more." We are standing in a shoe shop in the Medical Arts building. I know this is a shoe shop because I've been here before and talked with the shop assistants. But to the naked eye this is just a storeroom. There are no shoes on display. The store is packed to the ceiling with boxes, and a man is climbing from one stepped column of identical cardboard cartons to another, to extract a package of sneakers that a customer has come to collect. The box he retrieves is labeled for its journey across the South China Sea and the Indian Ocean:

JOHANNESBURG
MADE IN CHINA

Undercity

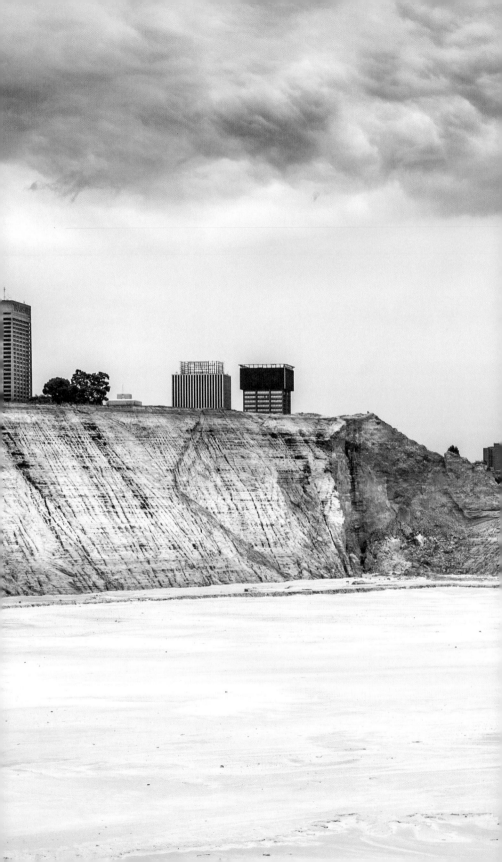

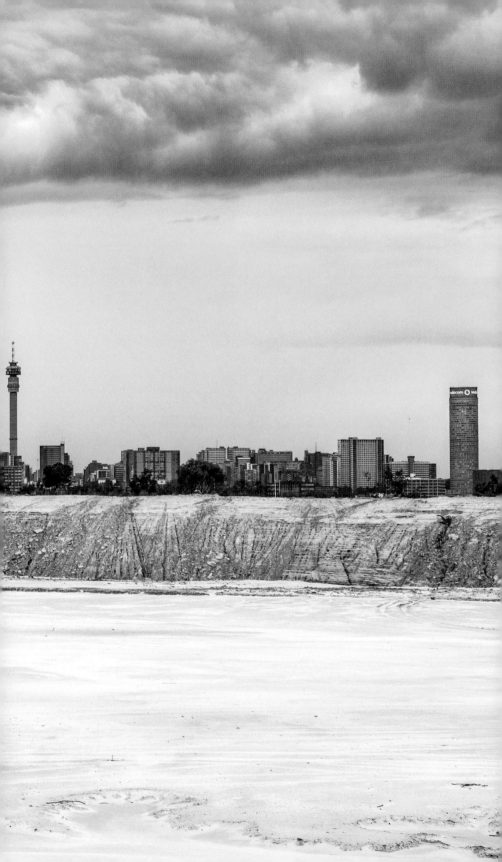

FNB

"THIS PARK IS CLOSED UNTIL FURTHER NOTICE. Entry strictly forbidden." The City of Johannesburg sign at the entrance to the George Harrison Park on Main Reef Road is hardly menacing, and we are not the first to ignore its instruction.

To the left of the park entrance stand the charcoaled remains of a commemorative pavilion. We can't make out the writing on the plaque, but no doubt it records that on this site in March 1886, one George Harrison struck gold on the Transvaal farm Langlaagte. Does it mention that this man—credited with discovering the richest gold vein on the planet—quickly sold his claim for ten pounds sterling and disappeared? Or that it is rumored he was killed by a lion?

The find precipitated a rush of fortune seekers from around the world to the watershed that drains its life force into two oceans one thousand kilometers away. Within a month, three hundred prospectors had occupied a hastily established mining camp. By August the residents numbered three thousand. In October, public diggings were declared, and the village that had sprung up was named "Johannesburg." But everything, from the basic grid layout of streets to the iron-and-wood houses, was made with impermanence in mind, and it would take until 1928 for the government to have enough confidence in its future to proclaim Johannesburg a city.

The memorial to Johannesburg's founding moment is sadly neglected. A blackened wall, a partial floor, and stone pillars reaching hopelessly toward a lost roof honor an industry—now depleted—that made South Africa the richest economy on the continent, and Johannesburg its wealthiest city.

We've come here in the hope of meeting men who know that the Lan-

glaagte belt contains more unmined gold than any other vein in Johannesburg's gold reef. They call it FNB (First National Bank).

The incongruous sound of a weed eater startles us. A municipal worker is trimming lawns around this mess. His coworkers, lounging under a large tree, ignore and are disregarded by the stream of backpack-carrying men going to and from the far end of the park. We follow the men through the gaps in a precast palisade fence bordering a huge cavern, the lip of which is a narrow mound of excavated soil, where men are sitting or lying in various stages of undress. Pieces of mud-caked clothing mark spots that were left in a hurry, and the ground is littered with discarded batteries from head torches.

Men are packing rocks into backpacks that will disguise their labors when they catch taxis later this morning. Some are changing out of their double-layered work pants, others are washing their faces and arms in what dirty puddles they can find. A young boy is selling pieces of soap. Every eye turns on us. We've clearly trespassed into a private space. At least Mark's camera explains his presence, but all I have is my curiosity.

I skulk to one side and wait for someone to approach me. In this way I meet nineteen-year-old Edmond Lusinga from Harare. He is suspicious of my story-collecting mission, but once he has cross-examined me, he speaks with roller-coaster excitement of going underground and returning with rocks that might contain gold. He makes money; he spends money; he makes more. "It's a good job. You fight with rock and get money," he says. "You are here as a foreigner; you haven't got a bank card. So you waste your money on having a good time."

Others step closer to talk or listen. I meet Boniface Marira. He's surprisingly bulky and somewhat older than the other men who have been in the shaft since sunset yesterday. He has crawled and walked and climbed for two hours this morning with a twenty-five-kilogram sack of rock on his back. "You can only carry so much," he says, explaining that much of the passage underground is a leopard crawl between sheets of rock. "But anyway, we survive from this place. I'll make R500 to R1,000 [US$35 to US$70] from these stones." Once he was very lucky: he earned R17,000 (US$1,180) in one week. But he has never overcome his fear of going underground. "It's the most dangerous work in the world," he says. But he is experienced; he knows where the good spots are. When I ask if this work has changed his life, he answers methodically, "This gold sent my two children to school. I have one house in Leratong. At home in Bulawayo I built a three-room house and bought three cows and five goats."

310

Going Under

Monyane Tlali's backpack is a repurposed mieliemeal[1] bag that he is filling with tinned meat, two liters of cooldrink, two loaves of bread, pap, two packets of cigarettes, a chisel, a five-pound hammer, a paraffin lamp, and a head torch. He will stay underground for a week. He says there are over two hundred people underground at any one time. Contrary to the tales of ethnic gang rivalry we will hear from others, Monyane says, "When we are down there, we are one blood. We don't see Zimbabweans, South Africans, or Basothos. And if someone's hurt or dies, we carry him out. If someone must be buried, we help to pay for that." He estimates that he walks seven kilometers to the rock face he works. He says, "You can walk to Welkom underground." This is because every shaft has an escape route—made when the mines were in operation—that links it to a neighboring shaft. It's a rabbit warren down there. Monyane is nonchalant when I ask about darkness and disorientation. "Nah, you can't get lost underground," he grins. "There are lots of tunnels, but obviously you just watch where you have gone. Then you will know the way back." Going underground is not a novelty to the forty-three-year-old. He is one of 75,000 miners who have lost their jobs in the formal mining sector in the past five years.

We Die There

A serious-faced man who has been packing his own sack and nodding at Monyane's account volunteers additional details. Mangena Tshuma stands up to make his point: "We don't just mine for the whole week. There are many men down there, and you must wait your turn. We work in pairs or three by three. Teams wait for others to finish. It's not soft rock. It takes four hours to chisel thirty centimeters!" He raises his eyebrows and four fingers for emphasis. Searching for gold is neither quick nor haphazard. "We do research in the shaft," says Mangena, "We crush the rock to see if that belt will give us gold. If we find a line of gold, we wait our turn, and then our team works for two days solid at that place."

311

Njabulo Gwagwa is pacing up and down the line of men and bags and left-behind clothing. He stops to ask Mangena who I am. When he resumes his pacing, I ask if he's a miner. "No, he's not going down," says Mangena. Njabulo safeguards the miners' belongings and wards off gangs who try to

1 Mieliemeal is ground maize meal used to make a porridge known as "pap."

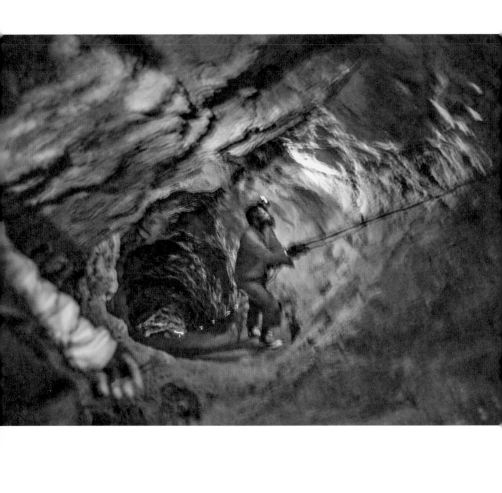

enter the shaft. "That's why we need security. Let me tell you, it's a tough job and dangerous. It's better to be a *Zama Zama*[2] than to be a security. Before we go down, they search us for guns and knives. And we pay them. It costs R70 [US$5] for each *Zama Zama* to enter, and if you come out, you give the security a plate," he says. This offering—the "plate"—is a pile of rocks poured onto a cardboard sheet.

But the guards cannot protect miners once they have entered the shaft. "Underground is a risk. We die there." Mangena sounds out each syllable and then rephrases the warning, "It is dan-ger-ous." He lists the ways you might die in this undercity. "You can be buried under rocks if there's an explosion. And sometimes there's a gas buildup down there. Any time that we struggle to breathe, we run! In 2013 some Zimbabwean *Zama Zamas* died because of gas. I was there, but I got out in time. And there are Swazi or Basotho gangs that rob or kill us underground or when we bring the rocks out." His mechanical tone belies the images his inventory conjures. Finally he says, "My younger brother died in a rock fall last year." Even with that horror fresh in his memory, Mangena still goes into the earth. "If it's your time, you will die anywhere," he says.

In any case this is his job. "My whole family is in gold," says Mangena. "My parents were *amakhorokhoza*[3] in Bulawayo. My three brothers were *Zama Zamas* here, and my sister crushes rock. So this is how we have always lived. Gold pays for my clothes, my family, and my kids' school. My wife also works in this business. She is crushing in Bramfischerville."

Crushing

Zama Zamas now stream out of the shaft in time to catch the first train back home to informal settlements on the outskirts of Soweto. There the gold-bearing stones are handed to a crew stationed at a concrete slab. All day long women, some with babies on their backs, kneel over the slab, grinding the stones into powder to prepare the gold-bearing material for washing, draining, and refining. The prize from a twenty-five-kilogram load of rock will leave the site in the miner's pocket as a small blob of gold and sand residue, bonded with mercury.

Mangena says buyers wait for the gold at the "kitchen," a highly secured

313

2 The local term for informal miners, this is an isiZulu expression meaning "those who keep trying."
3 The Shona term for small-scale miners.

shack in Bramfischerville. There, a man puts the blob into a clay crucible and, without any protective gear, heats it with a blowtorch. The mercury evaporates in a thick black smoke, leaving a gold pellet in the crucible. It is weighed, and the miner is paid according to the gold price of the day.

A muscular man looks up from where he is sitting on the ground, his arms leaning heavily on the backpack propped between his legs. He is irritated by my questions and, for that matter, my presence, "Look, we are just here to work. It's better than coming to break into your house!" he snaps. Emboldened by his rancor, his friend swaggers lustfully toward me and puts an arm around me. It's time to leave.

Nandos

As we turn to go, seven golden youth silently ascend the slope that rises from a shaft to the right of us. Their bare arms, shins, cheeks, foreheads, and eyelashes are dusted with the yellow earth that they have crawled through and loosened all week. Yellow dust clings to their clothing and their weary shoes. It cakes the protective "nappies," fashioned from builders' bags, that have shielded their genitals as they have slid down lengths of knotted rope or electric cables into the lower chambers of the abandoned mine.

They sling their rock-filled haversacks onto the ground and walk toward a grove of pepper trees. Without a word, the seven young miners bow over a cigarette-lighting ceremony. Then the group disperses as each man turns to his own thoughts.

It is Nandos Simao, leaning in elegant repose against the remains of a concrete wall, who catches my eye. He is beautiful. The interlocking silver rings in his ears complete his outfit, which seems more fashion statement than miner's gear. Green-and-yellow-striped sleeves extend from his cropped sacking overshirt. His waist is bare beneath a yellow undershirt, and a red XMAN-branded elastic band is visible above his rope-tied canvas pants.

I am reluctant to interrupt his meditation but also curious to understand the real experiences of these men whose youth and golden glow seem at once so ordinary and yet quite supernatural in this landscape, and so I walk over and talk to him. I learn that the twenty-three-year-old Mozambican lives in Orange Farm with two fellow miners, his cousins. The youngest is seventeen. Nandos's mother doesn't know how he earns the money he sends home. There's so much I want to know about this young

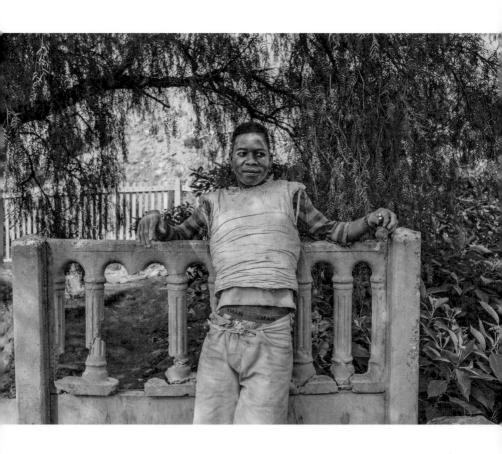

Nandos Simao, Langlaagte, 2018

man, but this is no place to talk. The men need to travel the forty kilometers home to crush their booty. Nandos gives us his number. "We can meet another day," he says. Our phone calls go through to voicemail for weeks, and we never hear from him again.

Nandos has followed a long line of Mozambican migrants to these goldfields. From 1896, the Witwatersrand Native Labour Association (WNLA) recruited labor from South Africa's "native reserves." When the pressure of land taxes failed to lure enough internal cheap labor to the goldfields, the WNLA went further afield. By 1910, two-thirds of black African workers came from the Mozambican east coast. When the Portuguese colonial government capped that supply, recruitment expanded elsewhere, until men from all of southern Africa were tied to Johannesburg's growing economy. They came from Nyasaland, Bechuanaland, South West Africa, Basutoland, and Southern and Northern Rhodesia (Innes 1984; Crush and James 1991; Crush et al. 1991). Without these migrant men, there would have been no deep-level gold mining in South Africa. They worked the earth under the city and lived in crowded single-sex hostels until their contracts spat them back to their families.

Every Dump in Town

Johannesburg rose with the sinking of deep-level shafts, and gold mining hastened South Africa's development into a modern industrial state, allowing it to leap through advances that Europe had navigated over centuries. The expensive technologies required for the extraction of this deeply buried, low-grade ore rewarded the wealthy. Artisanal mining was soon made redundant by the consolidation of six dominant mining houses. The men who worked these mines went to deeper and deeper levels for low wages and at high risk.

The politically expedient thing to do in Johannesburg is to demonize the artisanal miners. Media reports indicate that R7 billion (US$448.9 million) is "lost" to *Zama Zamas* annually. Apocalyptic articles claiming that these miners might cause entire neighborhoods to collapse contain terms such as "scourge" and "illegal foreigners." A recent tweet by the City of Johannesburg declares that "an investigation has revealed that if illegal mining continues at disused mines, the entire Nasrec precinct including the iconic FNB stadium, could go down in ruins." I contact officials in the City to ask about the report. No one has heard of it.

We have heard of a man in Krugersdorp who is an adviser to various

commissions on the environmental impacts of the Witwatersrand mining industry.

The hefty Mike Harris has spent his life along this reef. "My grandfather came here as a German immigrant, chasing the gold. And all his kids worked on the mines in some way," he says. Mike's childhood home was a corrugated iron bungalow, and his playgrounds were the mine shafts of the East Rand. He and his friends used to drop ropes down disused shafts and play underground. They once found dynamite sticks plugged into the walls of a subterranean chamber. "Thank God we didn't know about dynamite or detonators. We tried to light the sticks, but they didn't explode."

It is fitting that Mike, now retired, lives on the West Rand. His whole working life was focused on the gold seam. As manager of the railways' regional high-voltage electricity cable, he walked the rail line along the entire stretch of the reef for years. It allowed him to indulge his love of the mining landscape. "You can't show me a single mine dump that I haven't had a *braai* on," he chuckles. He has also spent months photographing the activities of *Zama Zamas* and the effects of acid mine drainage on the West Rand. And as a member of his neighborhood watch, he has entered mine shafts in search of suspected thieves. "But we hightailed it out of a shaft up the road when we found over one hundred people living inside there!"

We ask him about the threat of catastrophic sinkholes. "The *Zama Zamas* use a pick-and-shovel method, much the same as the first artisanal miners of Johannesburg did," he explains. "The difference is that 140 years later they are not working virgin rock faces. They are working the regulatory rock pillars that were kept in place during mining. Those pillars act as scaffolding, literally to hold the earth up." A city left standing on stilts.

He reserves special contempt for the reckless mining companies that performed no postmining remediation on this land and barely shut these shafts when they took their fortunes, bequeathing the Witwatersrand a legacy of uncountable costs in environmental damage. The amount of gold retrieved is minimal compared with the deadly waste it generates.

Pressing for rehabilitation of mining land is a cause with few champions, but foremost among them is activist Mariette Liefferink. A tour of the tailings, pits, and ravaged landscape of the West Rand with her is a jaw-dropping lesson in the geoscience and biology of this landscape, and in the alarming impunity that has contaminated vast swathes of soil and water, and endangered livestock and bird and plant life. The rehabilitation efforts of one mining house pale against the numbers that Mariette can clearly recite in her sleep: 42 tons of mine dust enter the environment ev-

ery day; the radioactivity in some of the soil here is 52 times higher than the recommended levels; the Witwatersrand produced more than 43,000 tons of gold from 120 mines in one century; the country generated an estimated 221 million tons of gold mining waste per annum.

Mariette shows us luminescent orange pools of acid effluent. Many such radiantly colored streams and ponds stain the mining land. The iron pyrite—or fool's gold—in this basin contains sulfur. When the sulfide-bearing crystals in the abandoned tailings are oxidized through exposure to water and air, a chemical reaction—pyrite oxidation—occurs. Sulfuric acid forms, in turn breaking down other minerals. The result is contaminated water. Water is present in all the mine chambers, and much of it is at risk of toxicity. This is not new. In the days of active mining, companies continually pumped this water out. But with the demise of formal mining, water fills the cavities and leaches into the soil and groundwater. The toxic brew is radioactive, and it threatens residential areas all along the reef.

Mike says, "This water is antithetical to life. You will not find insects, fish, or plant life in the water. Nothing can live in it ... except for the poor hippos at Krugersdorp's game reserve. Who *do* live in it. And might be going blind from it."

Gold under Her Shack

Mike says that Johannesburg's population is living on the largest concentration of radioactive uranium in the world. Residents in communities that are continually exposed to mine dust suffer from bronchitis, asthma, eczema, and lung cancers at levels that far exceed the national average. These are the neighborhoods where you can see the gold reef at surface level. And it is here, and on the mine dumps along the reef, that another group of *Zama Zamas*—those working aboveground—also employ methods that date back to the founding of Johannesburg.

MaLetsatsi Mamogele is digging for gold under her shack in Fleurhof. "This work is right for me. I get that R200 or R300 [US$14 or US$21] a day, and I can make food for my children," says the grandmother, who, at forty-two, has the stoop of a much older woman. Her son, his partner, and their children live in the RDP[4] flat that MaLetsatsi was allocated in 2007. Before that she lived in a hostel. "For ten years I was washing clothes in the hostel.

4 Refers to state-subsidized housing units. RDP is an acronym for Reconstruction and Development Program.

Now I wash gold," she smiles. In truth gold is present in everything that is washed in this windblown neighborhood, whose residents inhale mine-dump sand and wipe it off their cars and kitchen counters.

Some days MaLetsatsi simply digs for it right where she lives. Her hardboard-and-plastic-sheeting dwelling sits amid scraggly bushes next to discarded rolls of wire, bottles, empty food cans, a mattress, half a concrete angel, and the blackened floor of a burned-out shack.

But mostly MaLetsatsi works the building site across the main road. "They are building a substation here," she says when she shows us the scarified minescape with its dongas, exposed shafts, and clumps of blue gums rising out of the yellow-, concrete-, and rust-colored sands. *Zama Zamas* and contractors work side by side, the former with wheelbarrows, makeshift drains, and plastic buckets, and the latter with a sophisticated Caterpillar with metal arms and conveyor belts.

The contract foreman Jaap du Toit is standing next to his monstrous rock- and sand-sorting vehicle. The sand he mines will be sold to a company that extracts the gold from it, and the rock will be used in road making. "So the streets really are paved with gold," he says. "It's the same sorting process that those guys are doing, but on a massive scale." Of the informal miners, he says, "We don't interfere with them, and they don't interfere with us. The other day a *Zama Zama* came to me and said the Caterpillar was blocking a path they use. I said, 'No problem,' and we moved it." He points to the figures dotted in the distance. "Wherever you see *Zama Zamas*, there's gold."

A few meters from the roadside, Gotcha Gomani is standing in a donga, washing sifted soil across a drain he shares with MaLetsatsi. "If you drive past, you won't guess we are getting gold right here," he says. When he stands up to say goodbye, I wonder if the acid content of the water he's using might have accelerated the disappearance of Jacob Zuma's face from his ANC-issue T-shirt. MaLetsatsi also notices the faded visage. "Ja, Zuma wanted too much money for the Guptas," she smiles.

Gold Didn't Bring Us Here

The post–gold rush city carcass entices darkness and death. When a fire broke out in the Langlaagte shaft in September 2016, it was rumored that two hundred men were trapped underground. Distraught *Zama Zamas* insisted on joining the rescue effort. Relatives and traditional healers held a vigil aboveground. One of the would-be rescuers died. The bodies of two

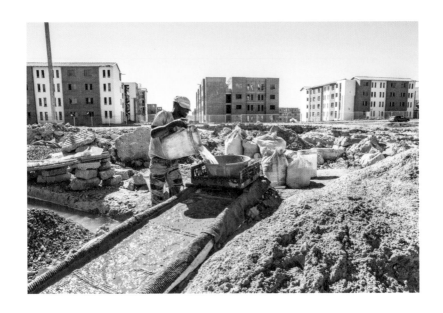

Gotcha Gomani, Langlaagte, 2018

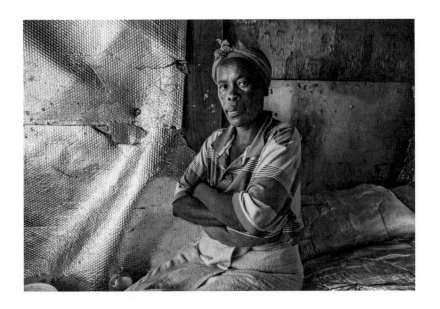

MaLetsatsi Mamogele, Fleurhof, 2018

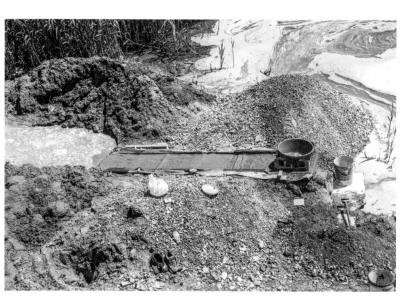

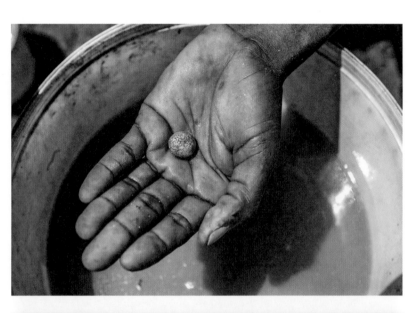

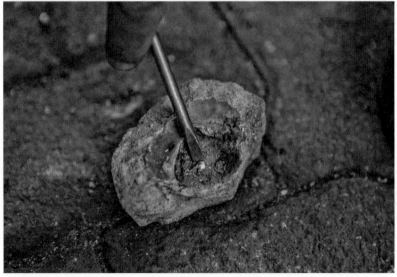

Zama Zamas were retrieved, and many miners who survived were arrested as they emerged. A traditional healer we met said it was the snake spirit that caused the deaths. She said the spirit was angered because miners had treated the space badly, by taking drugs and knives and bottles into the earth. She cleansed the area.

On the east side of town, Pastor Reggie Matura is predicting the awakening of another subterranean spirit. The leftover land on which the Johani Masowe Church is located is barely marked. A line of stones, a white flag, a modest altar, and a cross formed from two thin, painted branches demarcate this clearing at the base of the old Village Main mine dump just beyond the highway that skirts the inner city. More striking are the yellow, purple, red, and green robes of Pastor Reggie Matura and the other prophets. Their colorful mantles distinguish this church—whose founder was the resurrected John the Baptist—from the groups of white-clad worshippers, who also come and go or hold all-night prayer vigils on these foothills.

On Thursdays and Saturdays, enormous log piles disrupt the barren veld. These will fuel the bonfires that warm supplicants in the bitter highveld winter's night.

We are at the mine dump to meet with *Zama Zamas* when Pastor Reggie's purple robe catches our eye. We watch two young men remove their shoes before gingerly approaching one of the red-clad prophets. The kneeling men receive counseling and prayer from the senior prophet Pastor Jacobi before Pastor Reggie anoints them with water and milk.

Having established that the pastor is not to be approached directly, and that women are seated some distance from the men, Mark takes off his shoes before going closer. I tiptoe in my socks along a glass-strewn path to where Reggie's wives and three other women are seated. Immediately someone jumps up and covers my jeaned legs with a large sheet and my head with a scarf. "So that the husbands don't see you," she says. I talk with Pinky Matura, whose red robe signifies that she is praying to angels of war for protection. She describes the three-hourly rhythm of prayer that worshippers perform daily: "At nine we pray to Gabriel and Michael. At twelve we pray to Jesus. At three we pray to the angels of war, Moses, Elijah, Joshua, Caleb, and others. At six we pray to Abraham, Isaac, and Jacob." Tonight communal prayers will continue at the same intervals as saints, angels, and Mother Mary are called upon.

Meanwhile Pastor Reggie is telling Mark, "We worship on this open land, but gold didn't bring us here . . . the mine dump is insignificant to us. All we do is clear a space and make it safe." Safety lies in defense against bad

324

spirits, and prayers are offered at this altar for such protection. At times of great need, a pigeon or dove or even a sheep might be sacrificed on another altar at the top of the mine dump.

Pastor Reggie anticipates that an offering will be required soon. He has warned that the discord "between foreigners and owners of the land" has unsettled the head spirit that moves beneath the city. "When it rises, it will smell the blood of xenophobic violence," he says, and it will not be appeased until more blood has been spilled. He fears the spirit is rising in Johannesburg again.

Philip

"Excuse me!" A young white man is half-running through the undergrowth along the base of the mine dump toward the church group. With little regard for sacrament, he breathlessly asks if anyone has seen any balaclavaed men running past. Carlos Mendes was held up on the highway just a few minutes before, and he's shaking as those Joburg crime words blurt from him: "Men ... guns ... cell phone ... wallet ... ID book ... I'm fine!"

Carlos hasn't taken the risk of following the thieves into the wasteland because he expects to recover his money or his phone. It's just his in-built Joburg reaction: "Maybe they'll at least throw my ID on the ground or in a bin somewhere ..."

Mark and I spot Philip Adelion in the distance. We've arranged to meet him here today. As we get closer, he says, "Why does the white man suspect me? The *tsotsis* are people who don't work. They don't dress dirty like me." Philip well knows the attire of the *tsotsis* who work this dump. He's stopped counting the number of times they've held him at knifepoint and stolen his clothes, his phone, and his gold. "They bury their guns and knives in the sand," he says.

Twenty-one-year-old Philip doesn't go underground. He's been working this mine dump since he arrived from Mozambique two years ago. He works alone. "I start digging up there at 4 a.m.," he points to the dump. "From which part?" I ask. "Where your mind tells you, that's where you must try. If you are lucky you will find it." Philip tests a small quantity of the sand before he digs. "You mix sand with water and shake it in this plate until the sand is smooth. The light sand will wash off. Then you will see if there is gold left on your plate." If it looks promising, he shovels it into the side of the dump. On the day we observe the process, he carries four builders' bags full of the sand to "the place where we try." It's a small rivulet at

325

the base of the dump. In dry months the *Zama Zamas* feed water to this low bed from a one-and-a-half-kilometer pipe they have attached to the municipal stormwater drain on the roadside. Philip finds a leveling in the dry grass next to the rivulet. There he shovels heaps of sand into a plastic washbasin-turned-sieve and shakes the contents onto a pile. It takes him an hour to sift one bag of sand into a bucketful of finer grains. While he works, he raps a love song that is more croon than hip-hop. "I'm gonna leave this work to make music," he says.

But for now his muscle is his livelihood. He carries bucketfuls of the fine sand to the sloping cement-slab drain he shares with other *Zama Zamas*. The drain has ridges formed from reeds and sticks, and is covered in towels. Philip pours scoopfuls of sand and water into the basin at the top of the drain. He swirls the mixture with a metal plate, willing it through the holes and onto the toweling surface. As the sludge washes across the drain, the toweling fibers grab the heavier gold-bearing sand. Other heavy particles are also trapped against the ridges.

Philip washes the towels in a bucket of water. What remains are tiny black and gold grains. He wrings the water from this residue in a piece of umbrella fabric. Then he scoops a handful of the mixture into his right hand. With his left hand, he takes a little glass bottle of silvery liquid out of his pocket. He sprinkles droplets of mercury into the grains and rubs them together in his palm. The mercury absorbs all the shiny particles into a small sphere. A motor mechanic who services minibus taxis under the highway bridge will blowtorch the silvery ball. This task of refining is the only assistance Philip seeks in his artisanal gold-processing mission. Afterward, he will take the shiny nugget of gold to the dealers near the Carlton Centre. He processes about forty buckets of sand a week. "Maybe I can get one gram from that. I get R450 [US$31] for a gram."

Cash for Gold

"Gold is a natural thing from God. It's like the oil in Nigeria. Even if people buy and sell it, there's always more," says Aku Obiyo. His Cash for Gold shop occupies a site that is certainly on the short list of Johannesburg's most dangerous corners. It's hard to see the shop amid the confusion it faces. On one side, the roof of the municipality's overdesigned trader market shades the public space where a hustle of shoe merchants, cooking mamas, touts, and hawkers compete for space. And on the other, people

burrow into used clothing piled on tables that are crammed along the length of the road.

Like every buyer stationed at the inner-city kiosks we visit, Aku maintains he doesn't buy raw gold. "*Zama Zamas* can give you the purest gold, eighteen or twenty-four carats. But it's illegal," he says. The police check his catalogue of purchases, and he may only buy finished products. I tell him we have counted twelve Cash for Gold stores in a few city blocks. Is there enough gold to keep everyone in business? "This is the land of honey," Aku says. "When you open your eyes, you will make it here."

"How profitable is this business?" I ask. Aku's not revealing his income. Instead he shows us the counters behind three bullet-resistant glass windows he has installed in the shop. The supplier offered a choice of three types of glass: basic reinforced, medium-strength bulletproof, and bulletproof that can withstand an AK47. He immediately paid up-front for the latter. It cost R85,000 (US$5,900).

Back on the mine dump, Philip agrees the earth under this city will never stop giving. "All over this Joburg there is gold. The trouble is, they built all this," he says, gesturing to the office towers of the Central Business District. "If they could just let us get under the city, we could find enough gold for all of us."

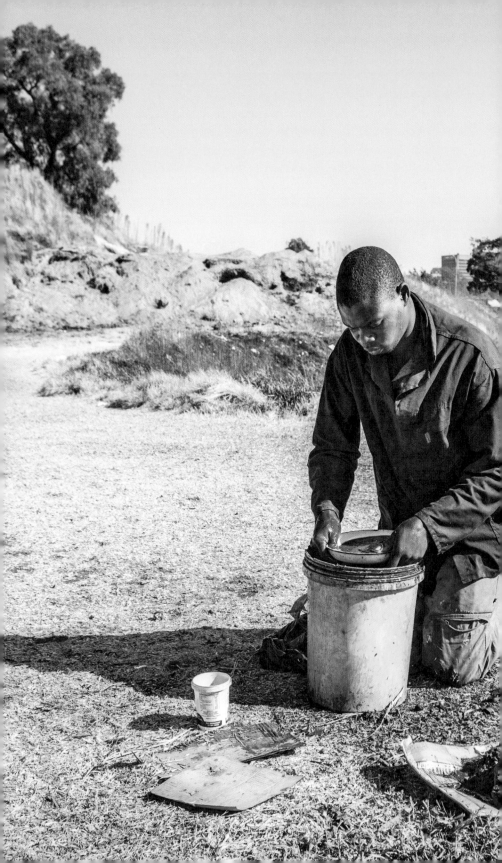

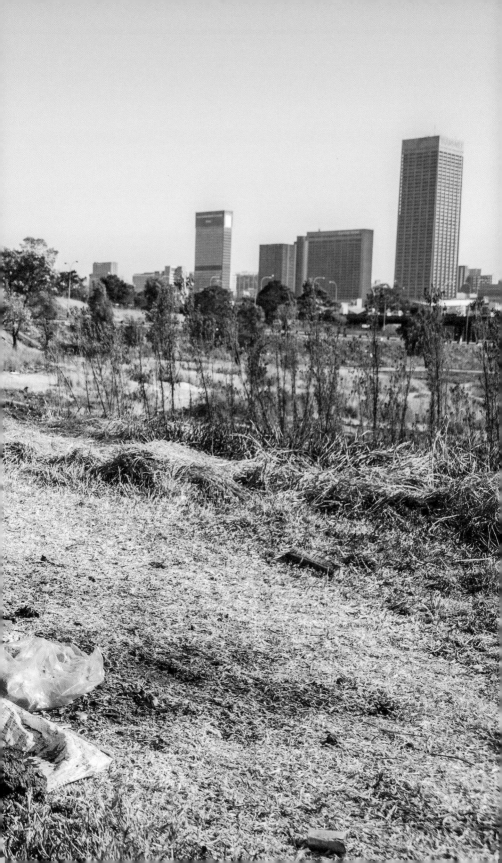

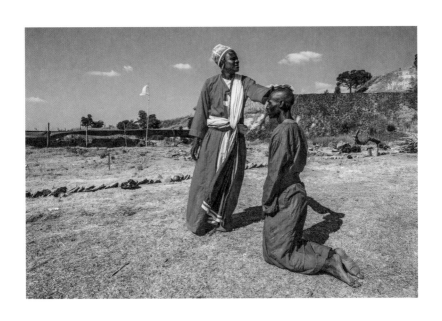

(*Previous spread*) Philip Adelion, Village Main, 2014
(*Above*) Pastor Jacobi and congregant, Village Main, 2018

References

Appadurai, A. 2007. "Hope and Democracy." *Public Culture* 19 (1): 29–34.

Beavon, K. 2004. *Johannesburg: The Making and Shaping of the City*. Pretoria: University of South Africa.

Benjamin, A. 1979. *Lost Johannesburg*. Johannesburg: Macmillan.

Chipkin, C. M. 1993. *Johannesburg Style: Architecture and Society 1880s–1960s*. Cape Town: David Philip.

Crush, J., and W. James. 1991. "Depopulating the Compounds: Migrant Labour and Mine Housing in South Africa." *World Development* 9 (4): 301–16.

Crush, J., A. Jeeves, and D. Yudelman. 1991. *South Africa's Labor Empire: A History of Black Migrancy to the Mines*. Cape Town: David Philip.

De Boeck, F. 1998. "Domesticating Diamonds and Dollars: Identity, Expenditure and Sharing in Southwestern Zaire (1984–1997)." *Development and Change* 29 (4): 777–810.

Dugmore, C. F. 2008. "The Making of Krugersdorp, 1887–1923." PhD diss., University of the Witwatersrand, Johannesburg.

Gluckman, H. 2007. "The Story of a Pharmacist in Hillbrow: 1955–1997." In *The Southern Africa Jewish Genealogy Special Interest Group Newsletter* 7, no. 4 (June). First published in *the Adler Museum Bulletin* 32, no. 2 (December 2006).

Harrison, P., and T. Zack. "2012: The Power of Mining: The Fall of Gold and Rise of Johannesburg." *Journal of Contemporary African Studies* 30 (4): 551–70.

Innes, D. 1984. *Anglo American and the Rise of Modern South Africa*. Johannesburg: Raven.

Mabasa, K. 2018. "Herman Mashaba and the DA's Politics of Racialised Gentrification." *News24 Online*, November 26, 2018. https://www.news24.com/Columnists /GuestColumn/herman-mashaba-and the-das-politics-of-racialised -gentrification-20181126.

Macmillan, A., and E. Rosenthal. 1948. *Homes of the Golden City*. Cape Town: Hortors.

Mbembé, J. A., and S. Nuttall. 2004. "Writing the World from an African Metropolis." *Public Culture* 16 (3): 347–72.

Melville, H. (1851) 2009. *Moby-Dick; or, The Whale*. New York: Penguin.

Mjo, O. 2018. "Mashaba Gets the Thumbs Down from Twitter after Citizen's Arrest." *Times Live*, November 14, 2018. https://www.timeslive.co.za/news/2018-11-14 -mashaba-gets-the-thumbs-down-from-twitter-after-citizens-arrest/.

Morris, A. 1999. *Bleakness and Light: Inner-City Transition in Hillbrow, Johannesburg*. Johannesburg: Witwatersrand University Press.

Murakami, H. 2014. *Colorless Tsukuru Tazaki and His Years of Pilgrimage*. New York: Knopf.

Parnell, S., and A. Mabin. 1995. "Rethinking Urban South Africa." *Journal of Southern African Studies* 21 (1): 39–61.

Parnell, S., and S. Oldfield, eds. 2014. *The Routledge Handbook on Cities of the Global South*. London: Routledge.

Saunders, D. 2011. *Arrival City: How the Largest Migration in History Is Reshaping Our World*. New York: Vintage.

Silverman, M., and T. Zack. 2007. "Grey Areas: Land Management and Democratic Governance Issues in Hillbrow/Berea, an Inner-City Area of Johannesburg." Unpublished report prepared for the Wits Centre for Urban and Built Environment Studies (CUBES) and Planact.

Index

Birthial Gxaleka, 213, 216–19, 234–35; Birthial's story, 237; on anyone being welcome in her room, 215; on unemployment, 221; rules, 220–21. *See also* Beaconsfield Court

Boikhutso Monnamorwa: on recreation, 234; on the state of buildings in Johannesburg, 224. *See also* Beaconsfield Court; Johannesburg; municipality

bones, 13, 32, 36, 124, 168. *See also* Kazerne

Boniface Marira, on earnings from gold mining, 310. *See also* gold; mines; *Zama Zama*

Bonze Seetelo, on the benefits of the street trade outside Anstey's, 198–99. *See also* Anstey's

Botswana, 67, 99, 300; Gaborone, 300

bottles, 59, 152–55, 161, 167–69, 319, 324. *See also* waste

braai, 36, 186, 199, 317. *See also* cooking facilities; fire

Braamfontein, 6, 198

Brenda Damoense, on activities in the city, 184–85. *See also* Anstey's; Nicole Damoense

Brian McKechnie, 208; and the difficulties of directing municipal investment, 201. *See also* Anstey's; municipality

bus, 17, 18, 136, 204; Bus Rapid Transit (BRT), 229; transnational, 291, 295, 300, 302

butcher, 13, 31–36, 40, 47, 96, 156, 161, 229. *See also* Kazerne

café, 6, 17, 192, 193, 221, 229, 267

Cameroon, 47, 90, 99

Carlton Centre, 132, 187, 228, 295, 330

cart, 133, 139, 149–50, 155, 161, 168. *See also* recyclers; trolleys

Central Business District (CBD), 1, 9, 16, 57, 282, 331

Charles Imo, on the diaspora community, 96. *See also* hair salon

China, 79, 285, 300; China malls, 282, 295; Chinese fashion, 106, 284, 286

City Council, 291. *See also* government; municipality

City of Johannesburg, 105, 309; City Council, 291; on informal mining, 316; mayor, 1. *See also* Johannesburg

cleaner, 48, 139, 157

clothing stores, 204, 284

Combi. *See* taxis

commuter, 9, 31, 40, 126

Congo, Kinshasa, 19

Connie Seetelo, on the uniqueness of Anstey's, 198. *See also* Anstey's

cooking facilities, 93. See also *braai*; fire

cooldrink, 48, 124, 136, 139, 167, 173, 311. *See also* corruption; police

corruption, 13, 96, 105

cow, 262, 310; cow head, 2, 3, 11, 12, 13, 31–36; cow head skins, 45–47; lobola, 269. *See also* Kazerne

credit, 102. *See also* Senga Mutombo

crime, 3, 10, 14, 20, 40, 185, 216, 224, 285, 325; hijackers, 156, 186; by police, 285–86; thieves, 317, 325. *See also* police; security

Crown Interchange, 45

CVs, 192, 220–21, 234. *See also* papers

dagga, 32, 127

Daniel Shabalala, 224, 228. *See also* Beaconsfield Court

David Majola, 215, 228, 239. *See also* Beaconsfield Court

Democratic Alliance (DA), 2. *See also* municipality

Democratic Republic of Congo (DRC), 15, 87; Kinshasa, 19

depot, 153–56, 167–69. *See also* recyclers

disability grant, 126, 217

drivers, 99, 102, 119–24, 127, 132–33, 139

dustbins, 152, 161. *See also* bins; waste

Eastern Cape, 168, 217, 291

East Rand, 36, 119, 186, 317

Economic Freedom Fighters (EFF), 2, 96n2, 153n1

electricity, 150, 224, 317. *See also* basic services; wires

Elizabeth Okahi: at Kazerne, 32, 36, 40, 45; on employment, 47–48. *See also* entrepreneurs

Eloff Street, 282

employment, 5, 221, 295. *See also* unemployment

entrepreneurs, 4, 10, 12, 99, 244

Ethiopia, 282; Ethiopian Quarter, 286

Europe, 249, 316

fabrics, 90–93, 102, 106, 107, 187, 252

fashion, 19, 182, 269, 284, 291, 314; discount, 179; disposable, 106, 192; fast, 14

Fattis Mansions, 187, 224

Fietas, 6, 187, 286

financial center, 6, 8. *See also* Central Business District (CBD); Johannesburg; Sandton

fire, 31–32, 36, 40, 45–47, 120, 127, 157, 319; bonfire, 257, 324. See also *braai*

First National Bank (FNB), 310, 316. *See also* gold; mines; *Zama Zama*

flat, 16, 93, 150, 179, 184–87, 192–93, 198–99, 204, 216–39, 251, 262, 266, 318. *See also* Anstey's

Fleurhof, 318, 321

341

343